portraits for
NHS heroes

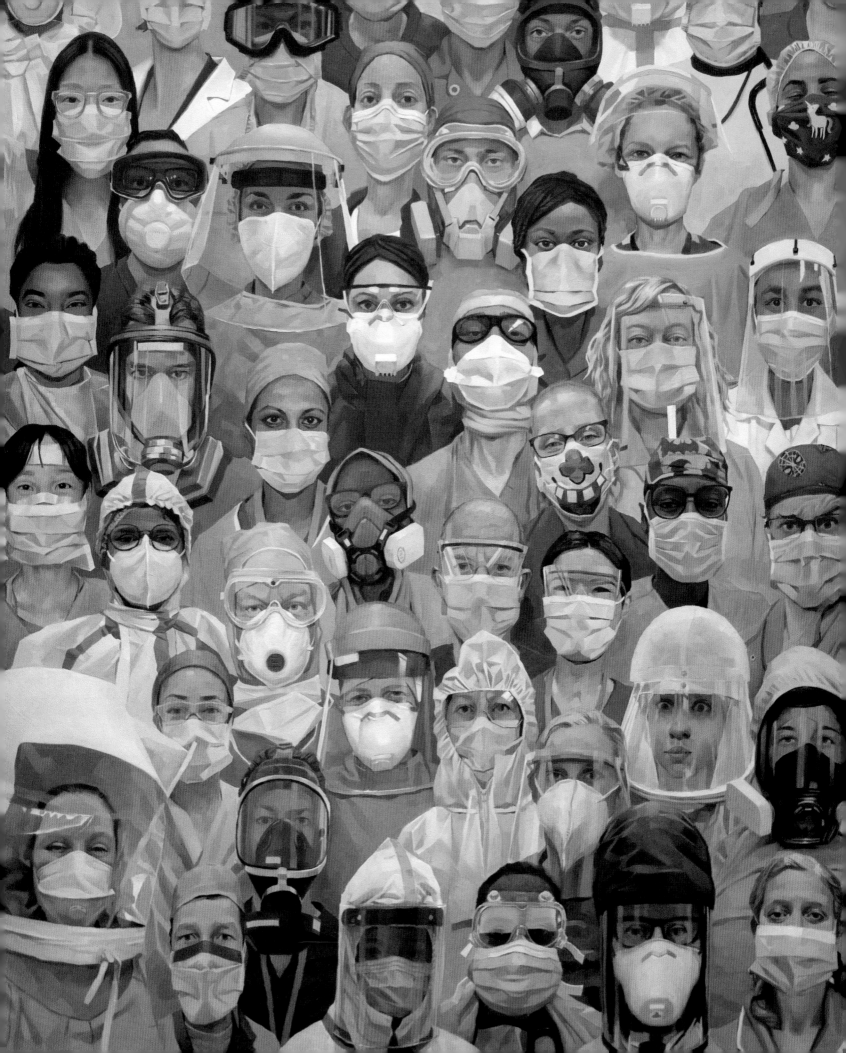

portraits for NHS heroes

initiated by TOM CROFT

BLOOMSBURY CARAVEL

LONDON · OXFORD · NEW YORK · NEW DELHI · SYDNEY

page 2

GROUP PAINTING by DARREN BUTCHER

OIL PAINT | 80 × 100 CM

page 5 by Nick Richards *detail from* p. 46

page 7 by A.S. Morrigan *detail from* p. 31

BLOOMSBURY CARAVEL

Bloomsbury Publishing Plc
50 Bedford Square, London, WC1B 3DP, UK
1385 Broadway, 5th Floor, New York, NY 10018

BLOOMSBURY, BLOOMSBURY CARAVEL and the Diana logo
are trademarks of Bloomsbury Publishing Plc

First published in Great Britain in 2020
Copyright © Tom Croft and Contributors, 2020

All image titles have been provided by the artist

A catalogue record for this book is available from the British Library
Library of Congress Cataloguing-in-Publication data
has been applied for

ISBN: 978-1-4482-1800-4

2 4 6 8 10 9 7 5 3

Cover and text design by Lucy Morton at illuminati, Grosmont
Printed and bound by Bell & Bain Ltd, Scotland.

To find out more about our authors and books
visit www.bloomsbury.com and sign up for our newsletters

CONTENTS

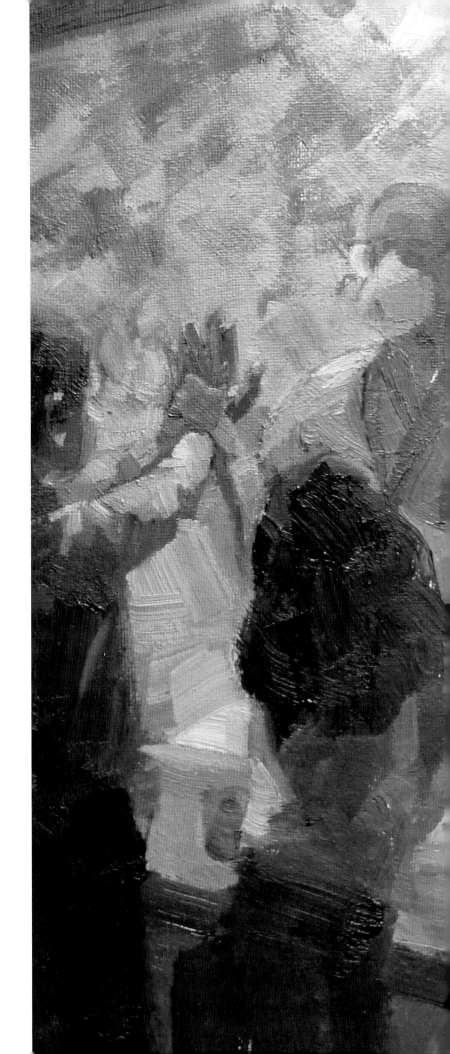

FOREWORD by MICHAEL ROSEN

Creating the National Health Service was an act of love. Of course it's possible to describe it in many other terms: a response to the huge class divide in healthcare provision that existed in pre-war Britain; part of a general demand for social provision and social care that came out of the British labour movement – that's trade unions and the Labour Party itself; a sense of a national destiny that became acute after the courage, privations and tragedies of the Second World War.

I see it as an act of love because the creation and running of the NHS requires an attitude that treats people as fundamentally the same – that at any time in our lives we might need the kind of care that only health professionals can give us. This needs a lot of money and resources – so it calls on us all to make a commitment to each other, to pay for something which may or may not at that very moment be something we need. At that moment, we are doing it for someone else.

We can all tell stories of how the NHS has come into our lives: at the birth, illness, accident or death of loved ones and friends. We have all seen that combination of knowledge, skill, care and close observation applied by doctors and nurses. Some of us have seen the particular skills of the emergency services, paramedics and their drivers. Out of sight, there is the army of cleaners, cooks, delivery people who sustain the whole system, while researchers and practitioners beaver away in labs processing the testing and experimenting with new forms of treatment.

My own experience has been various: I was born in 1946, before the NHS, but my parents always told me how it was a great hope of theirs in the years leading up to 1948. They recalled how miners in the 1930s had pioneered a local form of health service in some of their regions, or looked back to when they were children and parents had to count their pennies to see if they could afford a doctor's visit.

My first big encounter with the NHS was in its own way comical. I was fielding at 'silly mid-on' (very near to the batsman's bat!) in a school cricket match and was hit on the nose by the ball. I spent a couple of nights in the local hospital, which had done pioneering plastic surgery during the war on soldiers and airmen. My nose must have been a doddle for them. It's certainly not bent, which it was following the injury.

Then, again, not far from the hospital itself I got knocked down by a car and was whisked in with a broken pelvis and fibula. I spent eight weeks in a kind of hammock in a ward shared between motorbike accident casualties and old guys – some born in the nineteenth century – with various problems with their 'waterworks'. This was then followed up with two weeks in a rehabilitation hospital, where I had to learn how to walk and run again. When I've told people from the USA about this and how this kind of treatment is paid for through taxation and free at the point of service, they can hardly believe it.

I've also been at the births of all my children and seen the kind of teamwork that brings new

human beings into the world and follows it up with injections and home visits. It is easy to undervalue this too, and not appreciate what happens in places where there is no system of universal healthcare. As it happens, I'm a lifetime beneficiary of free medication as I have the chronic condition of an underactive thyroid. Since being diagnosed – not easy as I was a young man, an atypical patient – I have been able to enjoy free treatment, free testing now for over forty years.

The most difficult experience is ongoing: in March 2020 I was whisked into A&E by my wife, where they found that I was in a critical condition caused by Covid-19. A few days later I was put into intensive care and stayed there for 48 days, spent more time in the open ward and then three weeks at a rehabilitation hospital. This has engaged the work, thought, skills, kindness, care of hundreds of people and is ongoing with my visits to clinics dealing with what has come to be known as 'long Covid' – the long-term effects of this dangerous virus. There is no greater testament of this than the book made by the nurses who cared for me when I was in an induced coma: each day they wrote a kind of letter or diary entry 'telling' me how I was doing 'today'. It stands as a record of their diligence and devotion sitting by my bedside hour after hour.

This treatment saved my life – probably several times. And, of course, the same was going on all over the country. Tragically, the NHS cannot save everybody. All I can say is that I am the grateful beneficiary of this wonderful service.

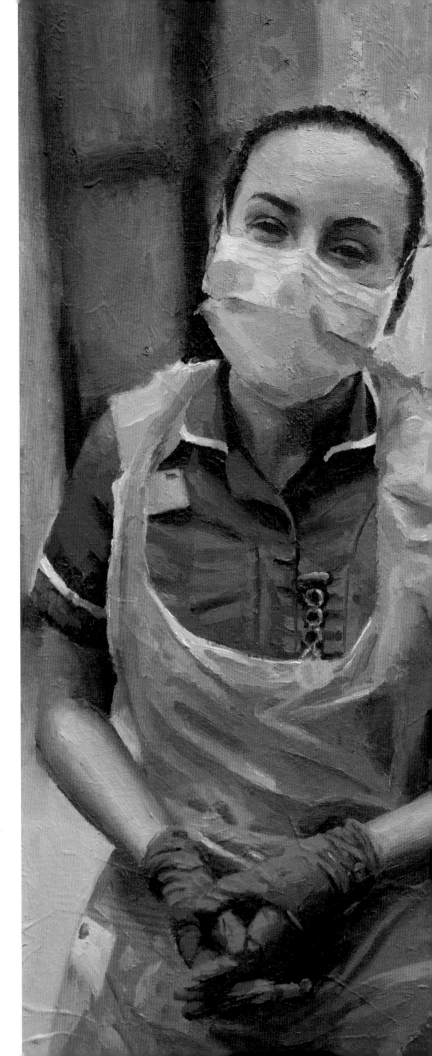

FOREWORD by ADEBANJI ALADE

VICE PRESIDENT, ROYAL INSTITUTE OF OIL PAINTERS,
ART TV PRESENTER (BBC) *THE ONE SHOW*

We shouldn't be holding this book. It was not even conceived in March this year. But things have changed so rapidly in the world we live in that at one point we almost couldn't remember what day of the week it was. I have never experienced anything like this year in my whole life – and of course I am not in the minority here. But I have learnt always to see the positive in everything, and this book is a great light in the sudden cloud of darkness that robbed us of lives, livelihoods and freedom. Wow! 2020 and a book in our hands to celebrate art and science is not what I saw coming...

There are people who experience things, there are people who watch things, there are people who say things and there are people who change things. Tom Croft is an artist like myself, but a man with a different mindset, who wouldn't just allow things to remain as they were. He rose to a challenge that many would not take up, and has made a great difference. His clarion call shows how the power of social media has become a great tool for activists. And, dare I say, Tom is up there with those who have come into the limelight because they were different – always prepared for a moment like this – and when the opportunity of life throws open its doors, they grab it and rise. I am in full appreciation of Tom and I know I'm speaking on behalf of all the artists who have contributed to this great movement to celebrate our NHS heroes.

At a time when most of us were locked up, scared stiff and trying our best to keep going in what I have come to call 'sleep mode', the key workers, especially the NHS workers, were out there giving their blood, sweat and tears. Listening to the news, and seeing that they were not only serving but laying down their own lives for what they believed in, simply blew my mind. I remember asking about my friend, Stan Nyakuhwa, because I knew he worked in an operating theatre... and his reply touched my soul. 'I'm at work, please pray for me.' He attached a picture of himself in a way I hadn't envisioned – he looked like those gas-masked guys of the Second World War. Well, pray I did – but I also asked if I could paint his picture just because I thought he deserved my service in some way and to remember such a moment. Now, creating portraits of these amazing heroes is what artists all over the UK and beyond got themselves into and it's been a delight to see.

All the artists were in the thick of it too. Many of them had exhibitions cancelled, art teaching brought to an end in schools or colleges with no return date; others couldn't get to their studios in lockdown. Add to that the emotional and eventual financial strain... But in the midst of this, when Tom asked if they would love to paint an NHS hero for free, the numbers started rolling in. This movement brought out the most beautiful experiences: it was great to see NHS workers receiving their portraits with beaming smiles and joy. I am so happy artists have created this monument, which was gloriously captured first of all on the Google Arts site. It is a wonder to

behold! The first time I visited the site I couldn't believe my eyes. In fact even before it was up, I was privileged to choose five portraits to speak or comment on. I was simply overwhelmed by the sheer brilliance displayed by the artists, to create amazing artworks of the heroes! Without them we wouldn't have this celebratory book today.

Now we have a book and the book will travel far and wide. I'm happy that the world will see what artists decided to do when called upon at such an unprecedented time in history.

These are powerful works. These are ordinary people portrayed in their work clothes, in casual clothing, in the very environment where they worked to save lives during the pandemic. Each has been captured in the medium most comfortable in the hands of the artist, and now it's here for posterity to behold. I'm so proud to be part of all this!

Finally, this is why art is powerful. As creators, we see the world differently. Sometimes we can be misunderstood, but in this book our intentions are crystal clear: we have brought to the world in our diverse ways the heroes of our National Health Service! Please don't just get one copy: get more, spread the news, make it a gift to open the eyes of anyone who may not have heard about this yet. This book is the testimony of our labour of love.

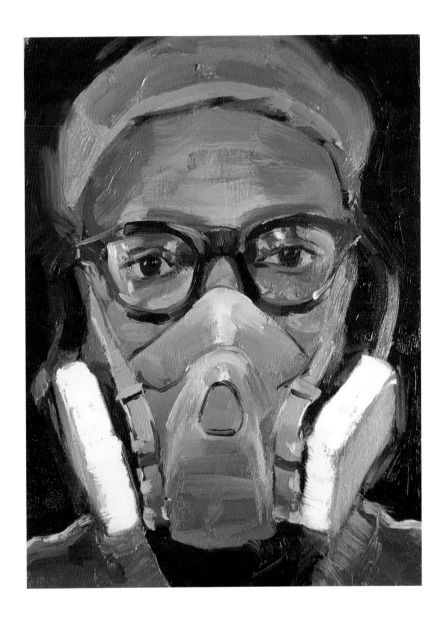

STANISLAUS NYAKUHWA
by ADEBANJI ALADE

OIL ON BOARD | 20 × 15 CM

9

DR JIM DOWN by LOUISE PRAGNELL

OIL ON CANVAS | 60 × 50 CM

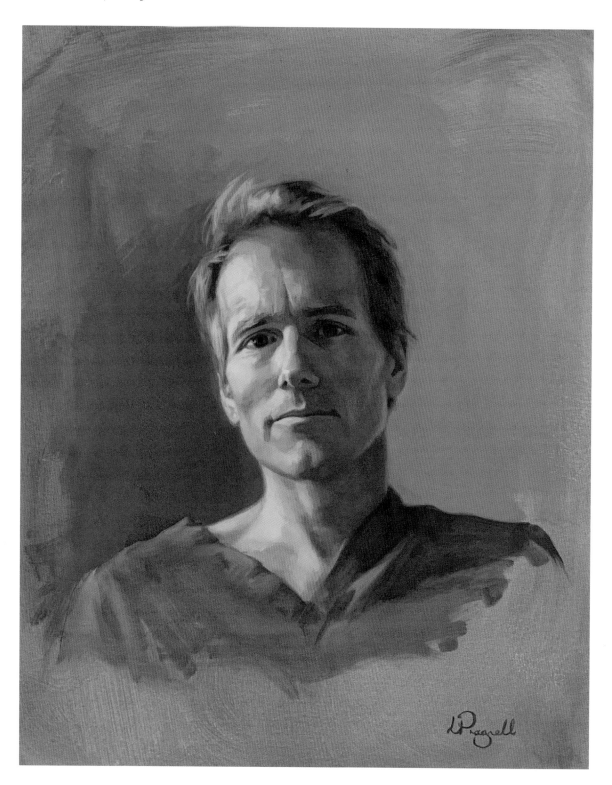

FOREWORD by JIM DOWN

CONSULTANT IN ANAESTHESIA AND CRITICAL CARE, UCLH

I have worked as an ICU doctor for over 20 years, and yet when Covid struck I was completely unprepared. I was ready for the surge in numbers, I was happy to return to night shifts for the first time in 16 years, I was getting used to PPE and I was reconciled to the risk to my own health. But what I wasn't expecting was this disease. It was like nothing I had ever seen before, so prolonged and fluctuant and unpredictable and brutal. Just when we thought we were getting a handle on it, it would throw something else at us: blood clots, life-threatening fevers, kidney and heart failure. One day a patient would seem to be on the mend and the next they'd be back at death's door. For many patients this went on for weeks. It was relentless, and all the while their loved ones sat at home, waiting for news, wondering and hoping.

In two weeks our ICU grew from 35 beds to 90, expanding into the operating theatres and onto a ward. Every one of those beds filled with Covid patients, and staff came from every part of the hospital to help. Apart from delivering babies and the odd emergency operation, it was all our hospital did for three months. Cancer surgery continued elsewhere, but everything else ground to a halt.

This story was repeated throughout the United Kingdom. The NHS was transformed. Surgeons became nursing assistants, dentists ran family-liaison services and medical students formed teams to turn rows of unconscious patients onto their fronts. None of us had ever experienced anything like it. The scale and severity of the disease were almost unimaginable.

Tom Croft's initiative brilliantly captures this unprecedented moment in the history of the NHS. Each picture tells a unique story, but together they build an image of the stress, exhaustion, fear, compassion, tragedy, camaraderie, hope, love, endeavour, commitment and sacrifice that staff and their loved ones experienced through the pandemic. As I moved from face to face I was transported back to my night shifts in April.

I couldn't imagine having my portrait painted. That was something for royalty and celebrities and I didn't think I would be able to sit still for long enough. I was also anxious about what I'd do with the picture afterwards, but when artist Louise Pragnell explained Tom's plan I was intrigued. She reassured me we'd do it over Zoom in three or four hour-long sittings. She was a brilliant artist, it was a great project and I was in my fiftieth year and supposed to be saying 'yes' to everything, so I did. I was self-conscious initially and assumed I'd sit silently so as not to disturb the artist, but Louise chatted away as she worked and soon I started to enjoy it. Sitting still for an hour a week, talking about kids and lockdown, not about ICU and Covid, turned out to be therapeutic. Finally in June, with some trepidation, I drove down to her studio to see the result. I shouldn't have worried, her work was, as always, extraordinary. I am proud to be a part of this project: a stunning collection of portraits, and a wonderful tribute to the NHS. Thank you.

INTRODUCTION by TOM CROFT

On 23 March 2020, my youngest daughter's 13th birthday, the government locked down the country to stop the spread of the Covid-19 virus.

As a self-employed portrait painter used to working from home I assumed this might not be too much of a change to my normal working practice. However, when you're painting you have a lot of head space and time to think about things. I listened to too much rolling news, and as the enormity of the crisis hit me I couldn't concentrate or focus on my work at all.

I ground to a halt. What is the point of a portrait in the face of a global pandemic? What is the point of a portrait at any time?

For all the thousands of selfies people now take, we rarely if ever print them out and frame them. As a physical record of our existence, a portrait is likely to last far longer than we will and hopefully get passed down through generations.

I get commissioned to paint portraits for many different reasons. It could be to mark a birthday, anniversary or retirement, to record and document a moment in time, or to celebrate significant achievements.

Walk through any major public gallery and the portraits tend to depict the great and sometimes the good of previous generations. People who stood out and made a difference to the world. It occurred to me that the subjects lining the walls of major galleries for future generations to look back on should be the people who made the biggest difference during this extraordinarily challenging period of history – the NHS key workers on the front line, risking their physical and mental health on a daily basis for our benefit.

I had rediscovered (or reminded myself of) the point and power of portraiture.

So I put a video message out on Instagram offering a free portrait to the first NHS key worker to contact me. Then I suggested other artists could do the same. If enough people took part, I thought, it could form an amazing exhibition in future to thank, record and celebrate the NHS workers for their heroic work.

I was overwhelmed by the response. I personally matched up over 500 artists and NHS workers in two weeks – it was a full-time job! Then, when I couldn't move fast enough to cope with the growing response, I created a traffic-light system where artists posted an image of a green canvas from my Instagram page that said 'I'm offering a free Portrait to the first NHS key worker to contact me'. NHS key workers could search under the hashtag #portraitsfornhsheroes to find an artist. Once they were matched up I gave them a red canvas to post, to say they were paired and to look for another artist with a green canvas. This way people could find each other themselves and the initiative could grow quicker and reach the widest possible audience. I asked everyone to post the final portraits on Instagram under the hashtag #portraitsfornhsheroes so that people around the world could see them.

Over the next few weeks I was also contacted by people in different countries wanting to start their own initiatives and asking my permission

to tweak the hashtag and green canvas to reflect their healthcare systems. This now grew things globally. Ireland, Belgium, Spain, France, Italy, the Netherlands, Germany, Poland, Croatia, Malaysia, Canada and the USA are among other countries taking part.

When I last checked there were over 13,000 posts under the hashtag #portraitsfornhsheroes. Many artists have painted more than one NHS worker and some artists have painted multiple portraits – over 50 for one artist – and all for free. There are different media utilized from painting, drawing, sculpting, digital, glass work to stitched portraits and one even made from marquetry using thousands of pieces of wood.

I am delighted to be working with Bloomsbury to produce this celebration of just some of the NHS portraits that have been produced. With all royalties going to NHS Charities Together, this is the first physical collection of the portraits and the first chance to raise money too.

People continue to paint, draw, sculpt, stitch and digitally produce portraits, and I am optimistic there will be a significant physical exhibition too to say thank you – a national acknowledgement so that we can all see what life looked like on the front line of the pandemic – through the eyes of the NHS heroes and through the hands of the art community.

I'm extremely grateful to all the artists who took part in #portraitsfornhsheroes, and of course to all the NHS workers for allowing us to share their images and tell their stories.

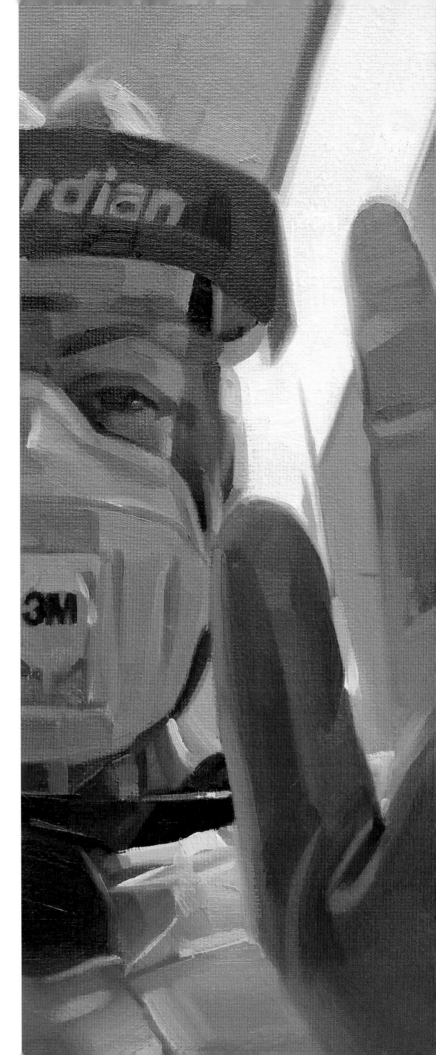

HARRIET DURKIN by TOM CROFT

OIL ON CANVAS BOARD | 30 X 25 CM

'I thought the image of Harriet in her PPE gear set the scene of what she has to go through on a daily basis to administer care. The cropped composition puts the viewer in the role of patient and the atmospheric lighting really appealed to me as a painter. Her hand is raised – we assume to wave at us, but it could just as easily be misconstrued as a reminder of the need for social distancing. It's far harder to read facial expressions with a masked face – I understand this can create additional anxiety for the patient and make the carer's job trickier. As a portrait painter you usually have the whole face to describe someone but with a mask on you only really see the eyes.' **TOM**

'I am an A&E nurse working on the front line. The picture was the first time I put full PPE on at work getting ready for a shift and I sent it to my parents. When I saw the portrait for the first time I felt so overwhelmed and speechless. I can look at that portrait and it will remind me of Covid-19, what my colleagues and I were going through. At the same time it makes me feel proud to be part of an amazing team that cares for every patient that comes through the door. I feel proud to be a nurse every day, but it's incredible to feel so valued and appreciated during such a difficult time.' **HARRIET**

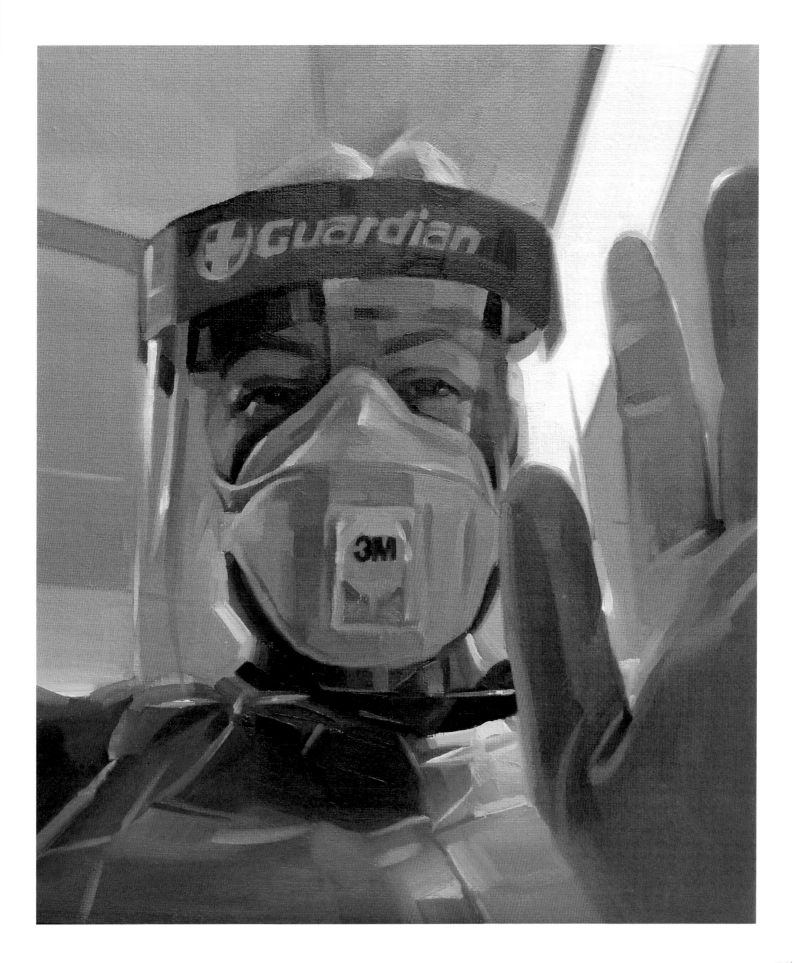

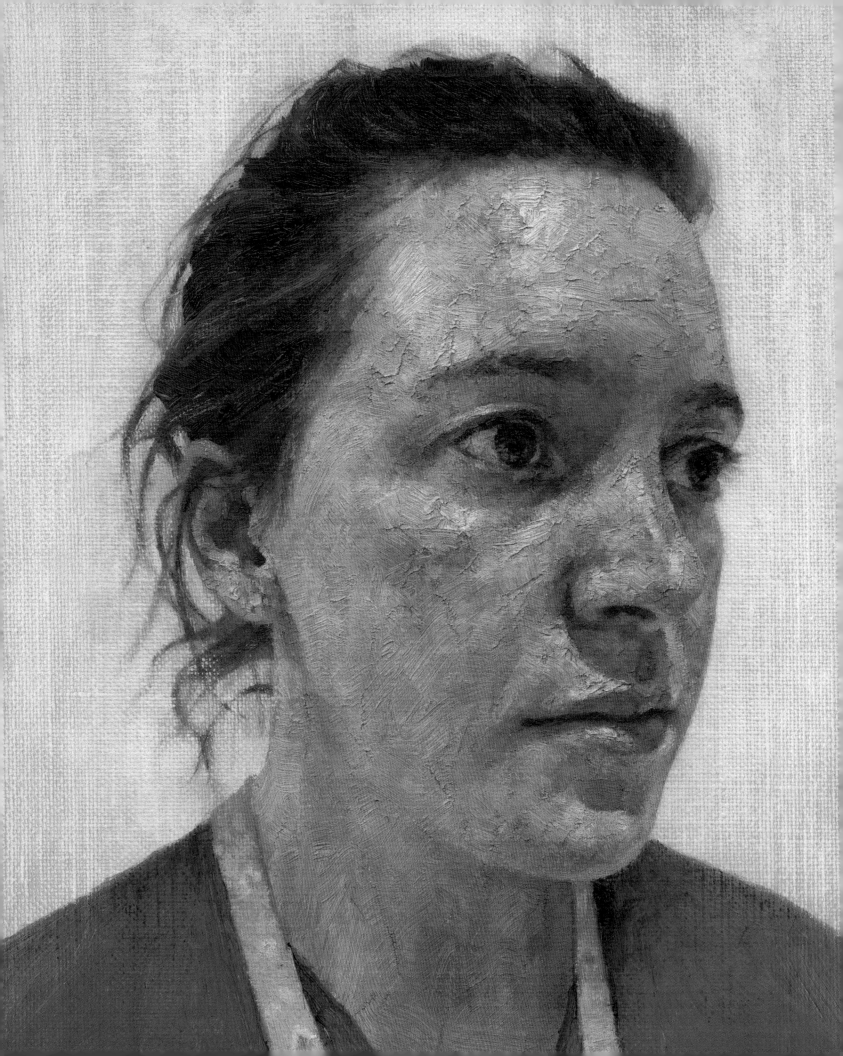

'Izzy is a staff nurse at John Radcliffe Hospital in Oxford. After discussing a few ideas I asked Izzy to share with me three very honest photos she had taken immediately after a 13-hour shift in full PPE. Her raw yet resilient expression and her sense of being physically and emotionally drained really spoke to me. I felt compelled to capture all this in the painting. Her portrait was a pleasure to work on and is my way of paying tribute to Izzy and all of our NHS staff for the incredible work they do.' DANNY

'I started my nursing career in February 2020 during the worsening Covid-19 crisis. I never imagined having my portrait painted as an NHS nurse during a pandemic, but Danny Howes had a clear idea of what he wanted. When I saw the finished painting I was struck by the emotion Danny had captured, reflecting the pressures that nurses and the whole NHS are under. I want to say a massive thank you to Danny for the portrait and to Tom for starting the project – I will cherish this painting forever.' IZZY

DEBORAH GARLOCK
by ALASTAIR ADAMS

OIL ON PANEL | 40.5 × 31.5 CM

'Being painted at such a time made me feel valued and proud of what we were doing. Humbled too, as it is our job to take care of people, being there for them at their most vulnerable. The first few weeks of the pandemic hitting were overwhelming: we were learning about a new illness and seeing really sick people. Staff too needed support and it was pretty exhausting. The hospital felt strange with no visitors and fewer patients other than those with the virus. It was all a bit unreal, home felt like sanctuary. I joked that I hoped the portrait would make me look younger, wrinkles ironed out, but the picture was after night shifts and I actually like its honesty, wrinkles included. A photograph is obviously a likeness but I feel a painting is more intimate as the artist has to study you and interpret. The fact that it takes time and work makes it more special. Working with thousands of NHS staff, not always celebrated in this way, the project's meaningful portraits capture a spectrum of emotions, not just depicting the uniform but contrasting the personalities and responsibilities within. Truly good portraiture thrives in this context.' DEBORAH

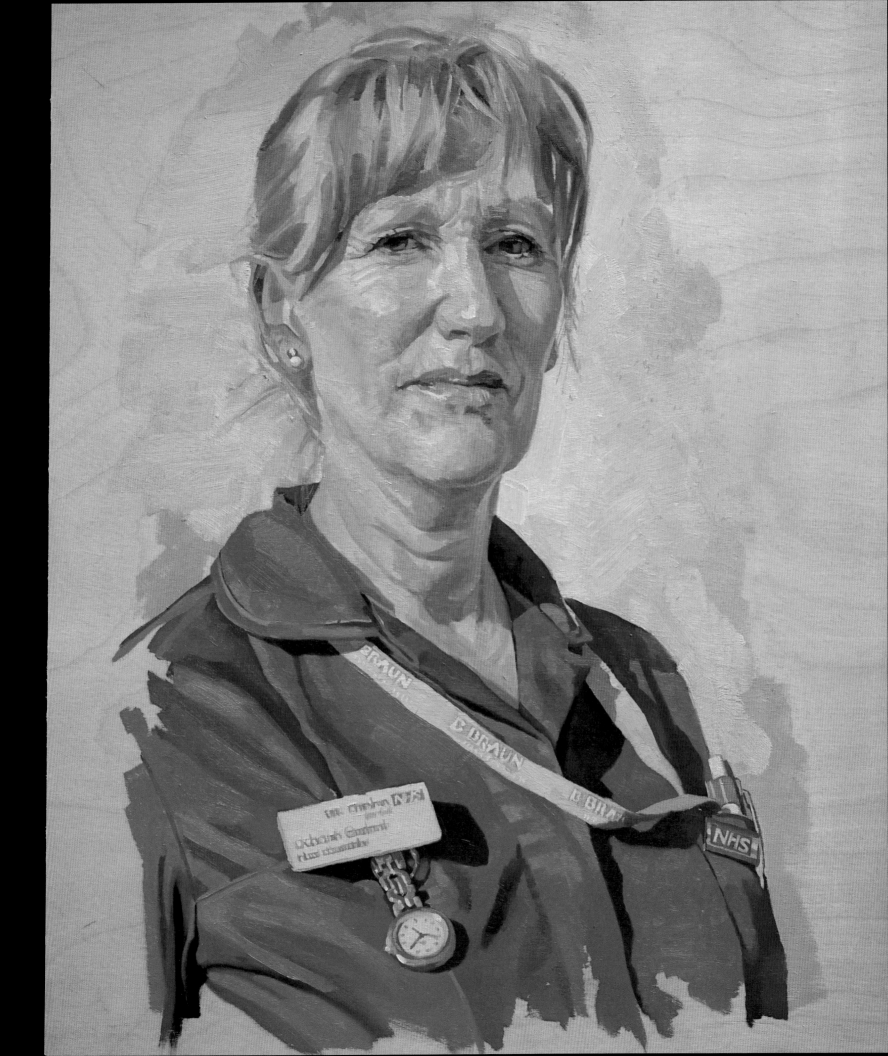

SKUKURA MURRAY
by KATHARINE ROWE

OIL ON LINEN CANVAS | 40 × 30 CM

DR NATASHA LEE
by ILARIA ROSSELLI DEL TURCO

OIL ON LINEN | 45 × 35 CM

'As an NHS worker, recognition is never the goal. However, I am extremely honoured to be represented as one of the many NHS members of staff working during the pandemic.' SKUKURA

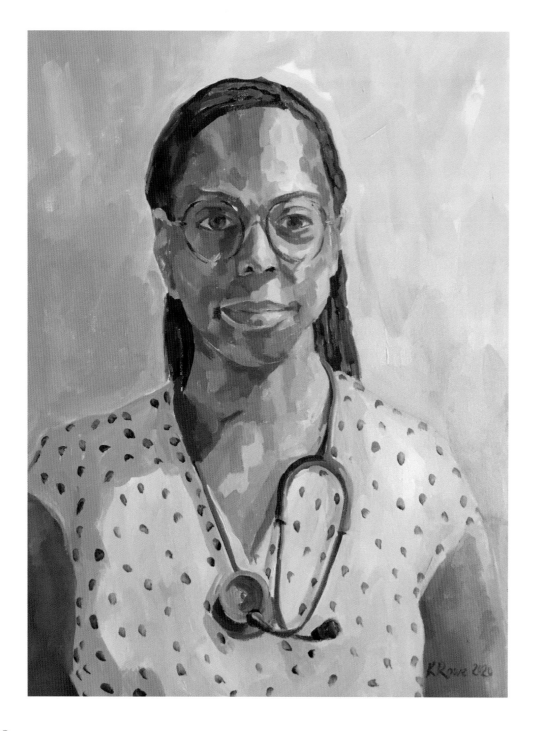

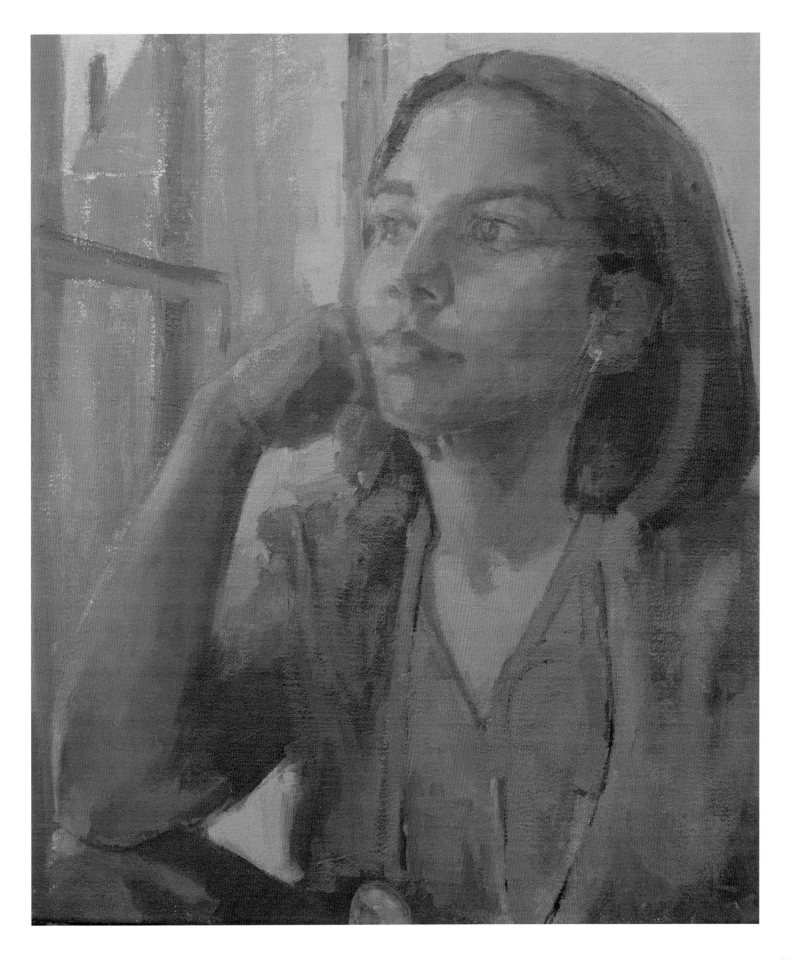

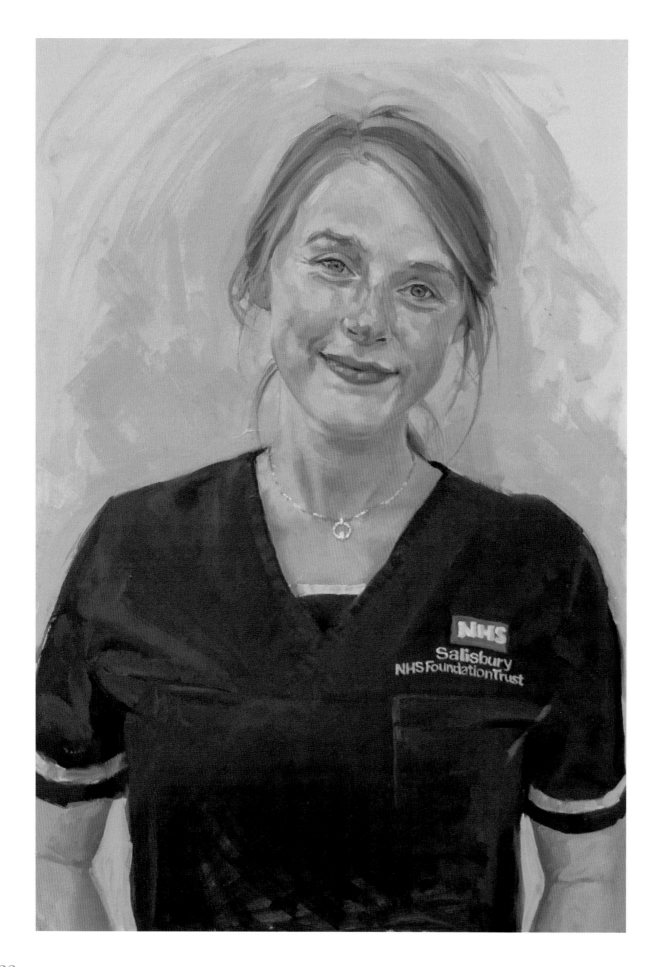

IAN COYNE
by CHRISTOPHER BANAHAN

ACRYLIC ON PANEL | 28 × 25 CM

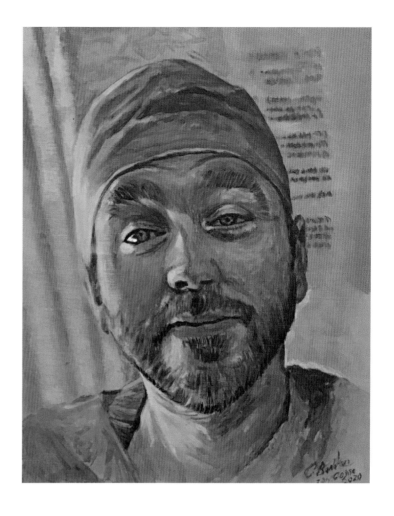

'I felt inspired by the charming grin Ian, an ICU physician associate, gives off in this image. Despite his obvious fatigue from the exhausting work as a frontline health worker during the Covid pandemic, he still manages to radiate an infectious smile that transcends the oppressive situation he finds himself in, and gives us hope and faith in these extraordinary NHS heroes.'
CHRISTOPHER

AMY by FELICITY GILL

OIL ON LINEN | 60 × 40 CM

'It was wonderful to see just how many people wanted to have their portrait painted for the Portraits for NHS Heroes project. Portraiture is clearly still alive and kicking! In this age of selfies, it shows how a painted portrait can tell a fuller story and show more facets and dimensions of the subject's being. I was delighted to be paired up with Amy, a radiographer who is studying for her Master's and training to become a sonographer. It was difficult to paint remotely rather than with a sitter in front of me, but her character started to leap out of the canvas as soon as I began painting.' **FELICITY**

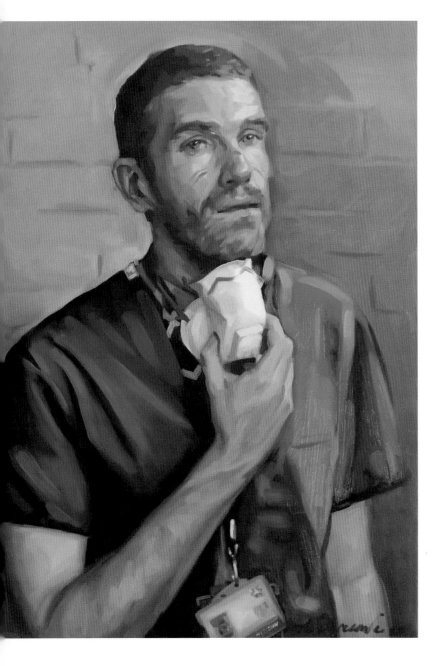

MIKE RAFFERTY
by CAROLINE DE PEYRECAVE
OIL | 70 × 50 CM

'Mike, an orthopaedic registrar, has been in ITU assisting with Covid-19 patients. Mike is painted here just pausing outside for a breath of fresh air. The marks of the extended time wearing the mask are still imprinted on his nose and cheeks.'
CAROLINE

'It was really humbling to be painted by Caroline. It was a pretty tricky time for me working in ITU. My wife is also a doctor in the NHS and things got even more complicated when we found out she was pregnant and we had to shield apart. My wife loves the painting and thinks it has captured me at my most drained.' **MIKE**

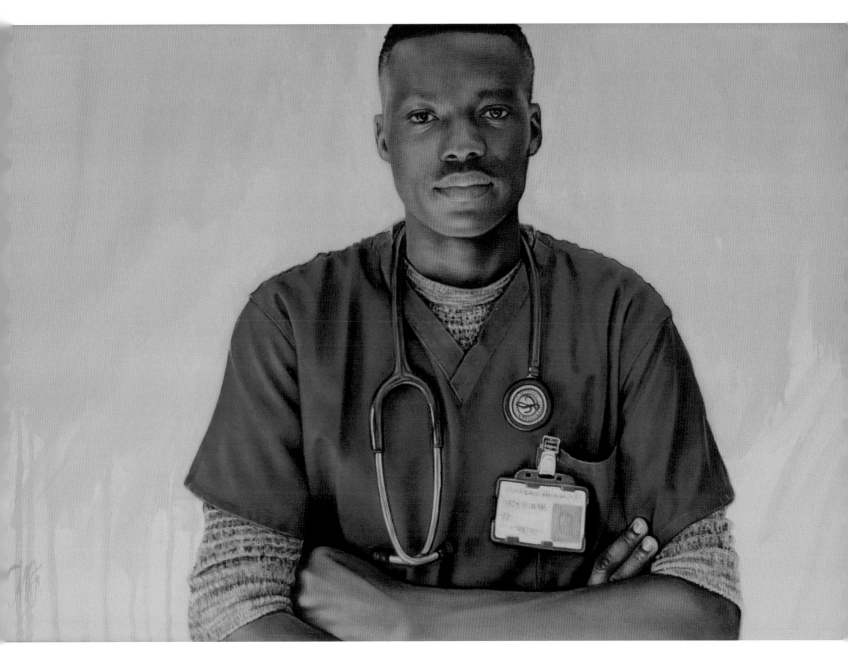

DR MAYOWA OYEBOLU by TRUDY GOOD

OIL ON CANVAS | 30 × 60 CM

'Dr Mayowa Oyebolu came from Nigeria to work in the A&E department at Coventry Hospital. At the beginning of the epidemic, he made the decision to move out of the family home so that he could continue his frontline work without risk of infecting his wife and baby daughter. I wanted to convey Mayowa's sense of isolation by stripping away any hint of his surroundings and placing him in a large area of clinical-looking background. My impression is that Mayowa is a very honourable and selfless human being – I hope that this portrait will convey these admirable qualities. It has been an honour for me to have been able to use my skills to give a little back to our incredible NHS heroes, adding purpose to my work and life during a frightening and unsettling time. Thank you each and every one of you for the sacrifices you have made.' **TRUDY**

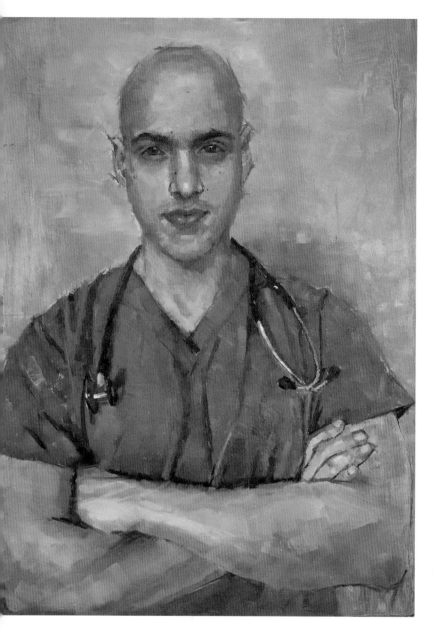

MICHAEL CAMILLERI
by LISA ANN PUHLHOFER

OIL ON BOARD | 51 × 41 CM

'The face and what lies beneath it hold an endless fascination. My goal is to establish a narrative by conjuring the character, emotion and likeness of a subject with honesty. This must always be an experimental process for me – otherwise what is the point? I was captured by Michael's strength in the pose but the softness and kindness in his expression. It was important to me to recreate this in the portrait.' LISA

'When I first saw it I could not believe my eyes how well she captured me. I felt incredibly flattered. My one-year-old daughter absolutely adores it. She loves shouting "Daddy!" when she sees it.' MICHAEL

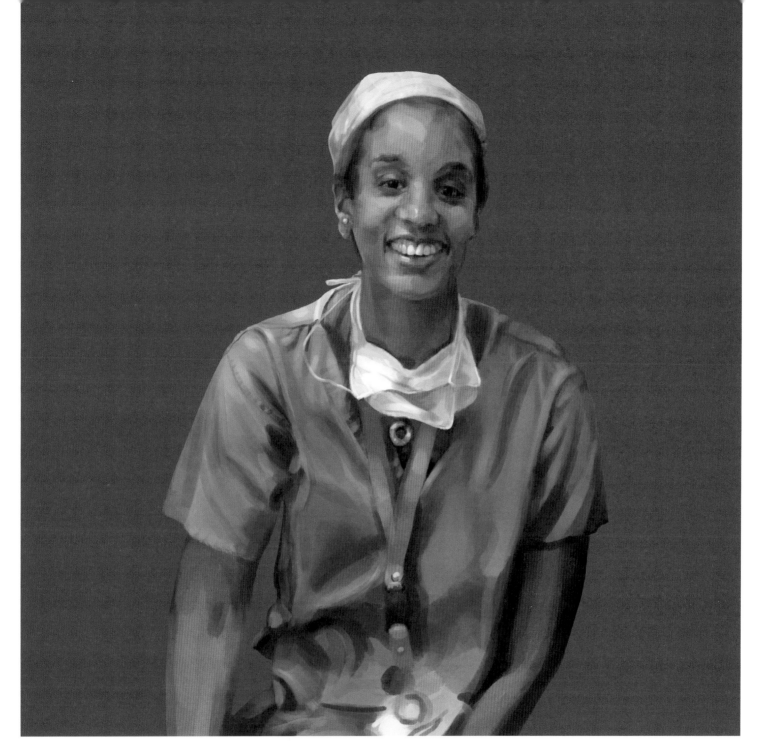

AMAKI by EVE MIKO

DIGITAL | 30 × 30 CM

'With how quickly events unfolded, it was important to hear stories of those on the front line, and to give something back. It was an honour to paint Amaki. I hope we meet in person one day!' EVE

'I have been redeployed from the operating theatres to work as a doctor on the Covid ICU. It's been incredibly hard work and emotionally challenging but also truly inspiring. My nursing colleagues, who are in PPE at the bedside of our sickest patients for hours on end, have shown superhuman levels of resilience. It bothers me greatly that doctors get more recognition, but the truth is we are nothing without the nursing staff. They are the true heroes.' AMAKI

DR KATIE ROGERSON by RO WILLIAMS

OIL | 32 × 22 CM

'The omission of a mask or clinical background in this painting was an attempt to deflect attention back to the person behind the mask. NHS workers have talked about how hard it is to convey reassurance and comfort whilst wearing a mask. I was really struck by Katie's gaze and I wanted to capture that in the painting.' RO

'As a paediatrician I am reliant upon two things: my grin (broad and friendly, with a lot of teeth) and my jokes. Then a global pandemic comes along and, just like that, my secret weapons are gone. No smiles. No jokes. Under the mask we have been working harder than ever to reassure our little patients. It is the greatest of successes when we can make them laugh, even when in PPE. When they can see past the mask to the smile behind. Because you can see the fear has left them briefly. They are "just normal" again. And you are a normal doctor. Not an alien, or a monster. Just a doctor in a mask. Your eyes can still smile. Although I am not sure my face has ever worked so hard as when it was hidden.' KATIE

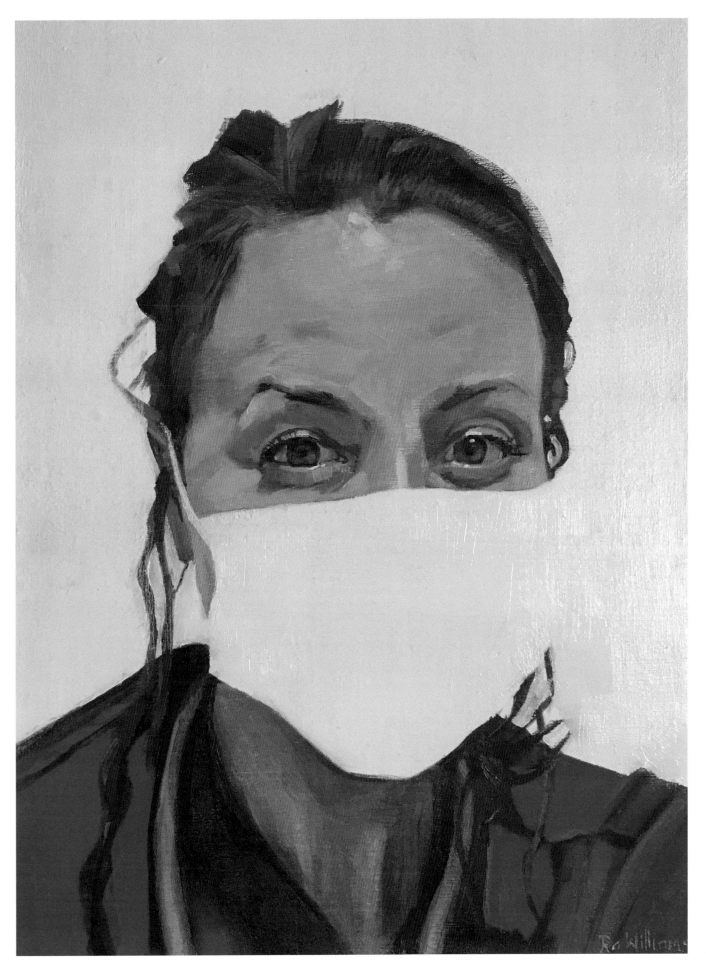

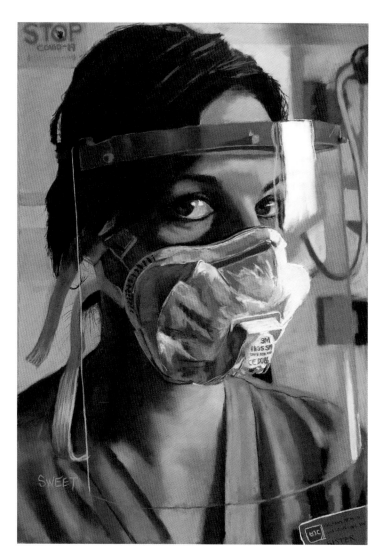

GEMMA CARTER by DAVID SWEET
SOFT PASTEL | 70 × 45 CM

'Gemma is a sister in the regional neonatal intensive care unit in Belfast. At the outset of the pandemic there were severe shortages of PPE. This visor was manufactured using 3D printing technology by Jim, husband of one of the consultant neonatologists. In the beginning staff underwent intensive training in PPE use and protocols for moving and caring for mother–infant pairs potentially at risk. Thankfully during the first wave of infections there were no cases of neonatal Covid-19 in Northern Ireland.'
DAVID

ALINA NICODIM by MICHAEL RIDDLE
OIL | 56 × 46 CM

'Alina is a sister working on an ITU ward in a London hospital. Alina was obviously working unbelievably hard under exhausting conditions, so we worked with a few selfies that she was able to take between work and sleep. She wanted a painting of her out of her PPE, so we included a little snapshot in the background. This was one of the most difficult, but most rewarding, portraits I have painted. Alina is an incredible person and I am so grateful to her and NHS staff for their dedication to taking care of us all.'
MICHAEL

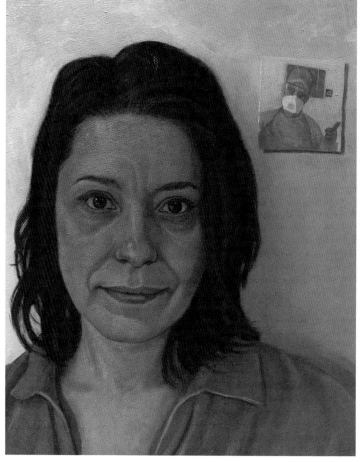

SUSAN by A.S. MORRIGAN

OIL ON CANVAS | 51 × 41 CM

'Susan was a gift to paint. The image of a single nurse smiling in the face of crisis reminded me of why I chose to take up the NHS Portraits for Heroes scheme. Not only was it wonderful to donate something to a fantastically brave frontline worker; it was also important to capture the human side of the pandemic. Even though you cannot see her smile, you know it is there, shining through the mask. It felt important for me to capture that. During a crisis the personal touch could all but be forgotten but Susan is a perfect distillation of the spirit of the NHS.' MORRIGAN

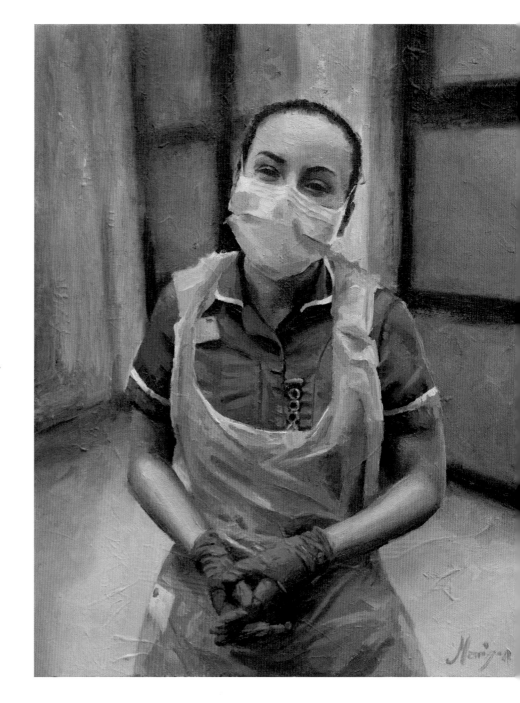

WILL MOEN by PAUL BENNEY

OIL ON PANEL | 40 × 30 CM

'Respect.' PAUL

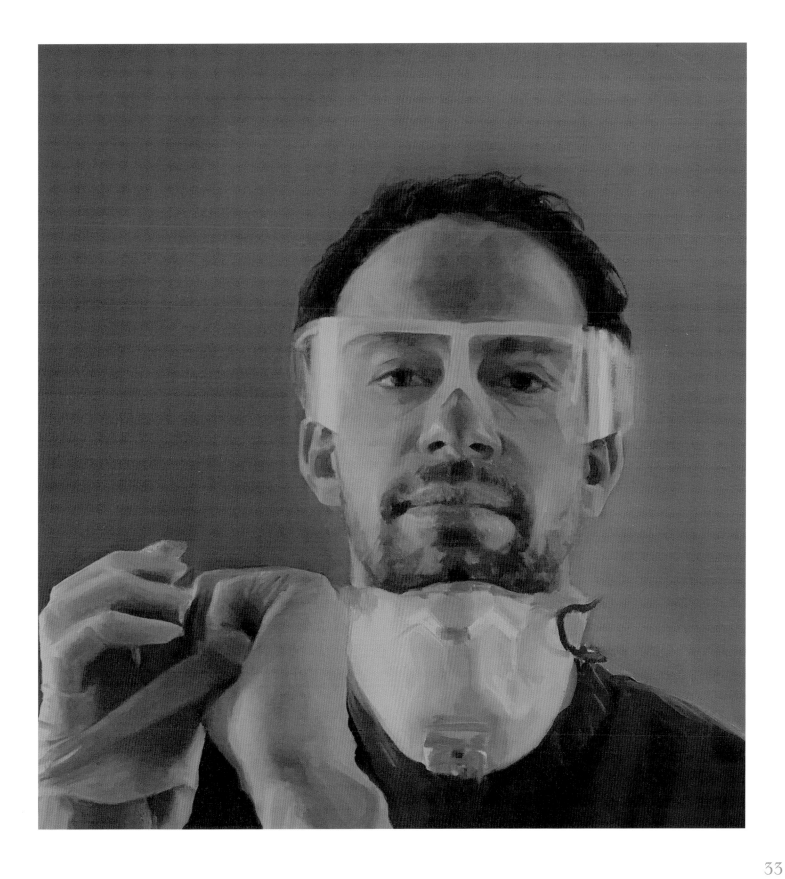

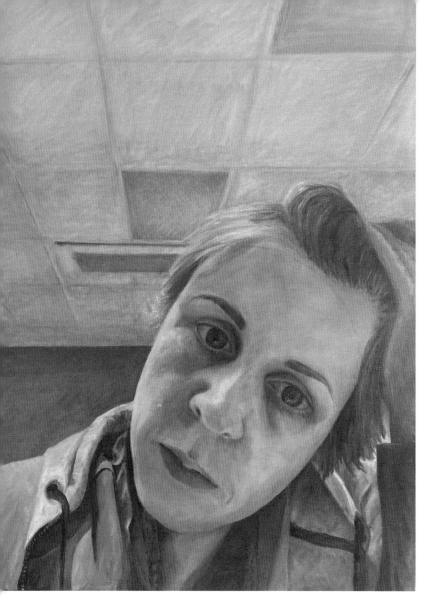

NANCY FAULKNER by GILLIAN HORN

OIL | 80 × 60 CM

'Nancy is usually senior sister in ENT outpatients at the Royal London Hospital, but with a background in critical care and anaesthetics she was redeployed in the Covid-19 ICU for three months while the pandemic was at its peak. I was struck by how gruelling her work on the ICU ward was, both physically – with the long, arduous night shifts – and emotionally, nursing so many critically ill and dying patients. We agreed to capture what she described as an overwhelming and relentless exhaustion as a commemoration of her time in the ICU. Although the portrait clearly speaks to Nancy's exhaustion, her compassion shines through. The inclusion of the ICU space, particularly the institutional gridded ceiling, also conveys something of the oppressive weight of the work. I have been so moved painting Nancy and humbled by her dedication – a true hero.' **GILLIAN**

SAMANTHA by KAREN WINSHIP

ACRYLIC ON STRETCHED CANVAS | 30 × 30 CM

'Samantha is a third-year medical student and works as a healthcare worker part-time at Leeds General Hospital, mostly in A&E. Her spirits were greatly lifted by her portrait. "Something lovely at this difficult time."' **KAREN**

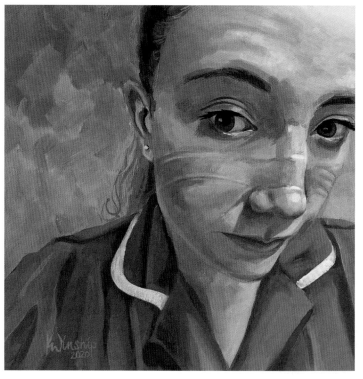

DOMINIC HART by SHARADA KHANNA

OIL | 40 × 30 CM

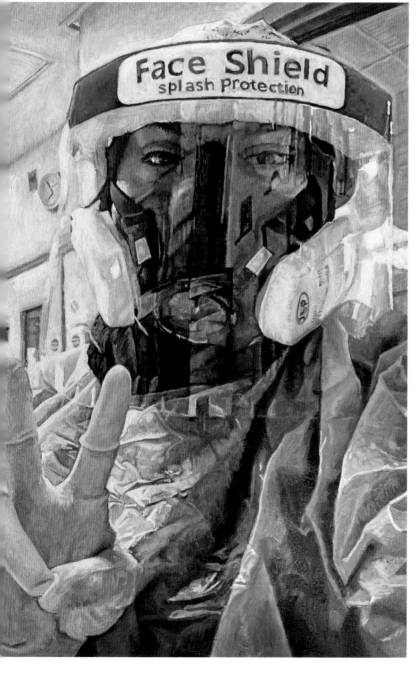

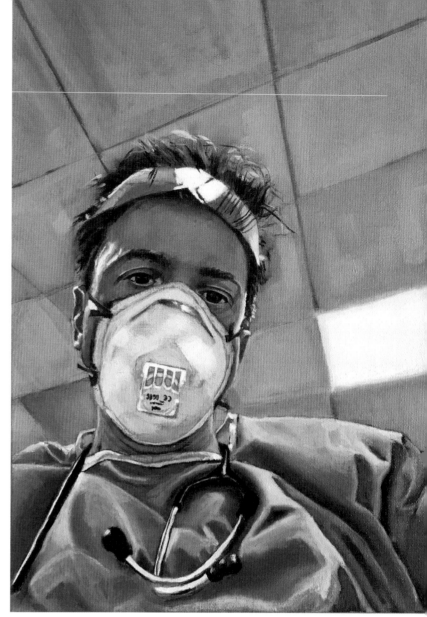

MARUFA by SARAH HARDING

OIL ON PANEL | 26.7 × 15.7 CM

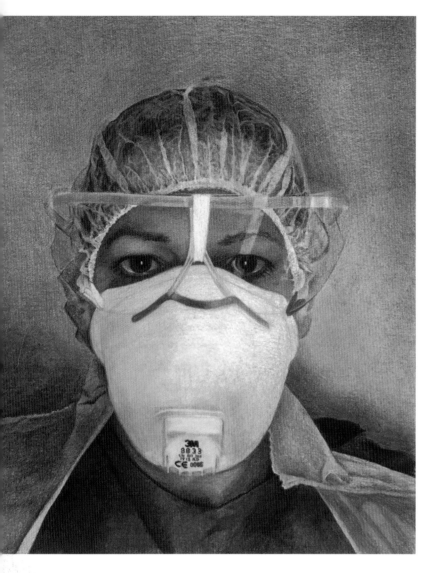

SARAH DEE by ABIGAIL WINFIELD

OIL AND ACRYLIC ON WOOD | 40 × 30 CM

'This is my portrait of Sarah, my son's amazing girlfriend, who works incredibly hard as a staff nurse in the intensive care unit of Bristol Royal Infirmary. It was painted from a selfie she took at the very beginning of the pandemic, when she was feeling very apprehensive and unsure about what was coming. After that the whole unit was taken over by coronavirus patients, and she no longer took her phone to work in case of contamination. I am so proud of what Sarah does, and wanted to show my appreciation and be a part of the amazing Portraits for NHS Heroes initiative.' ABIGAIL

NIA by ANNA JUDGE

PASTEL | 32 × 24 CM

'Nia is an emergency care paramedic practitioner who selflessly volunteered her services during the coronavirus pandemic. This is Nia in full PPE just before embarking on a night shift in the Intensive Care Unit.' ANNA

'Twenty years in the NHS, and until this year I had never understood what a war zone felt like. I was proud to join my colleagues in ICU and hoped I made a difference, albeit a small one.' NIA

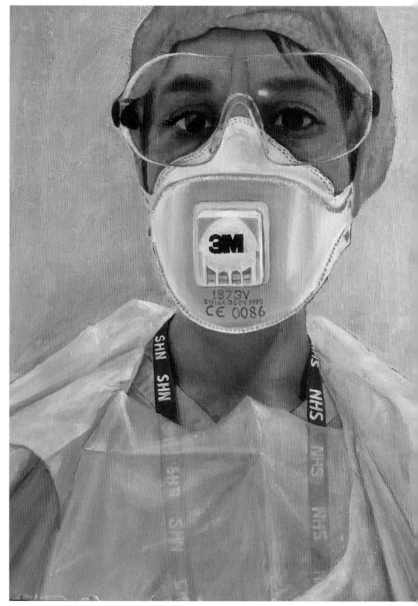

JUDITH LAIDLER by HANNAH THORPE

ACRYLIC ON PAPER | 40 × 30 CM

'Prior to working as an artist, I spent 20 years in the NHS. Like many, I felt powerless in the face of a pandemic. This was a chance to give something back to those who have made huge sacrifices. Judith has worked throughout the pandemic as a staff nurse on a Covid ward at Newcastle's Royal Victoria Infirmary.' **HANNAH**

'This portrait represents the thousands of nurses, doctors and healthcare workers who have faced fear going into work, sacrificing family time, camping in nursing homes and reading out emotional letters from relatives unable to visit dying relatives. Appreciate the NHS; we all need it!' **JUDITH**

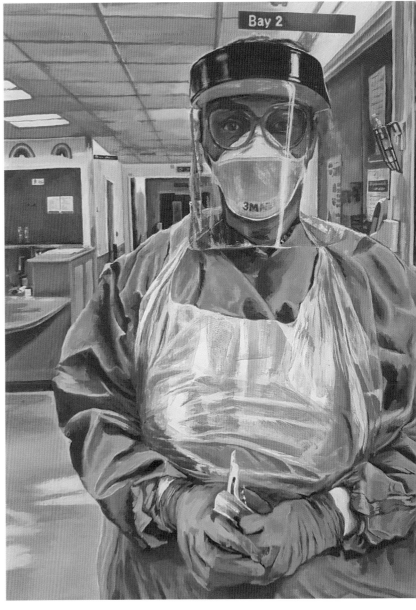

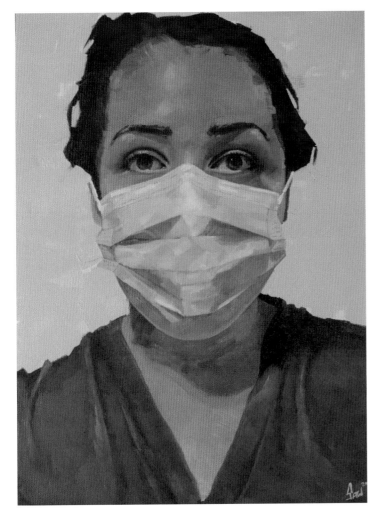

REBEKAH by STEPHEN WARD

OIL | 30 × 25 CM

TRAUMA by ALASTAIR FAULKNER

OIL ON CANVAS | 100 × 150 CM

'My painting features eight members of NHS staff whom I consider friends and colleagues. Every morning, we gather to discuss patients who have presented to hospital over the last day with various injuries. Surgeons, nurses, physiotherapists, radiographers and allied healthcare professionals work together to get the broken and injured back on their feet. Before lockdown, I gathered this amazing group of people together to create this composition. In the background are two figures: a skeleton, which is a symbol of the speciality we work in (trauma and orthopaedics); and a shrouded figure in full PPE as a visual reminder that this painting was completed in a time of Covid-19 affecting every subject in the painting. This painting is a celebration of the team I am proud to be part of and of how different areas of expertise help make trauma and orthopaedic patients better. Painting for me as an artist is a hugely important outlet alongside my other job being an orthopaedic surgeon, and this painting signifies how these different worlds can exist together.' ALASTAIR

Left to right JOANNE LYNCH, consultant anaesthetist, SARAH CANT, advanced trauma nurse practitioner, LINDSEY FULTON, senior radiographer, ALASTAIR FAULKNER, trauma and orthopaedic surgeon, FRASER HARROLD, consultant trauma and orthopaedic surgeon, JEMMA CATHRO, senior scrub nurse, CAROLINE HUTCHISON, physiotherapist, PETER DAVIES, trauma and orthopaedic surgeon (the patient). All members of staff work in NHS Tayside in Scotland.

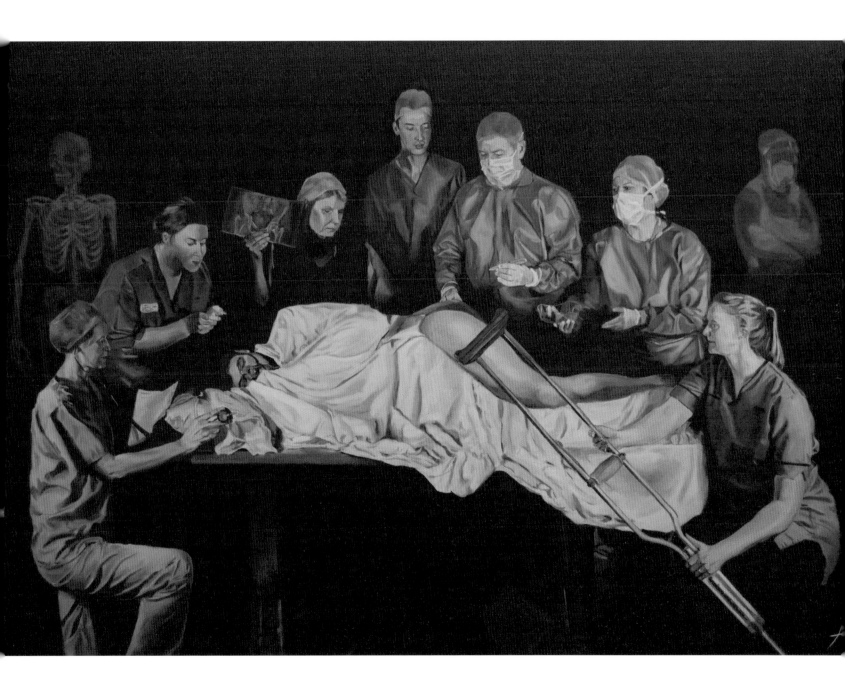

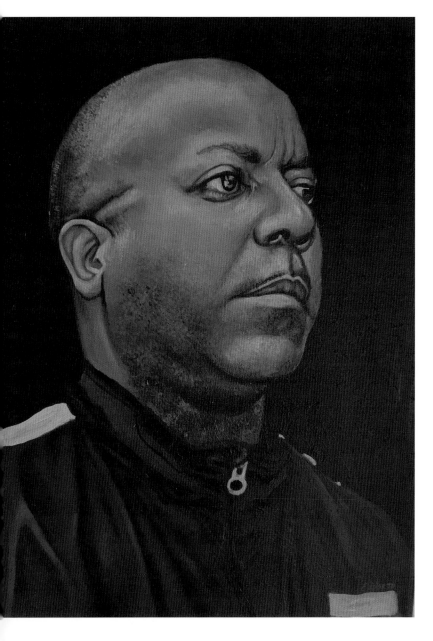

JERMAINE by EMMA WORTH

OIL ON CANVAS | 40 × 30 CM

'Jermaine Wright, senior pharmacy technician in the aseptic unit at Hammersmith Hospital, died in hospital on 27 April. He was 45 years old. He was enormously proud of his work and through his expertise helped save countless lives. He was kind, thoughtful, generous and always up for a laugh. I was contacted by one of Jermaine's good friends to paint his portrait during the Covid-19 crisis. I am so honoured to have been asked to tell this great man's story. I wanted to show him standing strong and full of courage: he truly was something special and his passing is a great loss to so many. The loss of Jermaine is a tragedy for his family and for all the many people who loved him. Rest in peace Jermaine, you will be hugely missed.' **EMMA**

DR BASIL MUSSAD by DYLAN LISLE

OIL ON GESSO PANEL | 36 × 28 CM

'Light in the darkness.' **DYLAN**

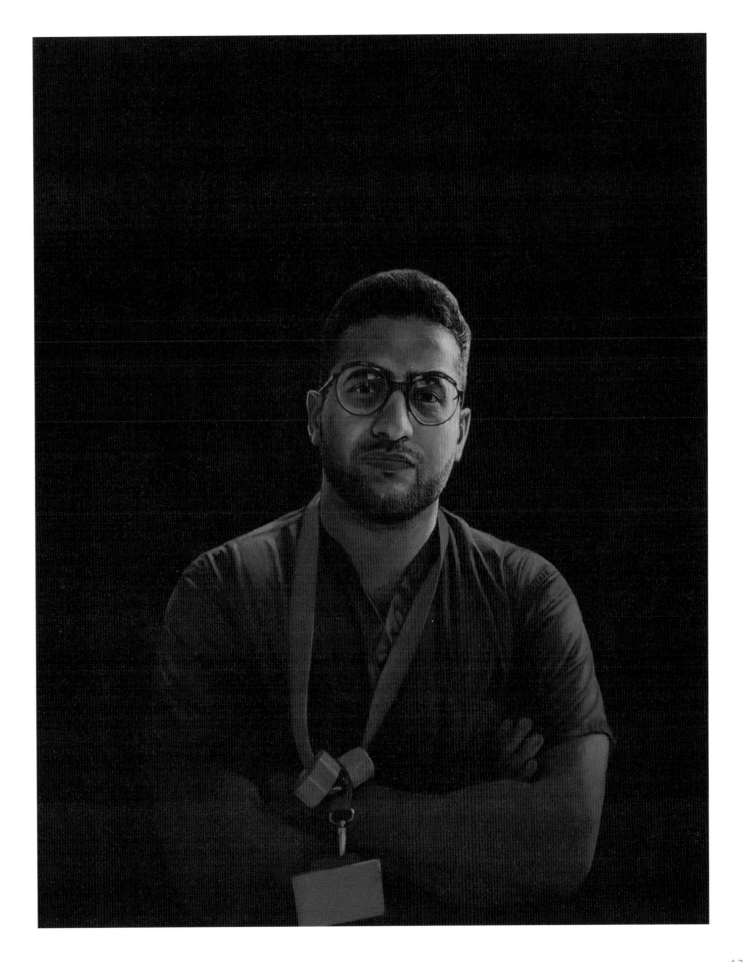

THERESA by HARRIET WHITE

OIL ON LINEN | 70 × 70 CM

'Theresa is an oncology and haematology nurse at Lincoln Hospital. She only qualified six months before the Covid pandemic hit the UK so it has been a pretty intense beginning to her nursing career. The challenge was to convey the emotion that she was clearly feeling when most of her face was obscured – lucky for me she has such expressive eyes. As an artist I was delighted to be a part of this project: it was great to have the opportunity to use my skills to show support and gratitude for something so important.'
HARRIET

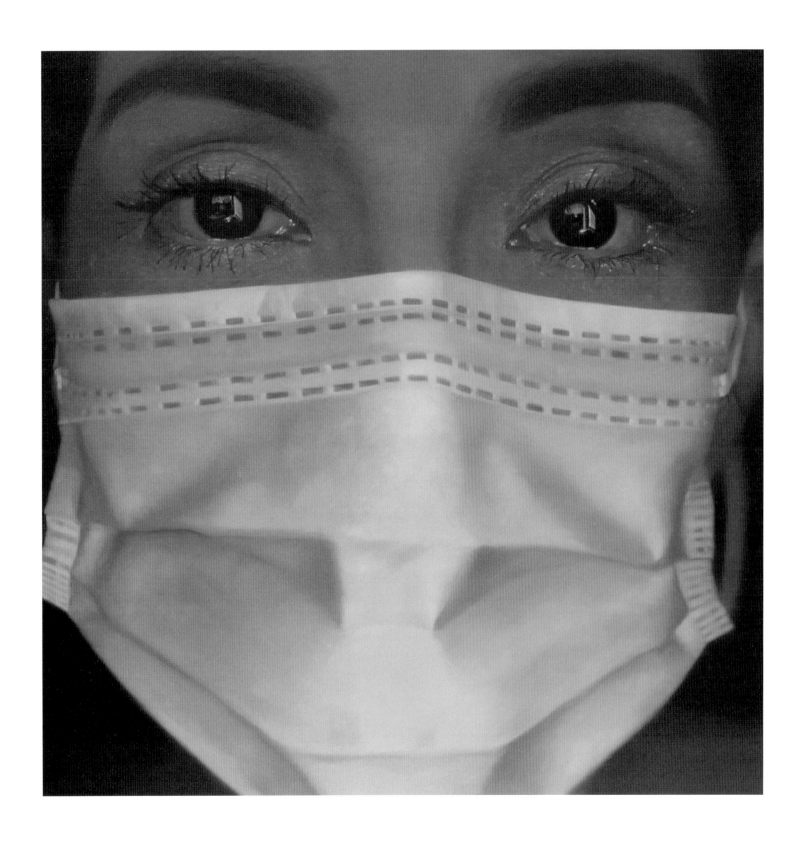

DR NICK STEWART by PETER KEEGAN
OIL | 80 × 60 CM

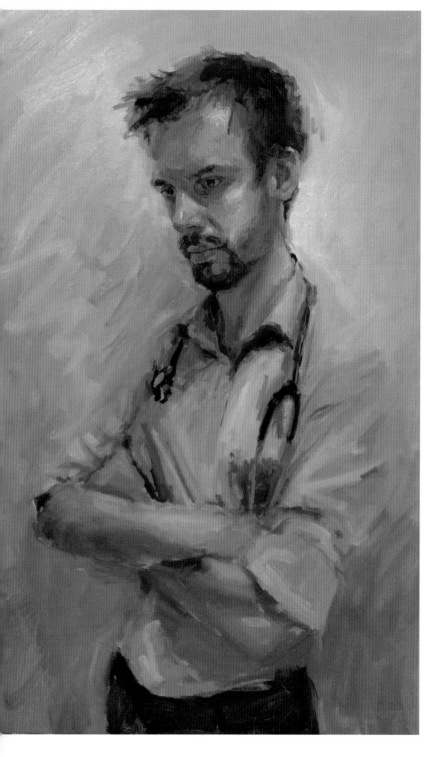

DR NICK DENNISON
by HARRIET PATTINSON
OIL | 50 × 50 CM

'Nick is a consultant anaesthetist at Frimley Park Hospital. At the start of the lockdown he made the incredibly hard but brave decision to move away from his family, away from his three-year-old son who is battling cancer, to do his job and save the lives of strangers. It really was a privilege to try to capture the emotion and struggle of such a decision, as so many NHS staff have to do, through a portrait. I owe a big thank you to Nick not only for sharing his story but ultimately for his bravery and dedication too.'
HARRIET

'Harriet's portrait of me was painted at a tough time. With incredible brush strokes she has captured some of the darkness of spring 2020. During this time I was treating Covid-19 patients in hospital but couldn't go back home to my family because of the risk of passing on the virus to my young son, who was on chemotherapy for lymphoma. Harriet has painted this in black and white with just a single splash of colour in her very unique, beautiful style. This portrait will always remind me of these times and that if you look hard at dark clouds you may find a rainbow.'
NICK

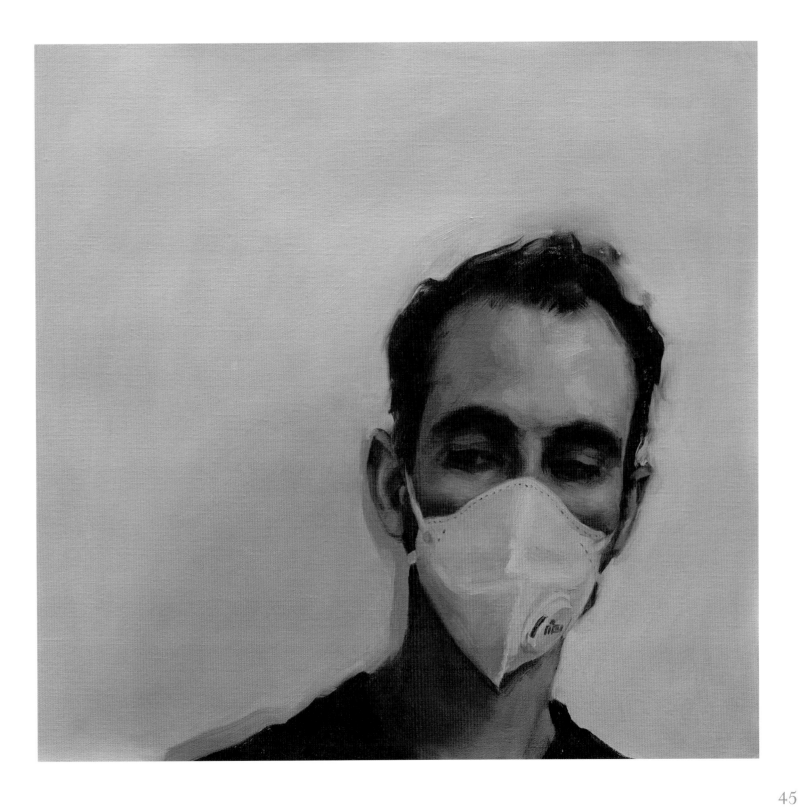

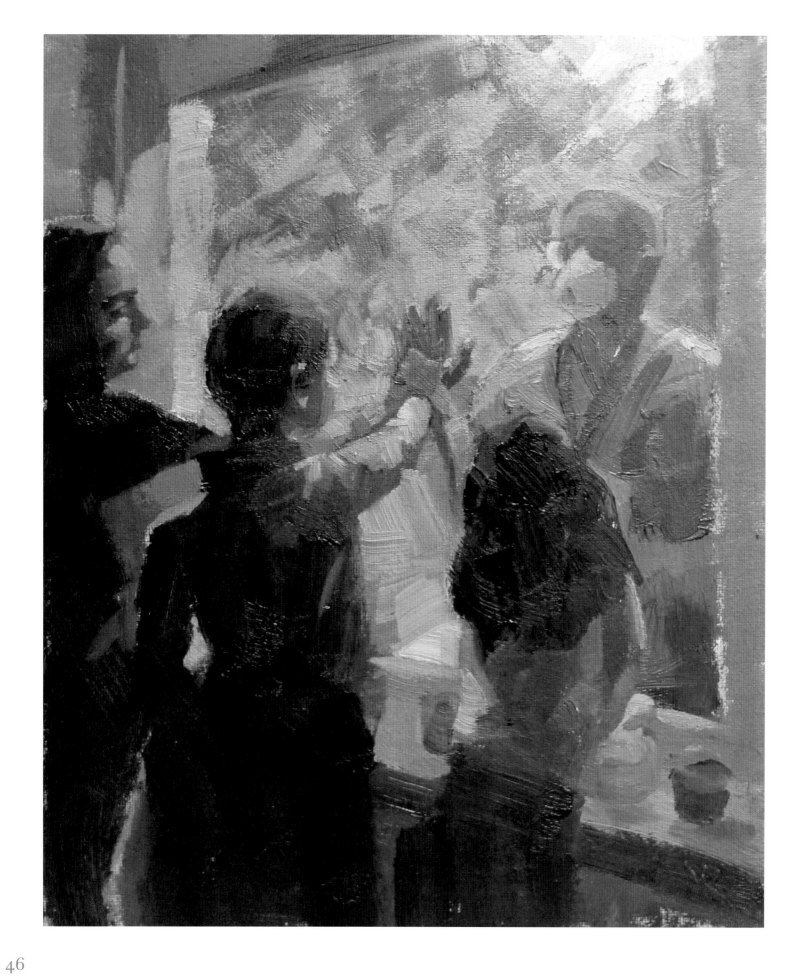

DR SALMAN by NICK RICHARDS

OIL ON CANVAS BOARD | 30 × 25 CM

'I have shielded myself from my youngest daughter, who is asthmatic, and I have missed her birthday. I guess seeing her through a screen or a window is better than seeing her on life support. I thought that this image will be more moving and paint a more realistic story.' **DR SALMAN**

'It was a very powerful source image so I painted in a bold, powerful way with a big brush and thick, impasto oil paint. I wanted to avoid producing a sentimental or melodramatic painting, but rather capture the raw emotional content of the image.' **NICK**

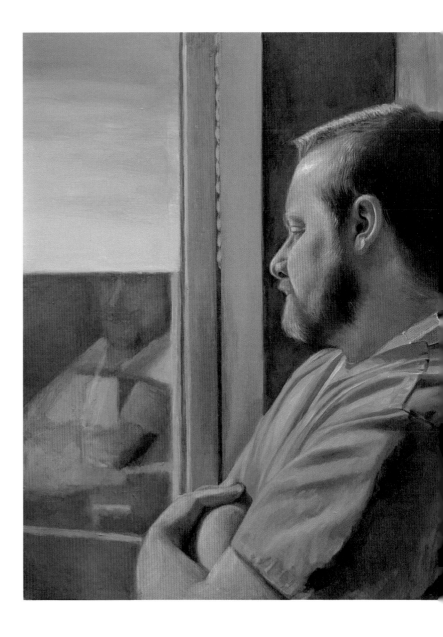

MARK CANNAN by TANYA LEVINA

OIL ON BOARD | 35 × 28 CM

SUKHPREET SINGH DUBB
by MARTYN HARRIS

OIL | 30 × 25 CM

SUKHPREET is an oral and maxillofacial surgery trainee based in Cambridge. He was the UK ambassador at the White House and United Nations and invited to speak at the House of Commons about social mobility in medicine. He is a proponent of widening participation, having come from a homeless background, and now champions several initiatives across the UK.

NINA by STEVEN HIGGINSON

OIL ON BOARD | 40 × 30 CM

'I was linked with ICU nurse Nina for the project, so I asked her to send me a photo taken in natural light outdoors, with strong shadows. My aim was to paint a bright, colourful and optimistic painting full of energy – something Nina could enjoy having.' STEVEN

DR MARIE EDISON by HILARY PUXLEY

OIL ON CANVAS | 50 × 40 CM

'Marie had planned to undertake medical volunteer work abroad before taking up a coveted place to train as a surgeon in the autumn. Instead, she found herself working in A&E at a London hospital where she experienced the full brunt of the coronavirus pandemic. She contracted Covid herself, fortunately not severely, but there were fatalities among the team Marie was working with. I met her on a beautiful sunny evening outside the house where she was living alone to protect her family. The sharp contrast between the mild inconvenience I experienced during lockdown and the daily assault, physical and psychological, of Marie's life on the front line as a hospital doctor could not have been more humbling.' **HILARY**

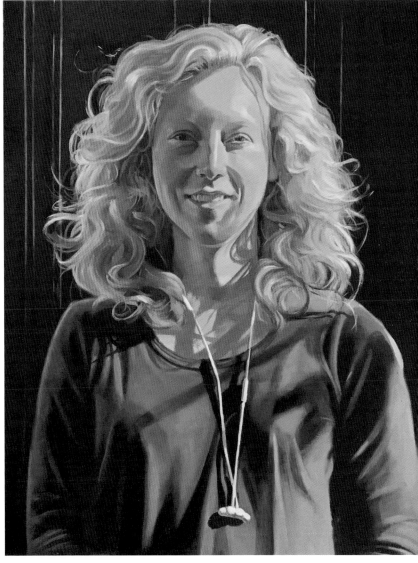

CONNIE by AMY CHUDLEY

OIL ON CANVAS | 40 × 30 CM

'I'm an HCA who has been working on a ward with patients tested positive for Covid. So far my job has been extremely challenging at times. However, it has also been so rewarding. The best feeling is going home knowing you've given your patients 100 per cent and given them the best care they need and deserve. It has made me realize that ward work is something I would love to carry on doing, it's opened up my eyes huge amounts.' **CONNIE**

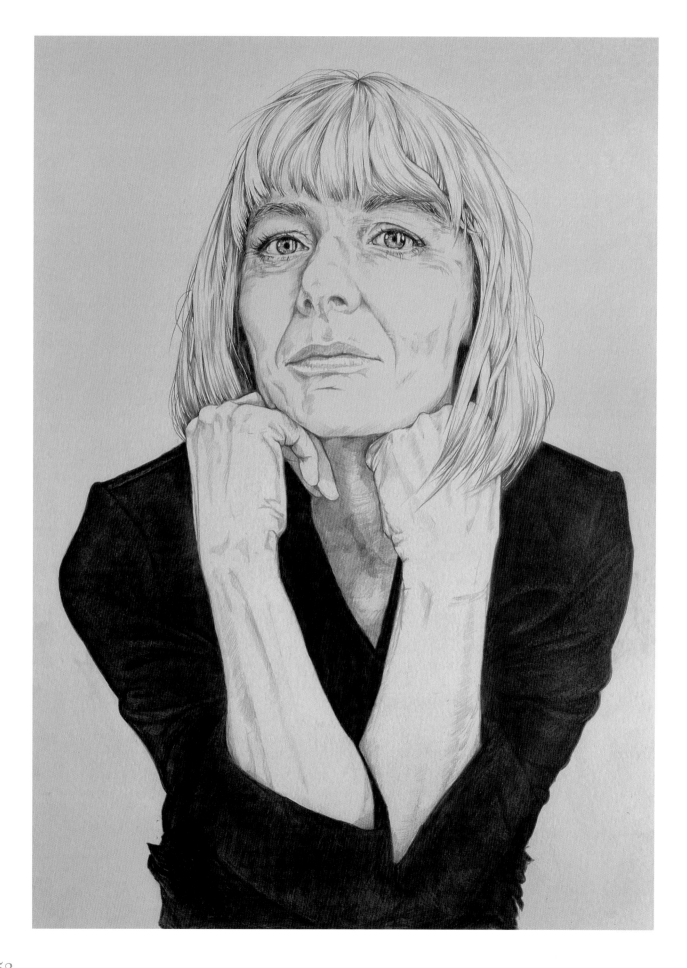

NURSE SARA FRANCIS
by MARK DRAISEY

OIL | 40 × 30 CM

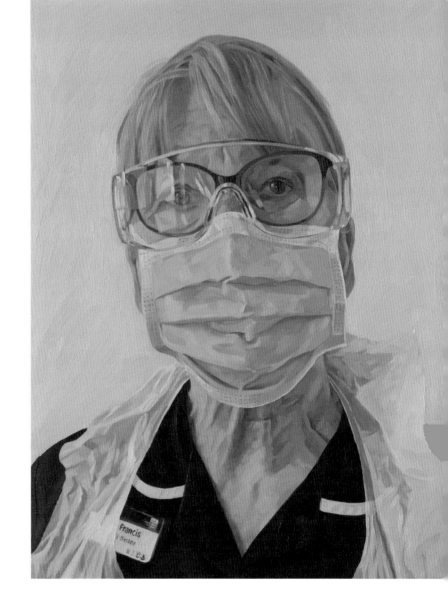

PROFESSOR CLIONA KIRWAN
by LIZZIE COLES

PENCIL | 42 × 29.7 CM

'The first time I saw this face, these beautiful eyes gently looked into mine and said the worst three words I've ever heard: "It is cancer." A year ago this amazing surgeon began saving my life. My world stopped and, without a second glance, was replaced with a new routine of weekly chemo, the horrors of hair loss, sickness, sore skin, surgery, daily radiotherapy and absolute emptiness. Professor Cliona Kirwan is an incredible lady, full of energy and enthusiasm, who cared for me, spoke to me with intelligence and changed my life. I wanted to capture her soft, calm depth, which I felt at that moment she told me to trust her – and I did. I cannot express sufficiently my gratitude in words, but in a world that feels strange and cruel I am thankful she is in my life.' LIZZIE

ALYCE by MARTIN JESSUP

OIL ON PRIMED GESSO ART PANEL | 76 × 60 CM

'Alyce is an apprentice nursing associate who works for
the south London and Maudsley NHS trust. We first
spoke after she had just completed working all night –
and had done so for two weeks in a row.' MARTIN

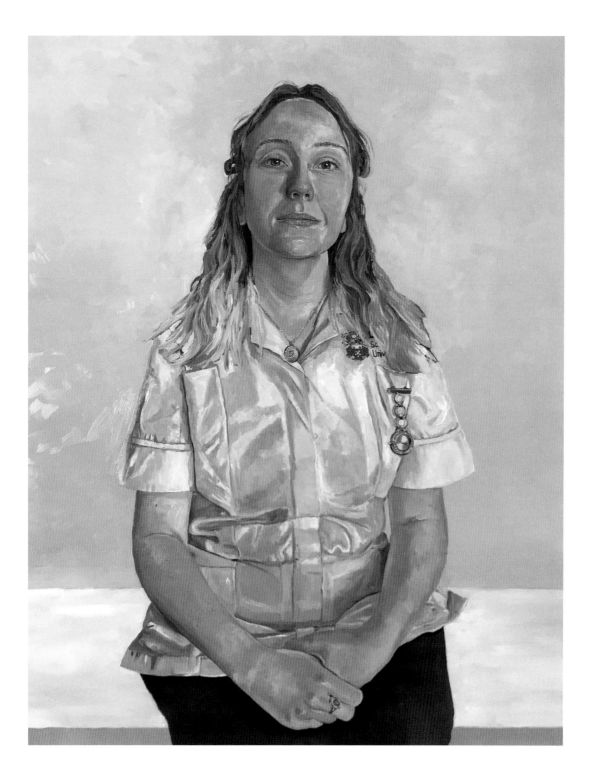

ZOE by ADAM GARNSWORTHY

WATERCOLOUR AND INK | 30 × 30 CM

'Zoe is a palliative care nurse in her community in Buckinghamshire. She visits patients at home who have life-limiting illnesses, so they can be cared for at home with their loved ones around them at this very anxious time.' ADAM

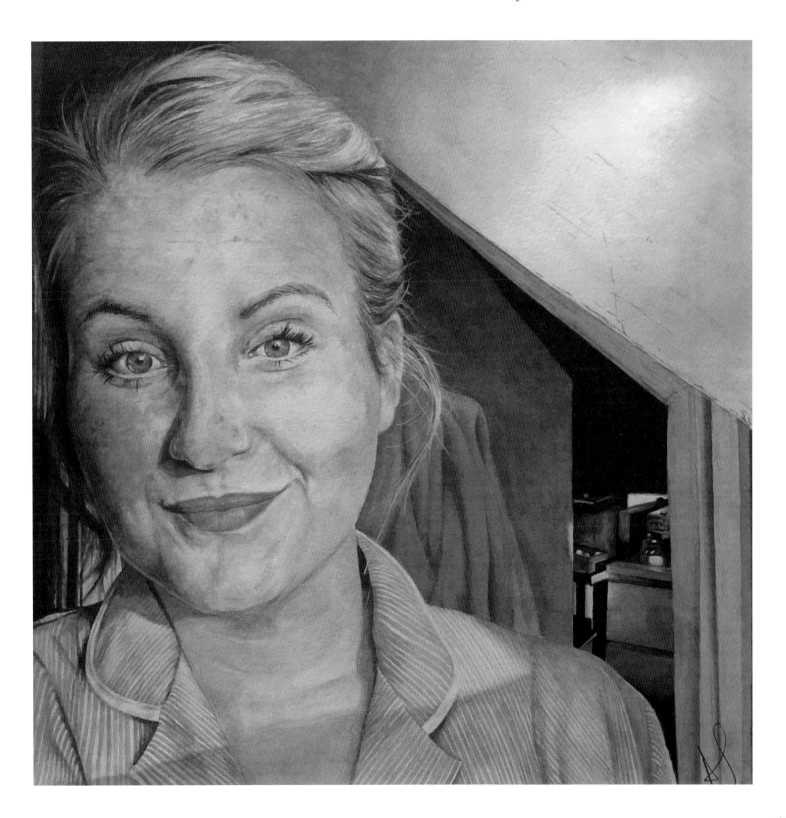

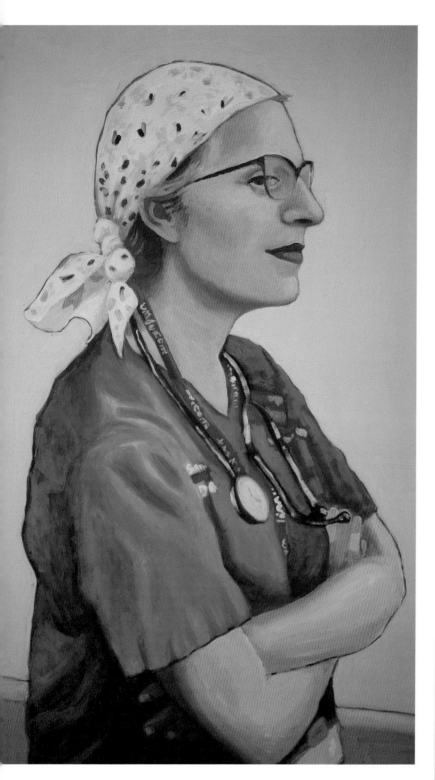

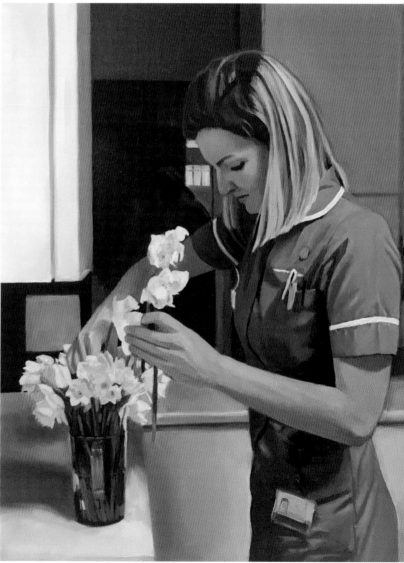

JOY HIBBERT-HINGSTON
by ALIX PHILIPPE

OIL ON CANVAS | 50 × 40 CM

STEPH HEDGE by PETER DAVIS
ACRYLIC ON CANVAS | 46 × 36 CM

'For me, the opportunity to get involved in this incredible project was not only a chance to thank someone who works in the NHS, but also fitted in with my passion for creating social realist portraits that document contemporary society.'
PETER

'I am a newly qualified staff nurse at St James's University Hospital in Leeds. I absolutely love my job but the beginning of the pandemic was really tough. This project is such a lovely thing and it's so kind of all the artists that have got involved. Peter's portrait of me is absolutely amazing, I LOVE it!' STEPH

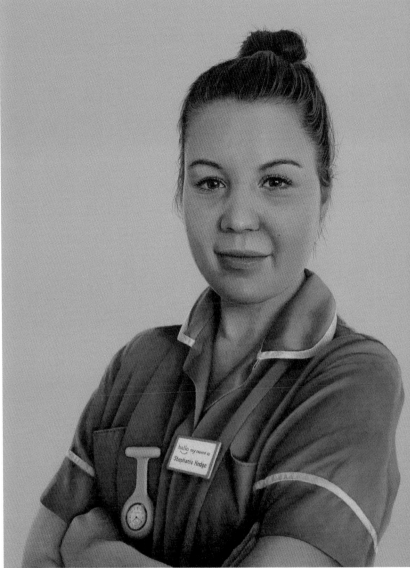

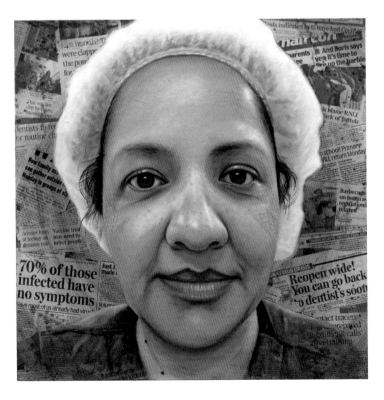

SUMITA by TIMOTHY SUTTON
COLLAGE, ACRYLIC AND OIL ON CANVAS | 60 × 60 CM

'What drew me to the photograph Sumita supplied were the indentations on her cheeks from the mask. These represented to me not just the physical damage but also the emotional impact this disease is having. This has been a fascinating opportunity to document this unsettling period of our history which is quite literally leaving its mark. I am guessing Sumita took the photo on her phone. These tend to have lenses with short focal lengths. The altered perspective again adds to the unusual story.'
TIMOTHY

RUTH KEEL by PAULA DAY

OIL ON CANVAS | 45 × 45 CM

'Ruth Keel is a former nursing sister and a site manager for the Covid hot hub on Shooters Hill. Ruth and the amazing Greenwich Health team set up and now run this site along with their day jobs. Ruth is the programme lead for education, setting up training for all the primary care staff in the Borough of Greenwich.' PAULA

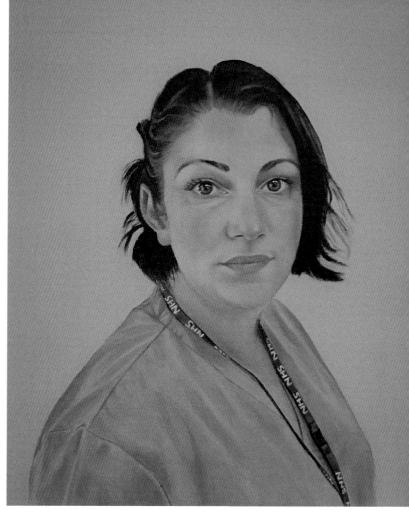

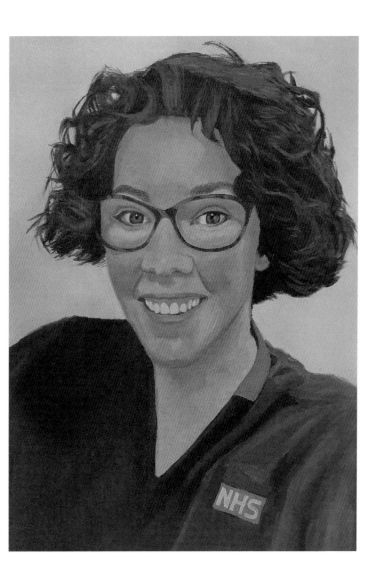

DEBBI by CAROLYN CLARK

OIL ON PAPER | 30 × 21 CM

'An artist and an NHS worker: two vastly different careers, with an incredibly similar striving-with-passion attitude for their work. This wonderful project was able to sweetly bring the two together. Debbi is a practitioner in the urgent care treatment centre at Lincoln A&E, and our paths would probably never have crossed otherwise. It has been so lovely to be involved in this amazing cause and to have been given the chance to use my art to say thank you to Debbi and every NHS worker for all their hard work.' CAROLYN

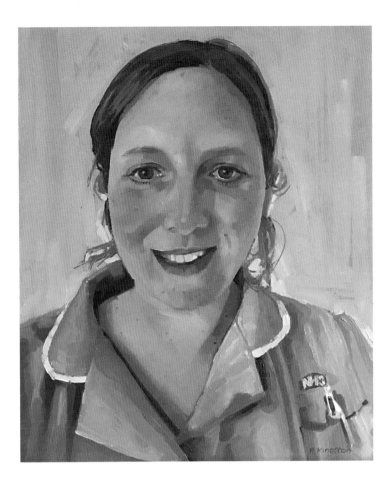

CLARE SUMMERS
by RODNEY KINGSTON

OIL ON BOARD | 30 × 25 CM

'The team has always been strong but Covid has definitely made everyone like a big family. The wider community support has been really lovely too. Lots of cake, hand cream and headbands! Being a mum to two young children has been a big challenge. We have a strict routine when I get home to try and protect them.' CLARE

JO HABBEN by JANE FRENCH

OIL ON CANVAS | 30 × 30 CM

'Head of clinical governance and patient safety at Western Sussex Hospitals NHS Foundation Trust, I have been seconded from my normal role to work clinically with the infection, prevention and control teams; including patient care and staff support. The portraits project has captured the honesty, rawness and reality of the NHS during the pandemic. Ordinary people doing their jobs – suddenly thrust into the focus and spotlight. My portrait captured so much of what that day and time (26/03/20 08:55 hrs) was about – wanting to show strength, positivity and the person behind the FFP3 respirator mask.' JO

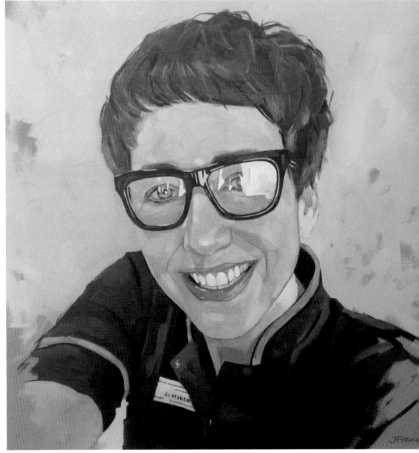

CHARMI by SARAH JANE MOON

OIL ON CANVAS | 50 × 40 CM

'It was a real pleasure to paint Charmi and be able to gift the portrait to her as a small gesture of thanks for all the dedicated work she has done with the NHS as well as her humanity and inclusion work in conflict zones internationally.'
SARAH

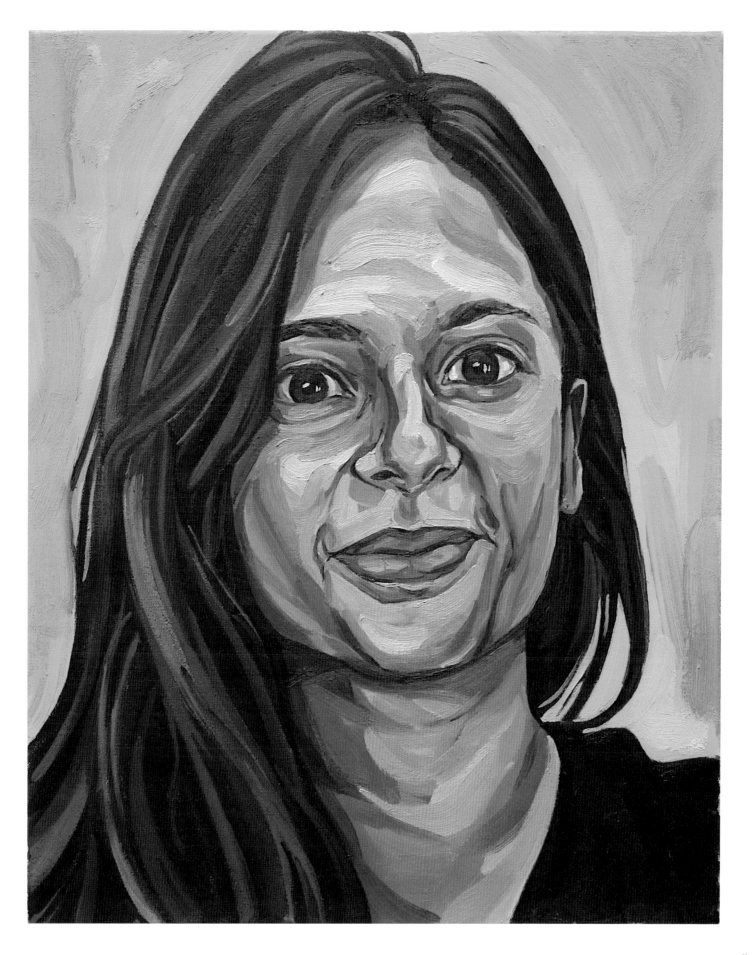

BECKY MURPHY by JOSEPH RYAN

OIL ON LINEN MOUNTED ON BOARD | 34 × 25 CM

'Working on the out-of-hours district nursing team has always entailed lots of palliative care, but we are now looking after end-of-life Covid patients in the community in their final days.'
BECKY

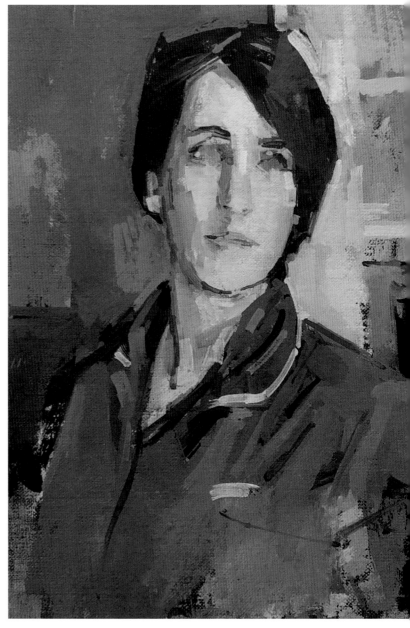

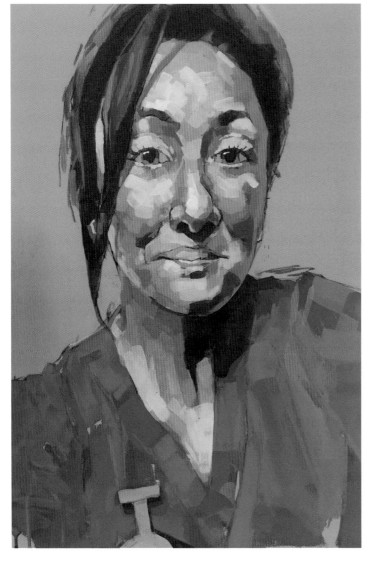

LINNE by JAMES THOMPSON

ACRYLIC AND CHARCOAL | 60 × 40 CM

ROSS HOFFMAN by LEO CRANE

OIL ON CANVAS | 30 × 24 CM

'Ross and I arranged an online sitting so we could plan our portrait and get to know each other. His training as a cardiothoracic surgeon had been put on hold so he could work at the Royal Brompton's intensive care unit for the severest Covid cases. We talked about his weird and stressful experiences there, before shifting to life outside the hospital. I wanted to capture this sense of calm reflection in his portrait.' LEO

'Looking back on that time, it seems like a nightmare. Everything was changing so rapidly. The work environment was suddenly hostile, unfamiliar and isolating, with no easy way to communicate with colleagues and patients. The portrait sitting was the first time I had stopped to reflect on what was happening. It was like a therapy session, a calming experience. The painting captures that strange and unusual moment.' ROSS

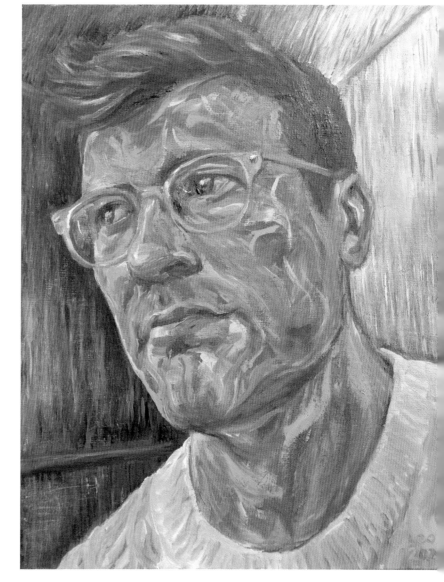

NURSE GINA KRISHNAN
by JACKIE ABRAHAMS

OIL ON CANVAS | 76 × 51 CM

'I was delighted when Gina chose me to paint her portrait: it meant so much to be able to give something back to those who were willing to put themselves at risk looking after Covid patients. I worked on the portrait for five weeks and tried to capture how mentally and physically tiring Covid care was. I also wanted her warm and caring personality to show through. The lamb on the pillow was added as a personal touch, as it is Gina's favourite animal. Gina had her wedding cancelled due to Covid: I hope this in some small way shows how much we appreciate and respect those who in our country's time of need stepped up to care for the nation.' JACKIE

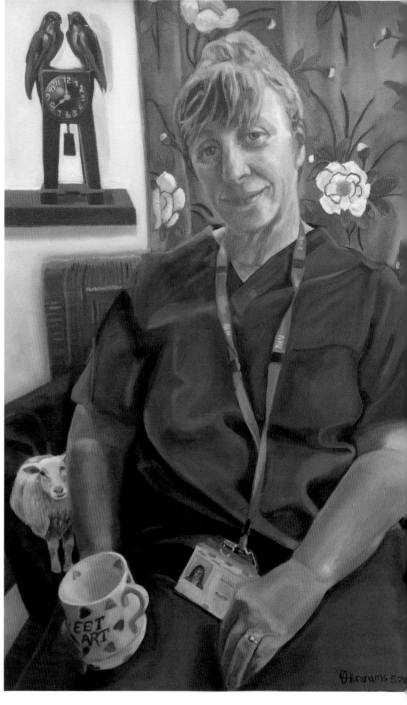

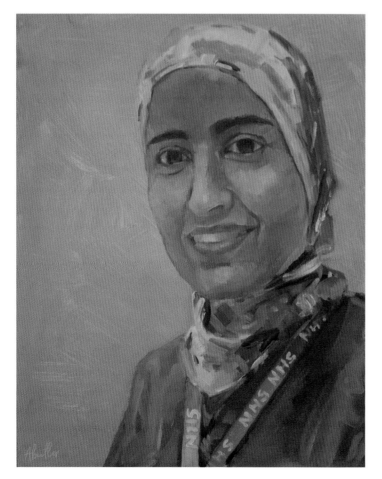

IKRAM NASR by ANDREW BUTLER

OIL | 30 × 24 CM

'Gastroenterology consultant. Patients first, and pride in what we do.' IKRAM

DR DAN & DR ED
by JANE BRAITHWAITE
OIL | 60 × 50 CM

'This is my portrait of Dan Neville and his father Ed, who are both working on the front line at the Queen Alexandra Hospital in Portsmouth. The photo reference captured a moment between them relaxing at this stressful time. Dan, a respiratory registrar, is incredibly proud of his father Ed, a consultant respiratory physician who came out of retirement to treat patients with Covid. Ed himself consequently contracted the disease but is thankfully recovered and back working alongside Dan on the Covid wards. As an artist, I'm used to isolation and so life during lockdown didn't change a great deal. However, I found that I lost my painting mojo. This initiative got me going again as I felt I was doing something useful, so thank you Tom!' JANE

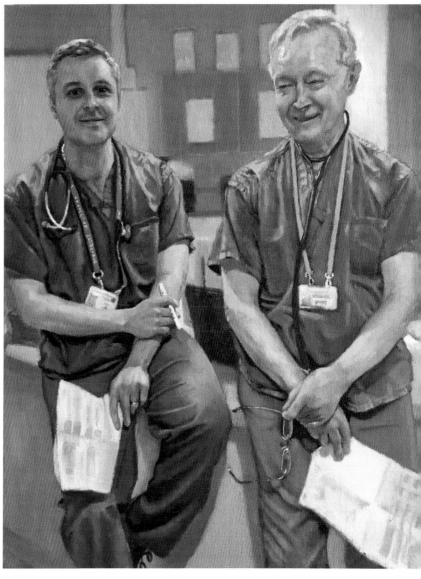

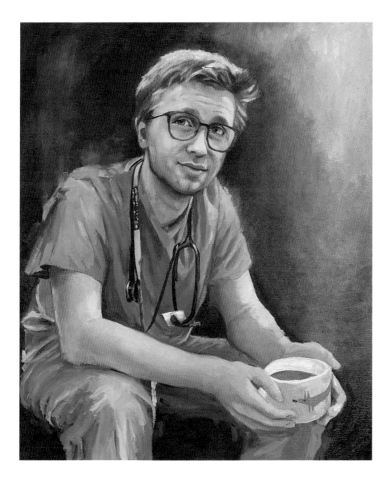

MICHAEL DEIGHAN by GERI JONES
OIL ON CANVAS | 60 × 50 CM

'Michael is a newly qualified junior doctor currently working at Ninewells Hospital, Dundee. This painting shows Michael enjoying a cuppa after a long shift volunteering at Hairmyres Hospital East Kilbride, at the height of the pandemic and before he started his permanent job. His dream since childhood has always been to follow in his parents' footsteps. Needless to say he has made the Drs Deighan very proud.' GERI

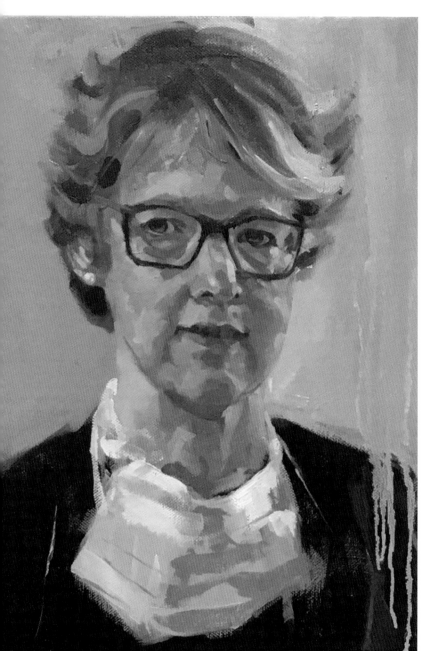

DR CLAIRE HALL by SKYE HOLLAND
OIL ON CANVAS | 30.6 × 20.5 CM

'Claire, a consultant oncologist, helped during the crisis to direct a Covid-19 ward. She described lost sleep and long anxious hours and yet thought perhaps she was not the right candidate for my portrait. I loved the photo she sent, a sensitive face with polish and poise, pearl earrings and pink lipstick, and yet there was anxiety etched around her sparkling, warm and intelligent eyes, the dark shadows reflecting this. I tried to capture that contradiction.' SKYE

'I am staggered that you managed to catch the likeness without ever meeting me. Richard says it captures my presence: my liveliness and my seriousness.' CLAIRE

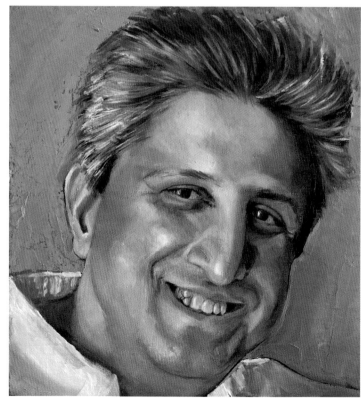

MINESH KHASHU by LEANNE PEARCE
OIL ON BOARD | 22.5 × 22 CM

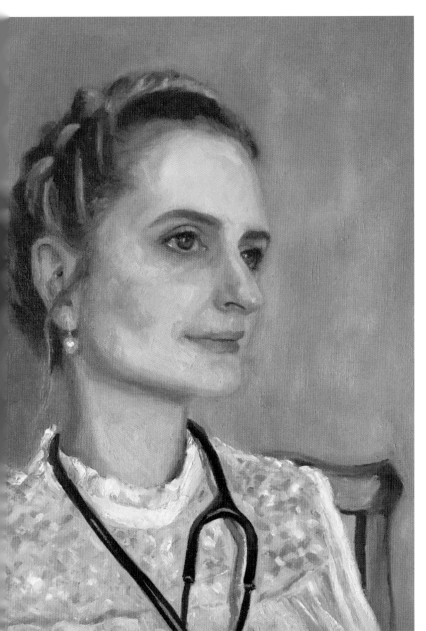

ALEKSANDRA by KATHRYN WARDEN

OIL | 40 × 30 CM

'Aleksandra was born and trained in Poland, and came to the UK in 2011 to start as a junior doctor in Dundee, where she met her husband Andrew, who is training to be a GP. She is currently working near Glasgow and says that her family and medicine are her life.' KATHRYN

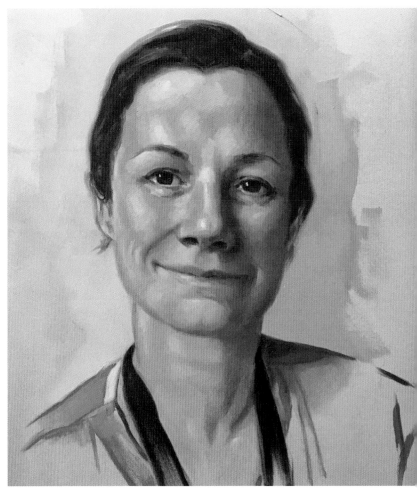

DR LAURA FULTON
by CATHERINE INGLEBY

OIL ON PAPER | 40 × 30 CM

'Laura has dedicated her life to working as a doctor, so it's a real privilege to be able to do her portrait. She and her husband are both working as emergency doctors throughout the Covid-19 crisis. The reference photo was taken at 6 am after the night shift, and I feel conveys the relief, exhaustion and empathy she feels working in such a pressured environment.' CATHERINE

NINA by CHARLOTTE JOHNSTONE

OIL ON BOARD | 25 × 25 CM

'Nina is a senior research nurse at one of the central London hospitals, but was redeployed to work in intensive care at the start of the pandemic.' CHARLOTTE

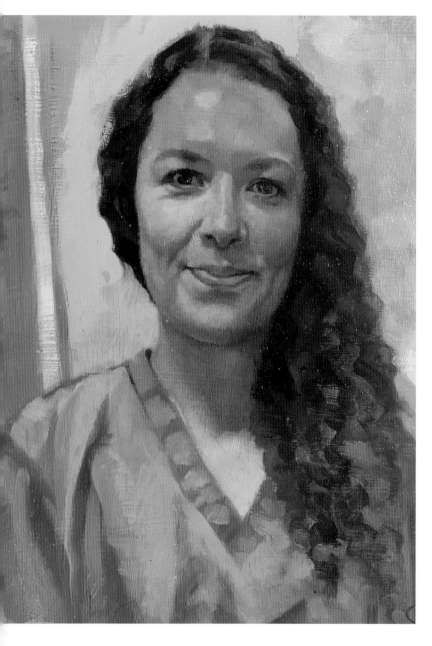

MEGAN by MARK FENNELL

OIL | 50 × 40 CM

'Megan Woodman works as a nurse at Chelsea and Westminster Hospital in London. She has only been nursing for a year and a half, and was transferred to the ITU unit during the Covid-19 pandemic. My aim in this portrait was to capture the vulnerability of this young nurse, risking her own life to save others, on the front line in the battle against the coronavirus outbreak in the UK.' MARK

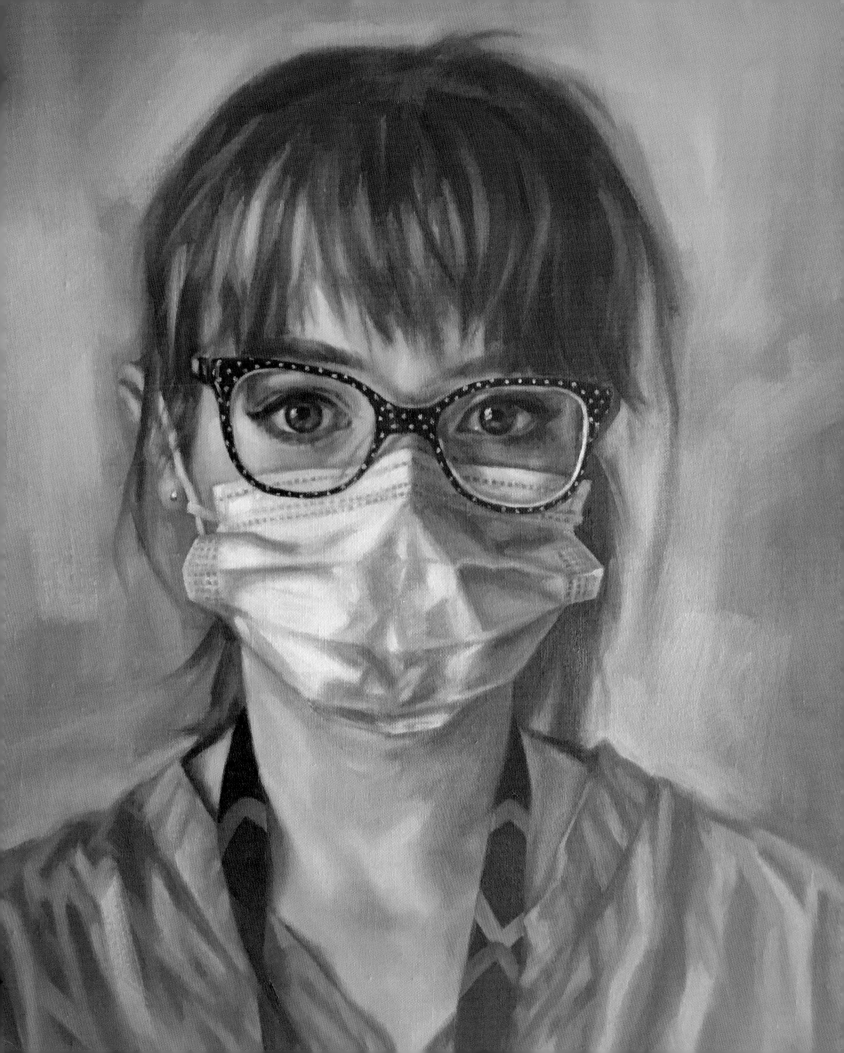

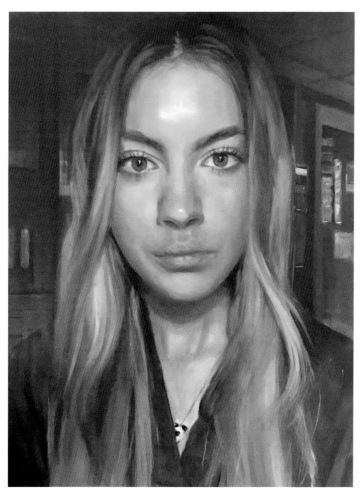

DORIS REGAZI by SUSAN BRUNSKILL
OIL ON CANVAS | 40 × 30 CM

'The worst part about this pandemic is not the work – I love my team and I love my job. It's hearing my mum's voice every day asking when she will next see me. I miss my family and my mum's hugs more than anything in this world.' DORIS

'It was a pleasure to paint Doris, a surgical nurse at the Lister Hospital, Chelsea. Doris is the same age as my own children and her words touched my heart. Thank you NHS heroes for your selfless acts, time spent away from loved ones and the care of those suffering during the pandemic. These portraits are a poignant document of the country's shared experience and it was an honour to contribute.' SUSAN

SISTER SHARON STONE
by PETER MONKMAN

OIL ON LINEN | 40 × 30 CM

'Sharon is a senior sister at Williton Hospital community and stroke rehabilitation unit. She was nominated for her strong leadership and warmth. Despite huge challenges recently, Sharon sees nursing as "the best job in the world". In the portrait I wanted to create a pose and expression that best communicate a reflective determination and hope for the future. Sharon was thrilled by the portrait, which had extra resonance as she received it on 12th May, International Nurses Day. She said her dad would be proud!' PETER

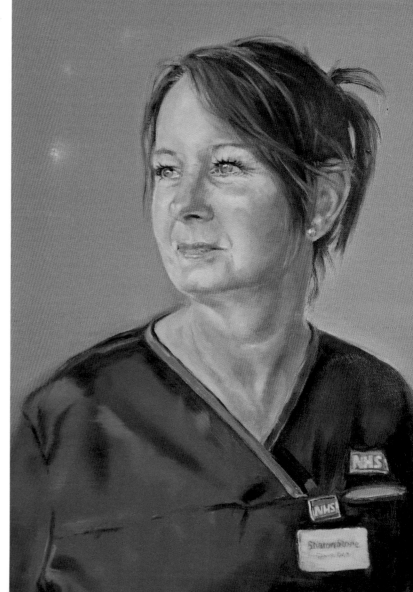

CLAIRE APPLETON by SHEILA WALLIS

OIL ON OAK PANEL | 23 × 18 CM

'I am a community occupational therapist and team lead on the rapid response team in Cumbria. We are currently looking after some very poorly people in their own homes. This picture is going to be something that I hand down to my two boys, who are seven and eight years old. Hopefully it will stay with them for years to come to remember this time.' CLAIRE

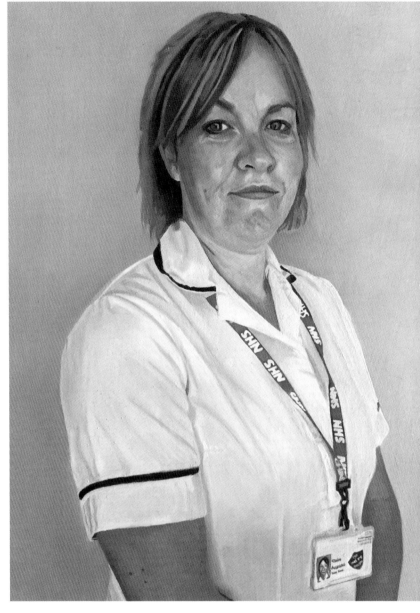

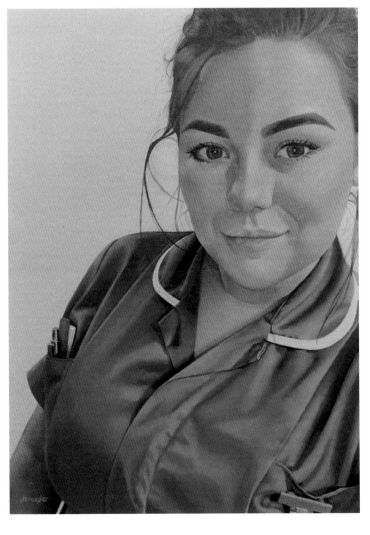

SOPHIE STEPHENS
by SALLY LANCASTER

OIL | 35.5 × 25 CM

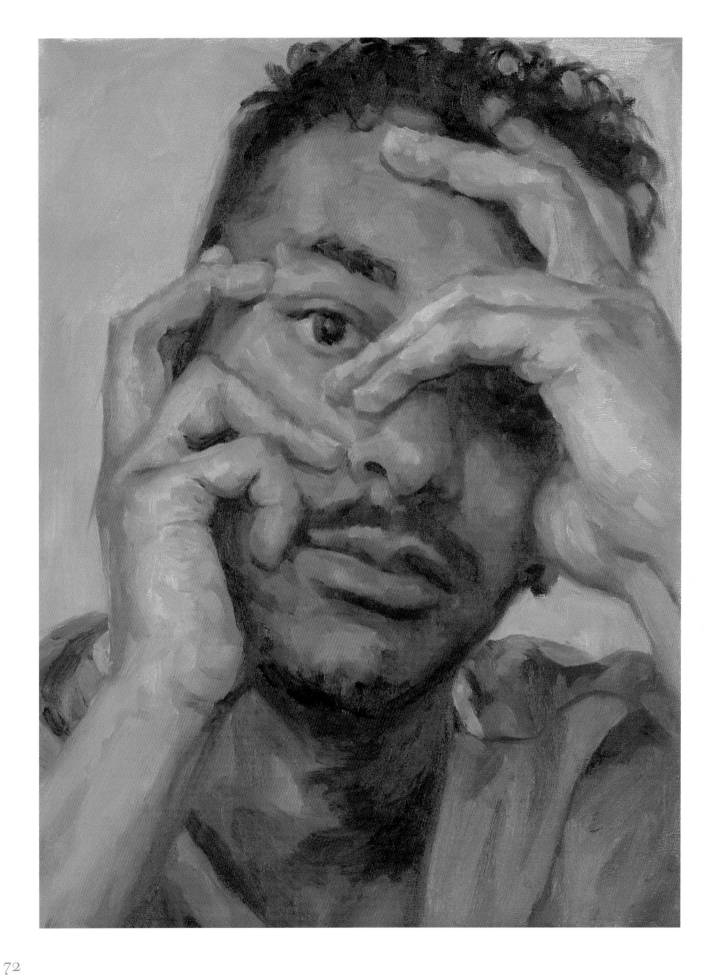

DR WILL HUNTER
by JANE CLATWORTHY

OIL ON BOARD | 30.5 × 23 CM

'Meet Will Hunter, who works in the A&E of East Surrey Hospital. It was wonderful to meet him and I loved that he chose to take part in #portraitsfornhsheroes with such vulnerable honesty. I suspect more than a few NHS personnel feel slightly uncomfortable with the "hero" label, or even being called "brave" – after all, (infectious) diseases and trauma are what they trained to confront on any normal day. And yet these are not normal days. Each day they go to fight a war, bereft of weapons with which to fight this particular battle; they go knowing that today there might be somebody they won't be able to save. To us out here, a life lost is a number reported in the daily death count (that I should ever have to write that sentence...), but to those on the front lines of this pandemic the number is irrelevant. What they see and feel first-hand is the grief of a family thrown into profound loss. There are no normal days anymore, and many of these wonderful humans are having to process all of this whilst in deep isolation themselves, deprived even of the simplicity of a wordless hug that can help shore up a soul. Beneath the label of hero is a very real person, one who is being asked to carry a tremendous emotional burden on our behalf and so deserves every bit of love with which we can possibly surround them.' JANE

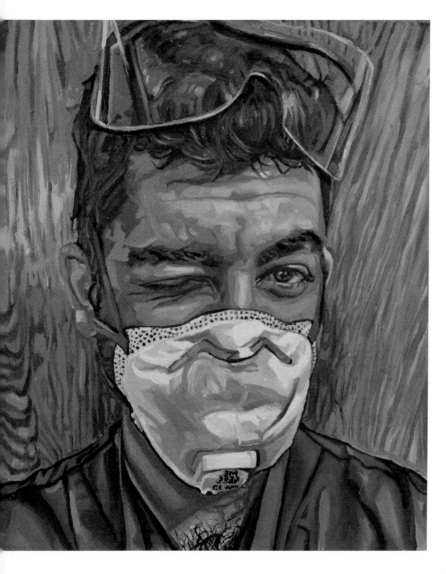

DR TRISHAN BALI by EMILY GILLBANKS

OIL ON STRETCHED CANVAS | 40 × 35 CM

'Trishan Bali, an A&E doctor working in Manchester, told me he was being inundated with messages from concerned family members and friends. When they asked if he was OK, he would respond with a winking selfie to reassure them that he was in good spirits, that he was coping well and not letting the risks posed to frontline staff get on top of him. As soon as I saw the selfie, I knew the pairing was ideal. My paintings often reference the immediacies of social media, and the constant flow of images found in the un-curated galleries of our pockets. I liked how the winking face worked as a more conceptual system of communication, like that of an emoji or memoji ideogram, usually used in the absence of physical facial expressions in online communications. Here the emotion captured by Bali's photograph is transferred into oil paint, giving the face a greater sense of permanence.'
EMILY

IAIN by ROSEANNA CHETWOOD

OIL ON CANVAS | 51 × 40.5 CM

'Thank you Iain, we are indebted to you and all the NHS workers who help us during our time of need. This is my small way of paying tribute to their tireless and selfless work: they truly are heroes.' **ROSEANNA**

'Yes it's been hard and yes it's been stressful but it's been equally amazing to have all the good work the NHS does so widely recognized. I and my colleagues have been humbled by all this attention, but it's been gestures like these that have made the hard times so much more palatable. Thank you for that.' **IAIN**

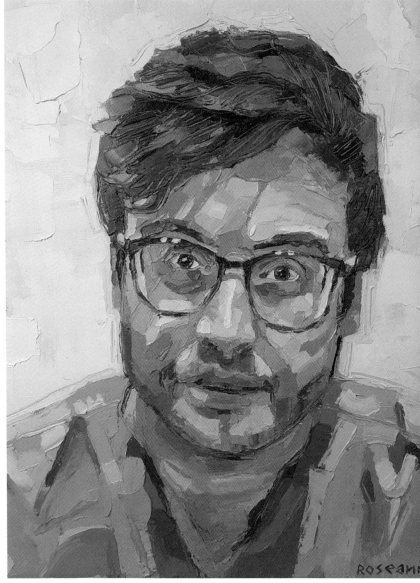

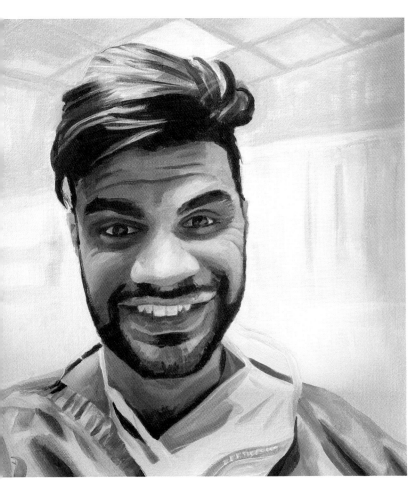

DR MOHAMMAD ABBAS KHAKI
by SARAH HUDSON VERNON

ACRYLIC | 30 × 30 CM

'It's been a stressful, exhausting and draining few months, but it's also been awe-inspiring to see the spirit of humanity, selflessness and goodwill. I'm thankful for the blessing to be able to serve the NHS and the nation at this time, and it's truly an honour to receive this gift too. Thank you Sarah for this wonderful piece – it perfectly captures the cheerful resilience of this unique time in history.' **MO**

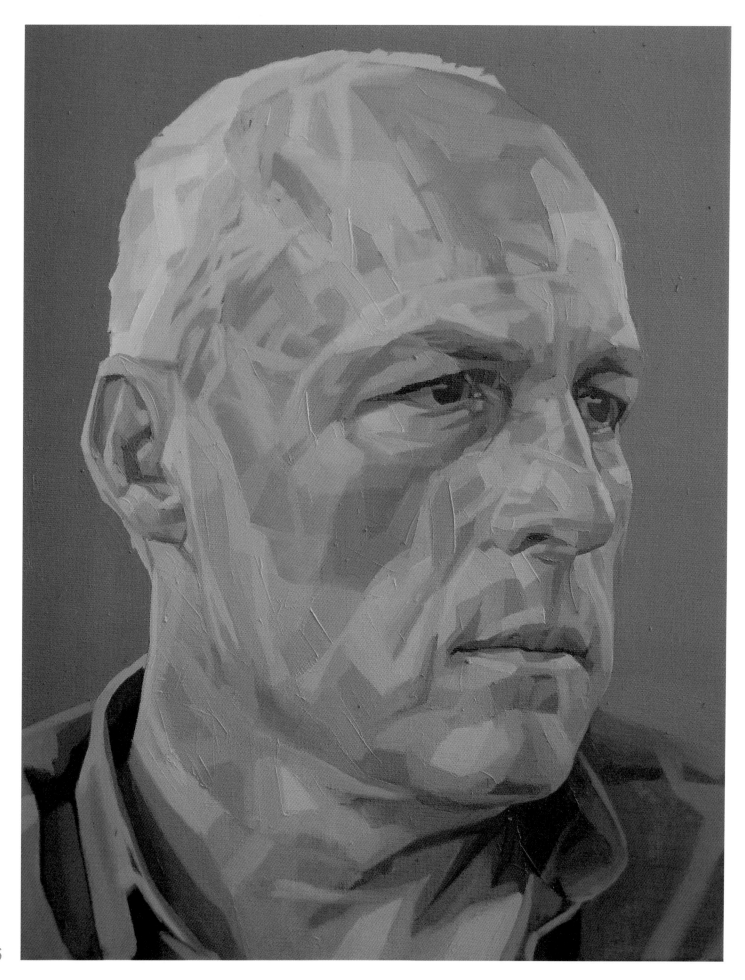

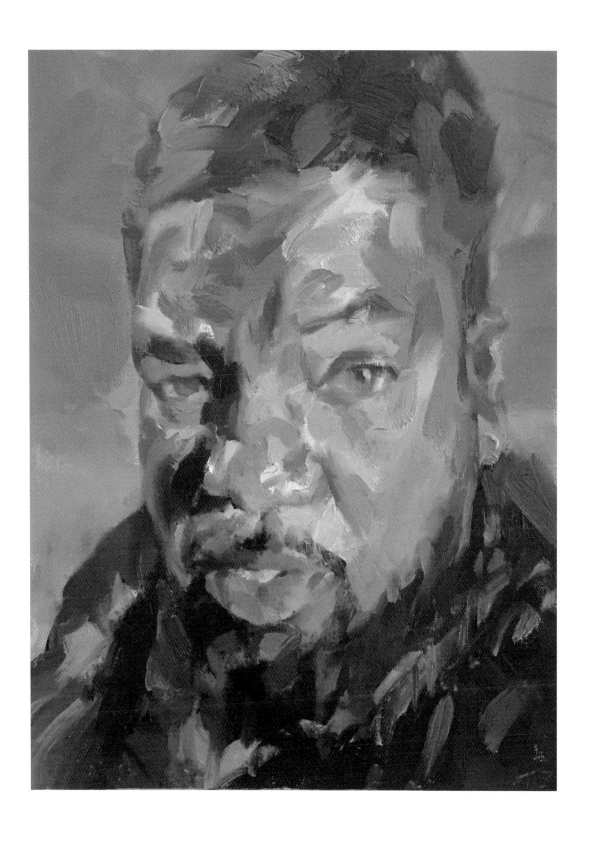

DR GERWYN REES
by DUNCAN SHOOSMITH

OIL ON CANVAS | 45 × 35 CM

KARL ELLIS by TIM BENSON

OIL ON CANVAS BOARD | 40 × 30 CM

DR CHRIS HEALEY by KEITH HOOPER

OIL | 70 × 50 CM

'Dr Healey is a gastroenterologist who has worked as a consultant at Airedale General Hospital and Yorkshire Clinic since 1998. The caring and professional way he applies his knowledge and skill marks him out as a true hero.' **KEITH**

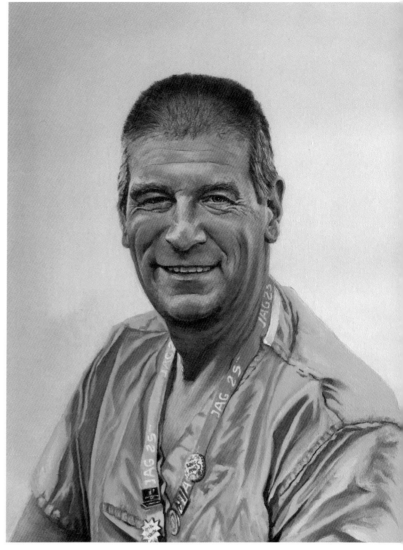

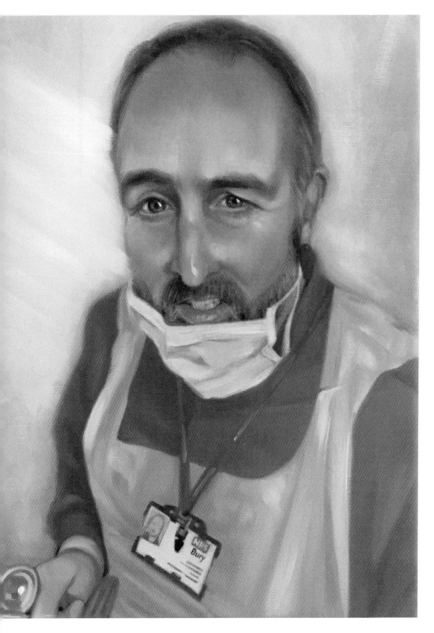

PAUL NORMAN by KAREN DE LA GORCE

OIL ON LINEN | 40 × 30 CM

'Paul worked as a GP during the pandemic, in the badly affected Greater Manchester area, often making home visits during the day then visiting nursing homes during the night wearing only the PPE protection that you see here. Paul says the difficult part of his work was witnessing elderly people at the end of their lives with no possibility of having family around. Thankfully, the frontline care workers were there to help and Paul was always on call maintaining his humour and winning smile.' **KAREN**

DR BEN OLIVEIRA by GRAHAM COOK
OIL ON PLYWOOD | 61 × 61 CM

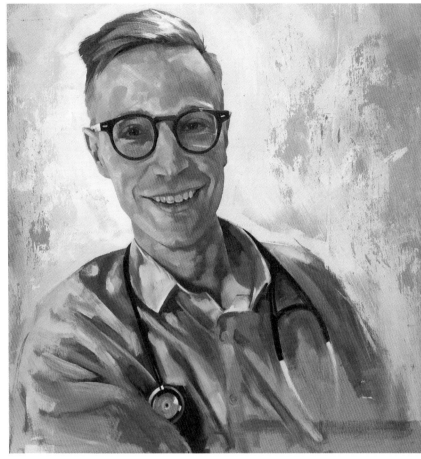

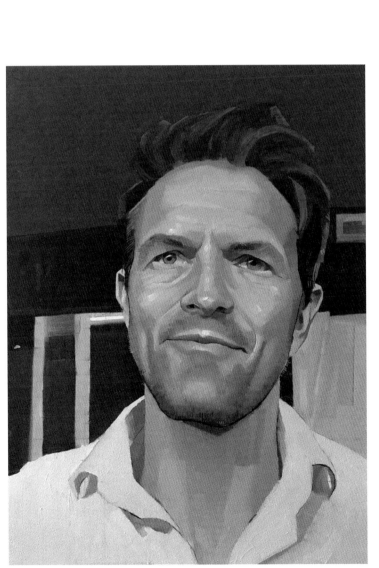

DUNCAN ROURKE
by SIAN WROE-JONES
OIL ON CANVAS | 61 × 46 CM

'Duncan is part of the west Oxfordshire community Covid-19 emergency response. His team ensures that there is enough capacity locally to cope with any demands the pandemic may throw at them, working closely with carers and health workers in care homes and in the community. In more normal times, Duncan is a partner in a GP practice just outside Oxford. In his spare time he enjoys working on his allotment and painting.' **SIAN**

'Bizarrely, I've recently completed a diploma in tropical medicine and public health, because I wanted to work with refugees. I did not realize that it would come in useful quite so soon and quite so close to home.' **DUNCAN**

AKINBAMI by VANYA MARINOVA

ACRYLIC ON BOARD | 30 × 25.4 CM

'Akinbami is a Nigerian-born doctor from Luton. The reference image he sent me was remarkably inspiring and majestic to work from. I could feel the strong sense of purpose and determination to be of service. I am sure he is doing amazing work!' **VANYA**

MR CHARLES NDUKA by RICHARD TWOSE

OIL ON BOARD | 81 × 62 CM

'Charles is a consultant reconstructive plastic surgeon. He wrote an article early in the pandemic, looking at the disproportionate effects of Covid-19 on BAME people.' **RICHARD**

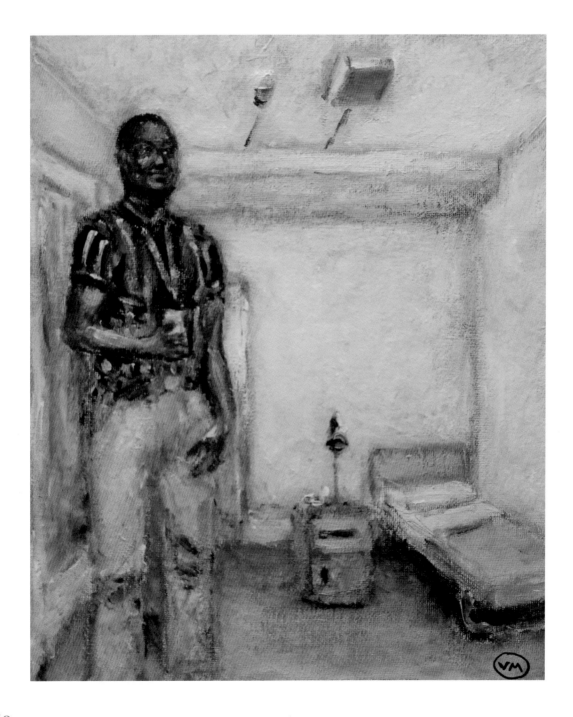

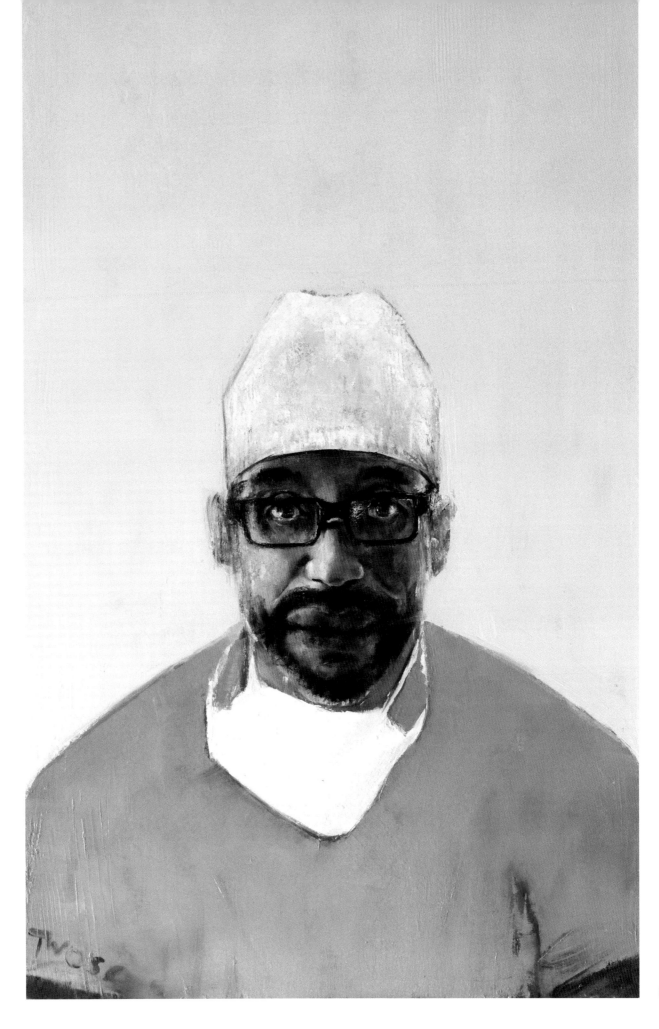

CHRIS WILDING by MARTIN BURROUGH

OIL ON CANVAS BOARD | 60 × 50 CM

'A young doctor, Chris was in the middle of a PhD at the Institute of Cancer Research in London when he was recalled to the West Midlands, handling trauma and orthopaedics. As the pandemic peaked, Chris contrived to provide some brilliant photographs. It seemed a shame to hide Chris's face behind all that protective kit, so we agreed on a double portrait, which was really fun to paint. Chris had imagined that portraits were reserved for politicians, heads of state and senior members of institutes and, once over his surprise, was delighted to be the subject. It just goes to show that portraits can be for everyone and that vital youthful endeavour is worth representing.'
MARTIN

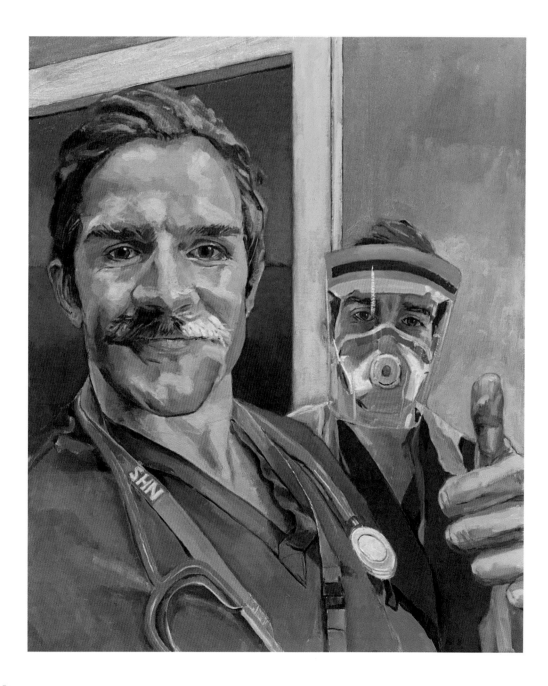

JENNIFER by DAVID GILLINGWATER

OIL ON CANVAS | 40 × 60 CM

'Jennifer is a nurse working in A&E at the height of the pandemic. The inspiration for the painting was taken from religious icons. I wanted to celebrate Jennifer and her dedication with symbolic reverence – almost like a guardian angel. The double portrait ensures one appreciates the person behind the PPE: a real person doing a real and dangerous job. The slight reflection in the visor represents her choice, knowing and aware she will be in harm's way. With gold oil paint on a red ground, the end result is a glowing tribute to her and the tireless NHS effort, but also I like to think the painting shines with hope.' DAVID

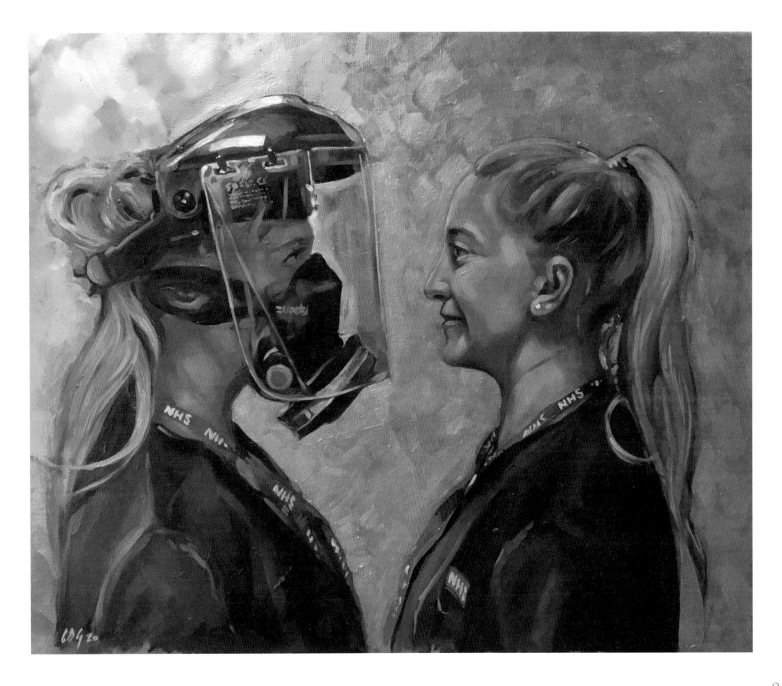

BEVERLY DOCHERTY by TOM MEAD

ACRYLIC ON CANVAS BOARD | 25.4 × 30.5 CM

'I felt it necessary to show the subject as both a
nurse and a person, to humanize the heroes and
remind the rest of us of the risks these people are
taking. Risking their own lives to save ours.' TOM

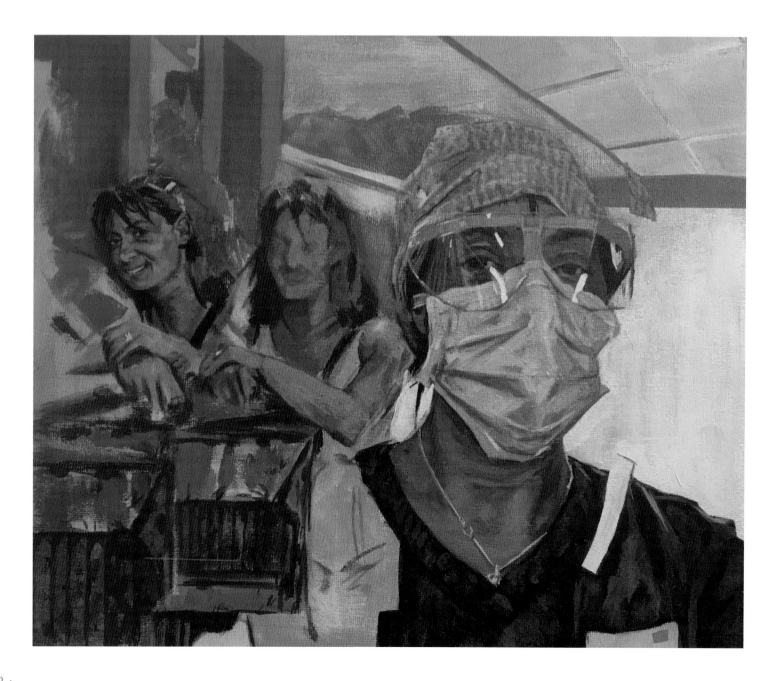

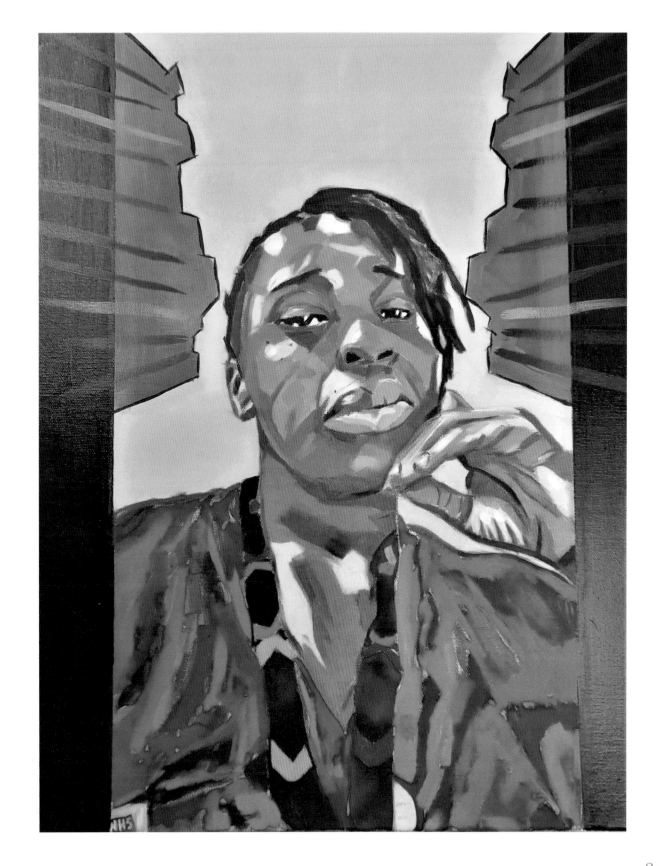

KATE by CARL RUSSELL

ACRYLIC | 40 × 30 CM

'This is Kate, who works at a residential care home in Berkshire. Kate says "We have six wonderful residents with complex and multiple learning disabilities who have been absolutely brilliant throughout this crazy time. They are truly incredible people and I love them all so much!" Thank you Kate, NHS Hero.' **CARL**

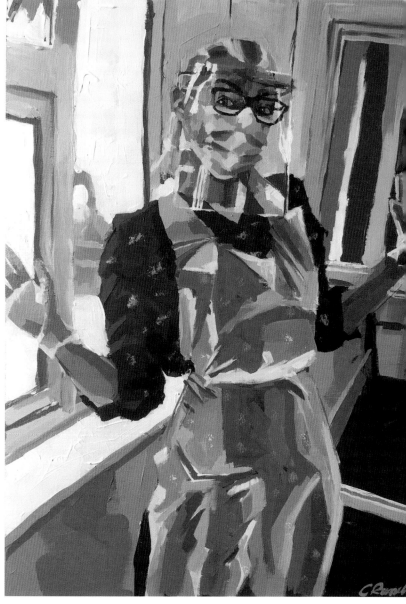

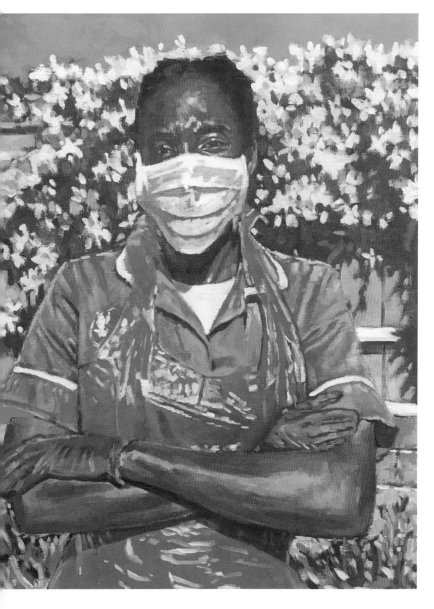

BEVERLEY JUNE ISHMAEL
by LOUISE GILLARD

OIL ON BOARD | 50 × 40 CM

'Not only is Bev a frontline carer working with some of the most vulnerable people in society, she's also an awesome drummer in a band. My mother was a carer for 35 years and I cannot stress how much admiration I feel for this little-recognized but vital part of our healthcare service.' **LOUISE**

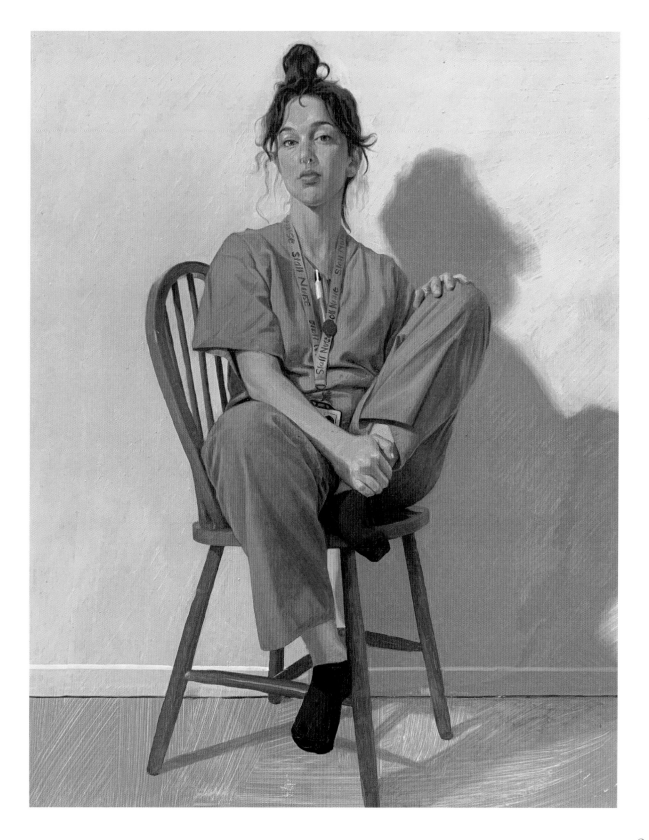

KATIE TOMKINS by ROXANA HALLS

OIL ON LINEN | 75 × 70 CM

'I was asked to paint Katie Tomkins, mortuary &
post mortem services manager, by her colleague
Natalie on behalf of West Hertfordshire
Hospitals NHS Trust. Katie was nominated for
her outstanding leadership through the Covid-19
crisis and in celebration of her extraordinary
courage, working in the less discussed field
of mortuary care. I was awestruck by Katie's
exceptional strength and tenderness during this
most challenging of situations, but also by her
distinctive appearance: her body art and tattoos
countering the uniformity of her scrubs and
PPE. Her style suggested for me something of
the Rosie the Riveter archetype or the wartime
portraits of Dame Laura Knight. I hoped with my
portrait to evoke something of the focus, resolve
and heroism of Knight's subjects, by placing
Katie within the realm of her highly skilled and
indescribably challenging work, simultaneously
appraising the day past while readying herself for
the demands of the day to come.' ROXANA

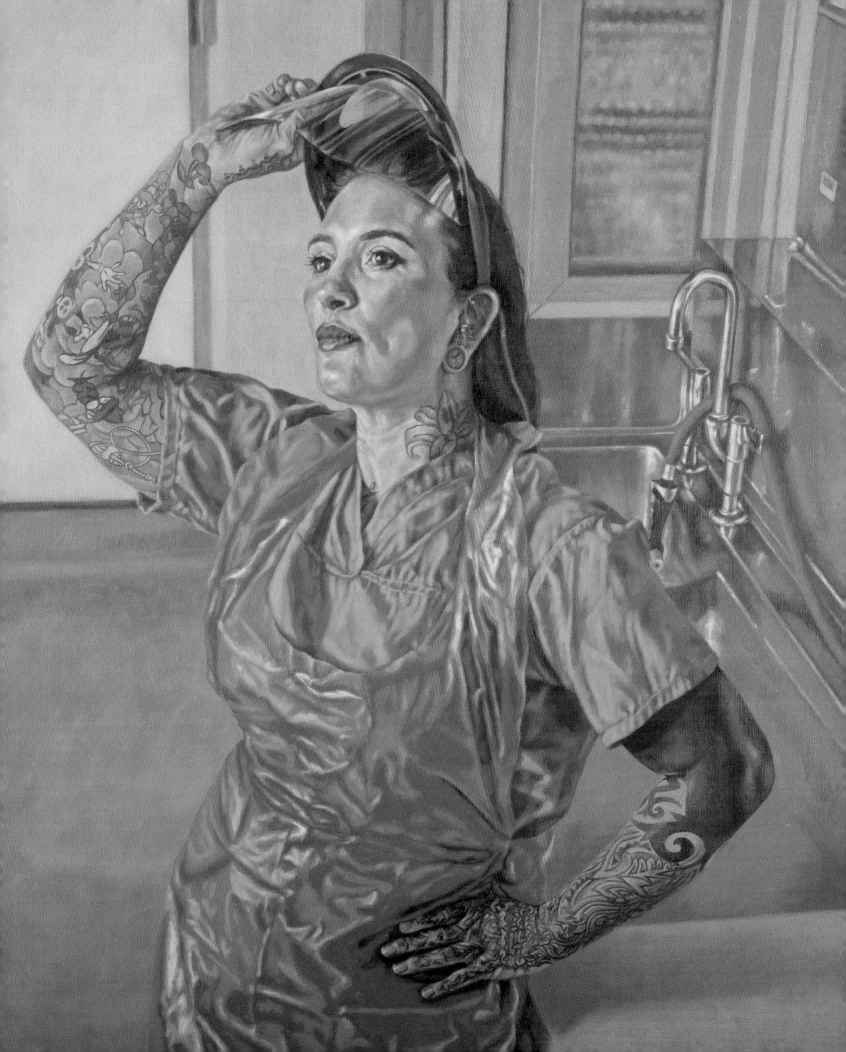

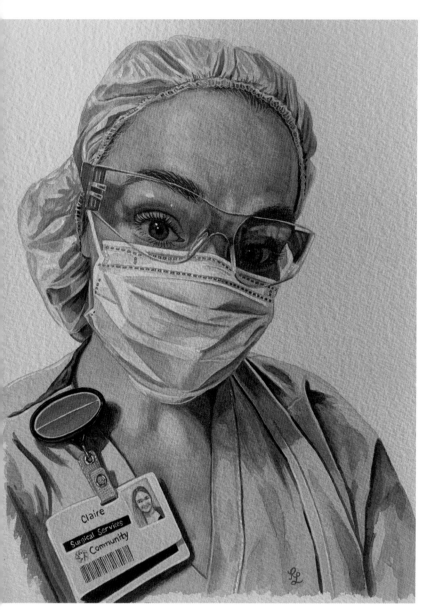

CLAIRE by RACHEL LINNEMEIER

WATERCOLOUR ON PAPER | 25 × 20 CM

'This is a watercolour portrait of my best friend Claire, who has bravely been working hard in her local hospital. She began her journey into healthcare shortly before Covid-19 struck, and she stuck with it and went to work every day, even when it was incredibly scary and uncertain. I'm very proud of her!' RACHEL

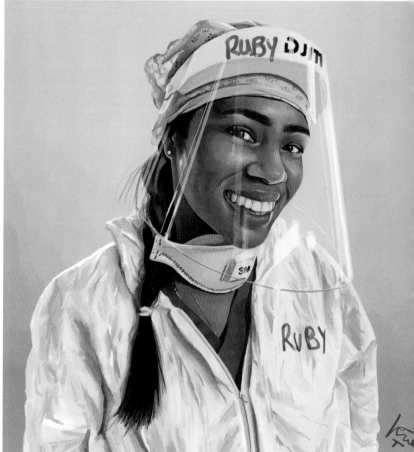

RUBY by KATIE TURNBULL

DIGITAL | 50 × 50 CM

GRACE by LOUISE BIRD

OIL | 40 × 30 CM

'Grace works at Huddersfield Royal Infirmary. She normally works as a physiotherapist, but during these unprecedented times it's been "all hands on deck". In my portrait I tried to capture a woman who is clearly beautiful, a little bit sassy and obviously caring. Through our chats Grace continued her nursing remotely: I had recently broken my shoulder and she gave me some good physio advice which helped tremendously! It has been an honour and a privilege to be a tiny part of this amazing project.' LOUISE

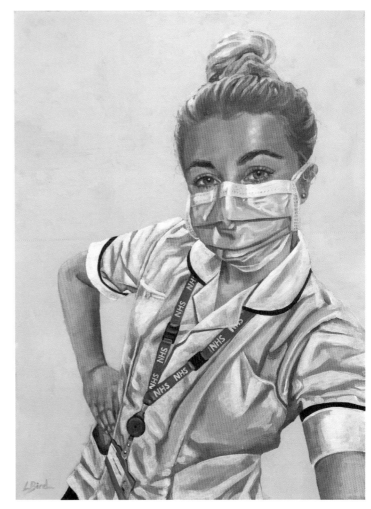

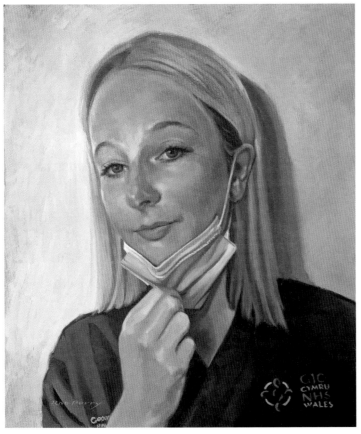

GEORGIE VAN DE POLL by ROB PERRY

OIL ON PANEL | 45 × 30 CM

'Georgie is an auxiliary nurse, working for Swansea Bay NHS Renal Unit. She has been on the front line throughout the Covid-19 crisis. I was delighted to have the chance, in a small way, to give something back to the NHS as a whole and to this special lady who has done so much for those in her care.' ROB

CAROLE ROGAN by ALISON BURCHERT

PASTEL | 18 × 24 CM

'My hero is Carole. I've known her since school and always admired her as a person and mother (of seven children). Carole's life took a turn when she wanted to do more to help those in need so applied for a job at Colchester General Hospital – just in time to face the Covid-19 pandemic! She took it head-on and hasn't looked back. Thank you Carole.' ALISON

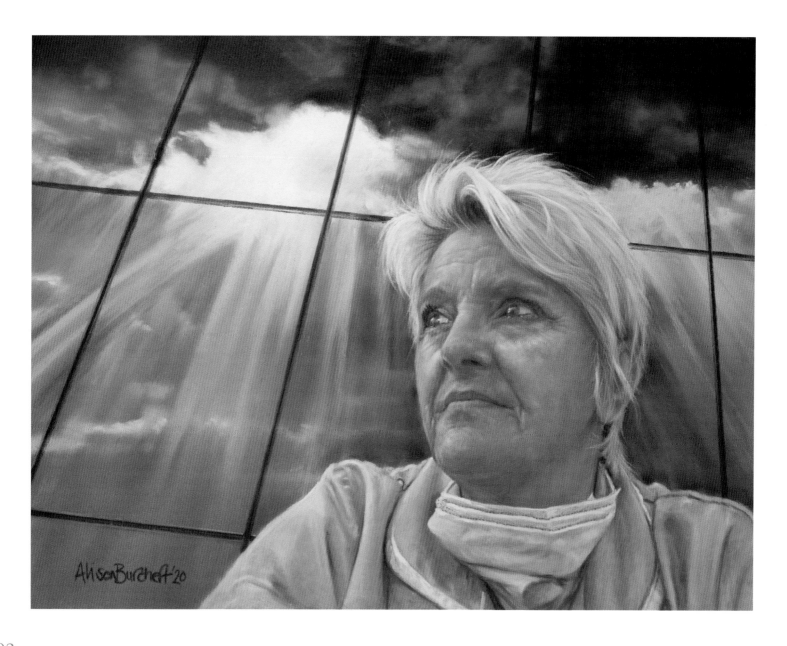

JOANNA by AMBER MELLIGAN-HART

CHARCOAL AND WATERCOLOUR | 42 × 29.7 CM

'I have felt a real sense of pride taking part in this unique project. My contribution for Joanna is to say thank you, not only to her but all the workers on the front, keeping us safe at home. This lovely lady has been a qualified nurse for 20 years. Since the beginning of the pandemic Joanna has had to adapt. As well as juggling a young family she is a clinical educator in immunizations. We will both have a unique view of our quite different lockdown experience but now have a painting to show our children and look back on with a mixed bag of emotions. This painting will always bring me fond memories of unity and courage. Thank you, Joanna, for being my muse.' **AMBER**

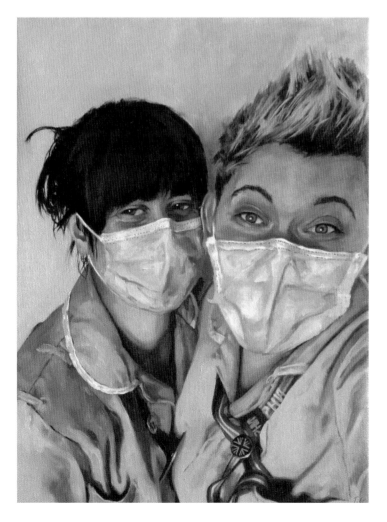

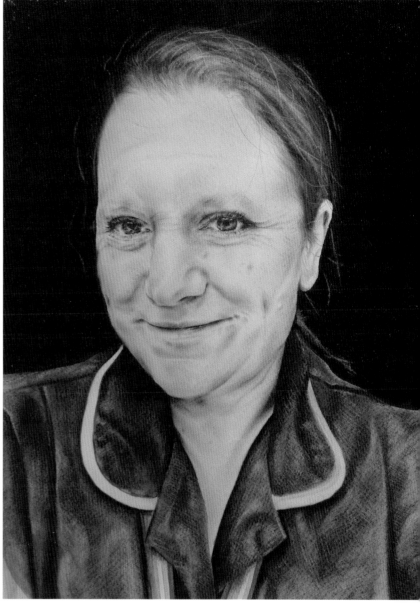

BECK & EMMA by TESS GRAY

OIL ON CANVAS | 40 × 30 CM

'I hesitated in putting myself forward with this initiative as I hadn't painted a portrait in a long time. It was an amazing surprise to be paired with two nurses who work at the same hospital my sister was born in and that also has been in treating my grandmother over many years. I'm so glad to have given Beck and Emma something to show my appreciation, and they've given me a reintroduction to portraiture which I couldn't be happier about.' **TESS**

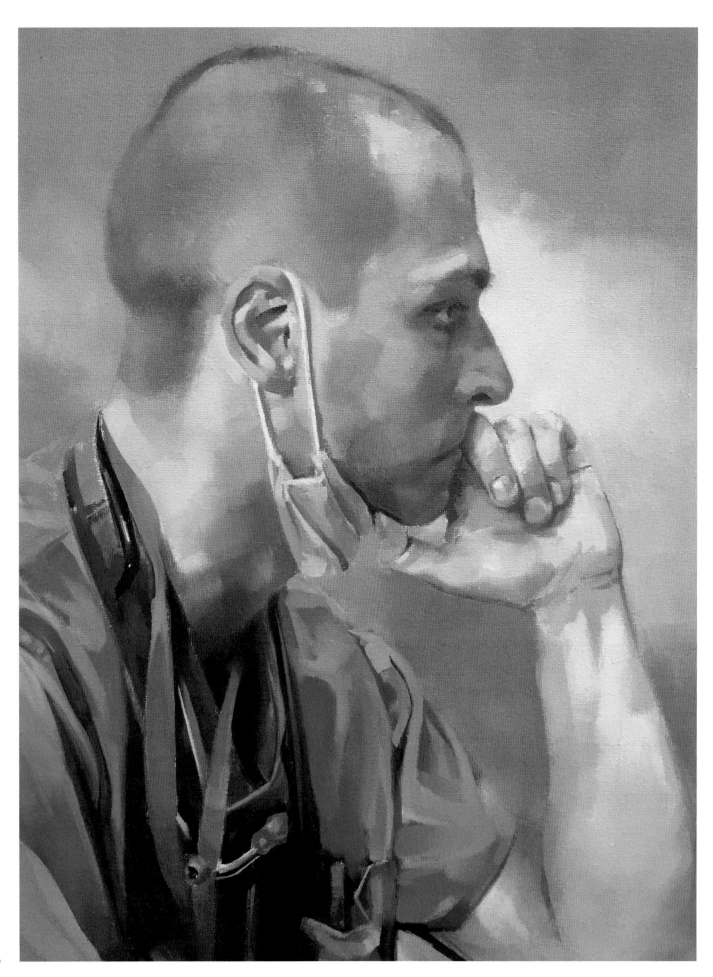

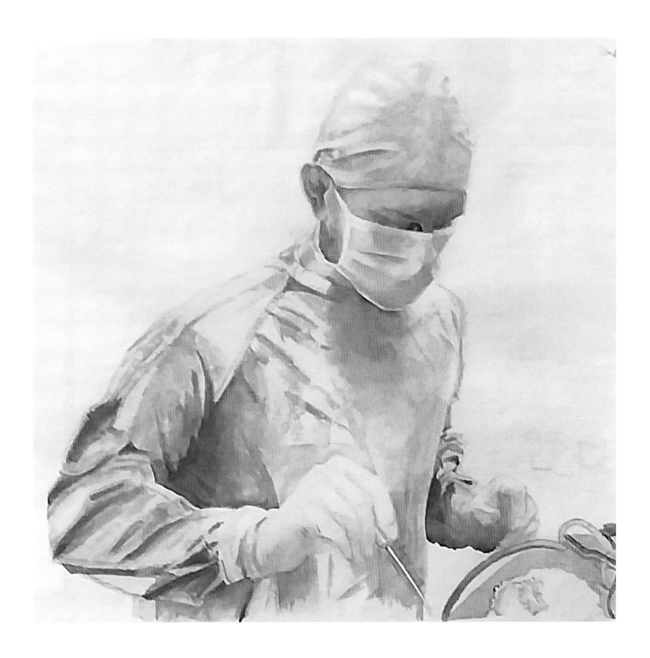

GREG by JULIA PAGE

OIL | 50.8 × 40.6 CM

'This is Greg, a house officer working in acute
medicine at Lewisham Hospital.' JULIA

PAVAN by KEEVA DENNIS

OIL ON WOOD | 40 × 30 CM

'I was honoured to be able to take part in this project. I wanted to create an accurate portrait depicting the PPE worn by the NHS staff at the moment, to highlight the work they are all doing for us.' **KEEVA**

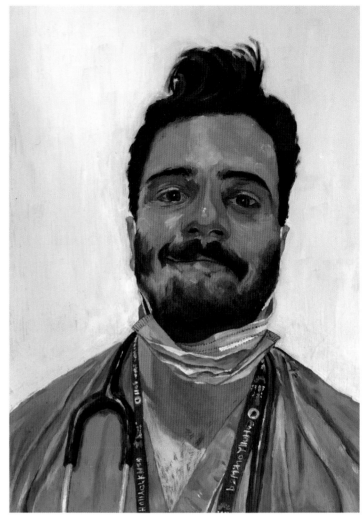

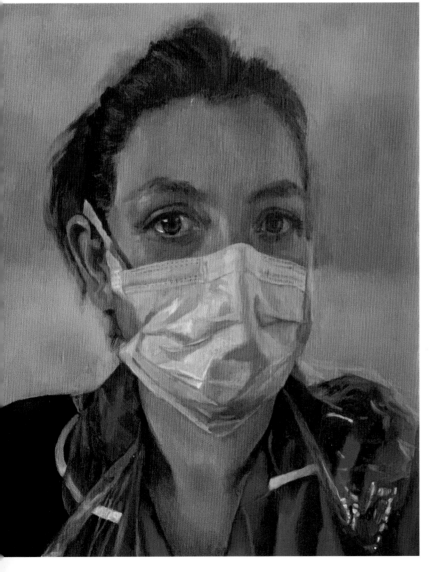

SARAH by SARAH THIEN

OIL ON LINEN | 30 × 24 CM

'I had the pleasure of painting emergency stroke nurse Sarah, who tirelessly worked alongside her brilliant team at the Sheffield Teaching Hospitals throughout the pandemic. Sarah's engaging personality makes it very clear why she is an amazing NHS Hero. I really enjoyed the challenge of representing Sarah's personality from behind the mask, and I tried to convey that through the expressiveness in her eyes. It was really nice to be able to use my skills to create a small token thanks to the heroes on the front line.' **SARAH THIEN**

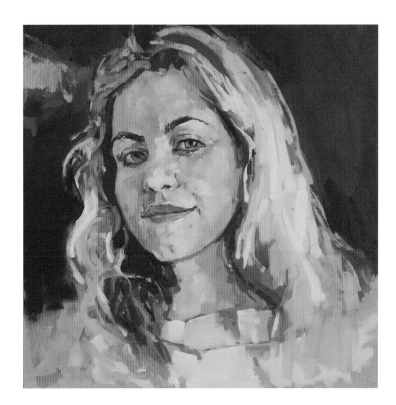

MYKILA DONALDSON by PHILIP TYLER
OIL ON BOARD | 30 × 30 CM

ELLEN CALLOO by JULIE BENNETT
OIL ON CANVAS | 35 × 35 CM

'Ellen is a twin, a sister, a daughter, an auntie, a godmother and an NHS healthcare assistant at Brighton Sussex University Hospital. Ellen has worked there for over six years. On the outbreak of the virus, her Cardiac ITU was quickly adapted to receive and support Covid-19 patients. Members of her team support one another during this uncertain time, whether it be personal or professional. Ellen loves her team as they are a strong unit and committed to caring for post-cardiac surgical patients. The team feels overwhelmed with the generosity of donations they have been receiving and wants to express their gratitude to all involved. They know everyone is playing a part in trying to protect themselves and others, so a big thank you from Ellen to all of you too!' JULIE

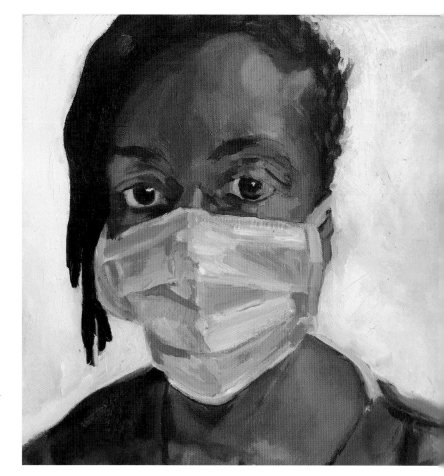

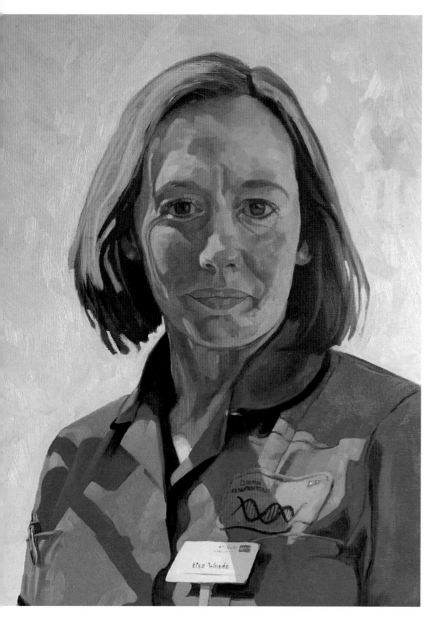

DR CHIKA IGWE by KATHRYN BELL
OIL ON CANVAS | 50.8 × 40.6 CM

LISA WOOD by ALEX COOPER
OIL ON PANEL | 40 × 30 CM

'Lisa is a stroke specialist research nurse at the West Suffolk Hospital in Bury St Edmunds. During the height of the Covid emergency she was redeployed to work on government high-priority Covid-19 clinical trials and her main job was to approach Covid positive patients to discuss the trial and consent. Her portrait was the first of eight that I painted and it meant a lot to me to feel I was doing something small to say "thank you" to these amazing people.' **ALEX**

'It has been both a physically and an emotionally draining time, the toughest of my 22-year NHS career, but I have also felt honoured to work alongside truly dedicated healthcare professionals and have met some amazingly brave patients along the way.' **LISA**

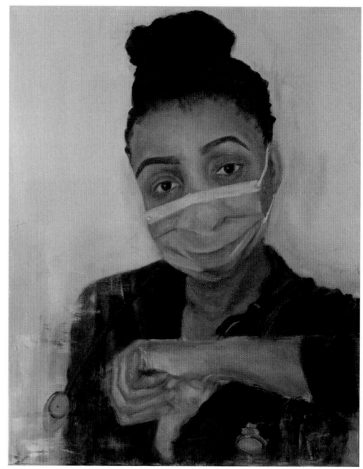

CHARLOTTE McGAWLEY
by ANDREW WOOD

OIL | 63 × 41 CM

'This is one of the first portraits that I have painted for a number of years. Due to lockdown I had the time to paint again. Charlotte is a nurse working on the high-dependency-care ward. Many of the patients have acute and/or long-term respiratory conditions. Charlotte and her colleagues have been on the front line throughout the Covid-19 pandemic.' ANDREW

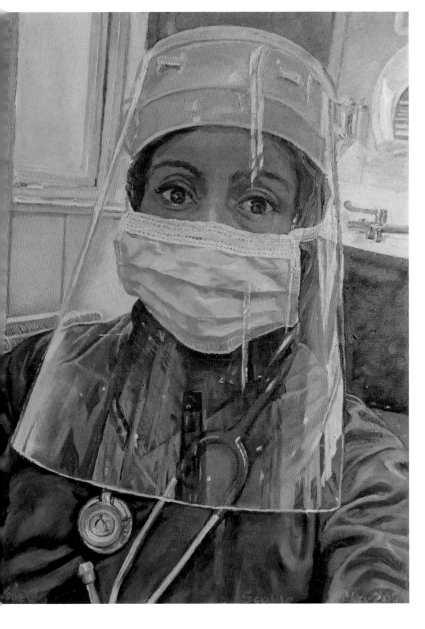

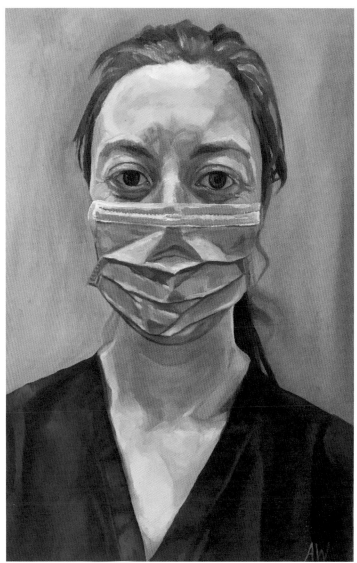

DR RUKHSANA SALIM
by LESLEY SCOBLE

OIL | 40 × 30 CM

'I am honoured and humbled to paint NHS heroine Dr Rukhsana Salim, who has received special mention from a representative of the Queen for the work that she has done to help save lives during the pandemic and her leading efforts to ensure provision of vital PPE to Stockport primary care.' LESLEY

'When I received the pictures from Lesley I thought what she had done was incredible. I love my portrait and was on a high after seeing it. Huge thanks to Lesley.' DR RUKHSANA

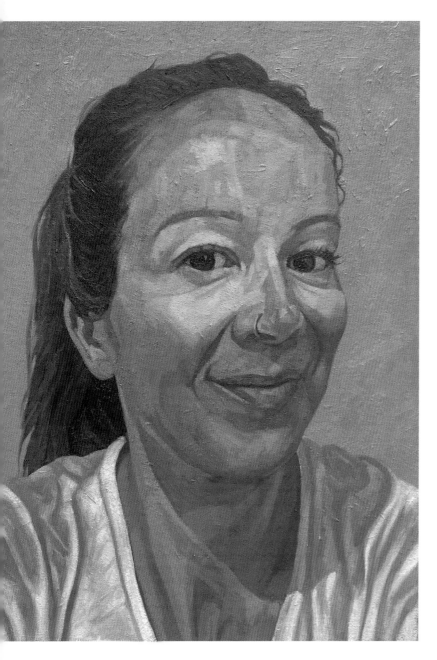

LAURA by JOHN MEREDITH

OIL ON CANVAS | 40 × 30 CM

'It was a pleasure to honour one of the many NHS heroes.' JOHN

'I'm so very honoured and touched that someone would go to the trouble and spend their time to do something like this.' LAURA

DARREN by JAMES BLAND

OIL ON PANEL | 40 × 30 CM

'Darren was great to work with, and very supportive of the semi-abstract style in which I painted him. This style was a tribute to one of my painting heroes, Harold Gilman, who died during the Spanish flu epidemic. I owe a debt of gratitude to the NHS for treating my scoliosis as a teenager, with major surgery that was both timely and life-changing. It's an honour to be involved in such a beautiful project. Tom Croft is a dynamo.' JAMES

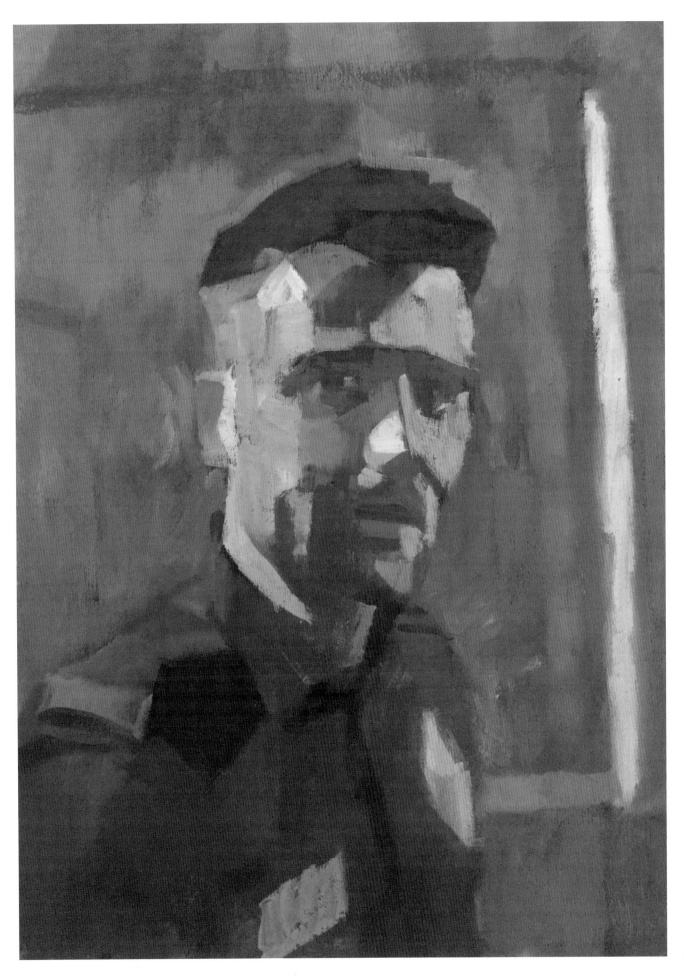

SPENCER by GRAY SIMPSON

OIL ON PANEL | 25 × 20 CM

'Spencer is a charge nurse in intensive care at St Thomas' London. We're incredibly lucky to have an institution such as the NHS but it would be nothing without skilled, caring people like Spencer. A big thanks to him and everyone else at the NHS for all their hard work and dedication during this difficult time.' **GRAY**

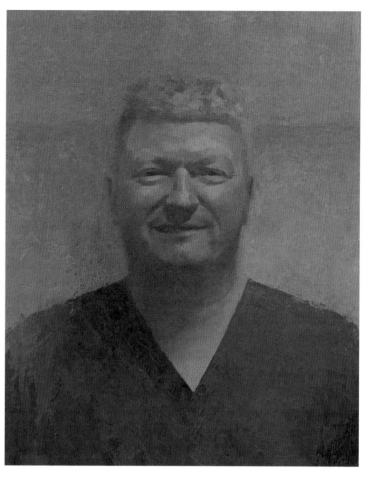

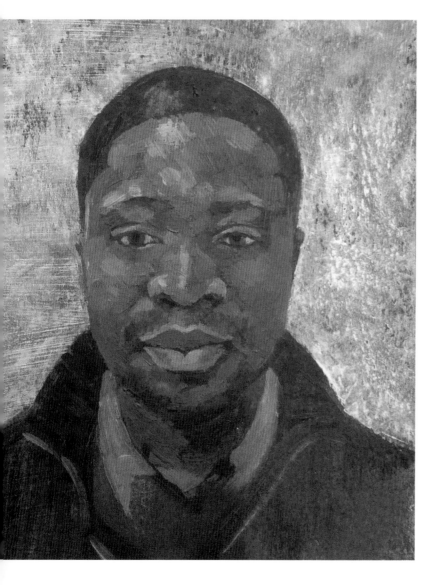

DR DILI AGU by SARAH GODSILL

OIL ON PAPER | 16 × 12 CM

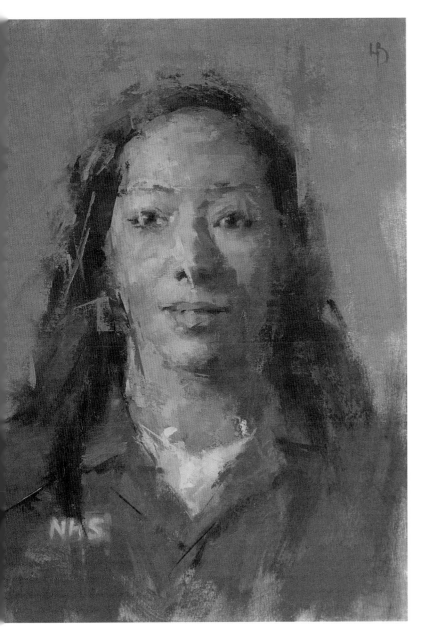

JAVIER by BELINDA CROZIER

OIL ON BOARD | 47 × 37 CM

LIAM HALLIWELL
by LAURA QUINN HARRIS

OIL ON BOARD | 25 × 20 CM

'Liam is a friend of mine who works as a paramedic in Manchester. He has worked for the NHS in various guises for 22 years. He says that, although he has faced many challenging situations throughout that time, he has never experienced such anxiety in the context of work as he did at the outset of the pandemic. Nowadays when he goes to work and sees the amazing amount of effort, bravery and dedication being put in at every level he says he feels reassured, and so do I. I'm delighted to have been able to offer this small token of my gratitude to Liam for all his hard work.' **LAURA**

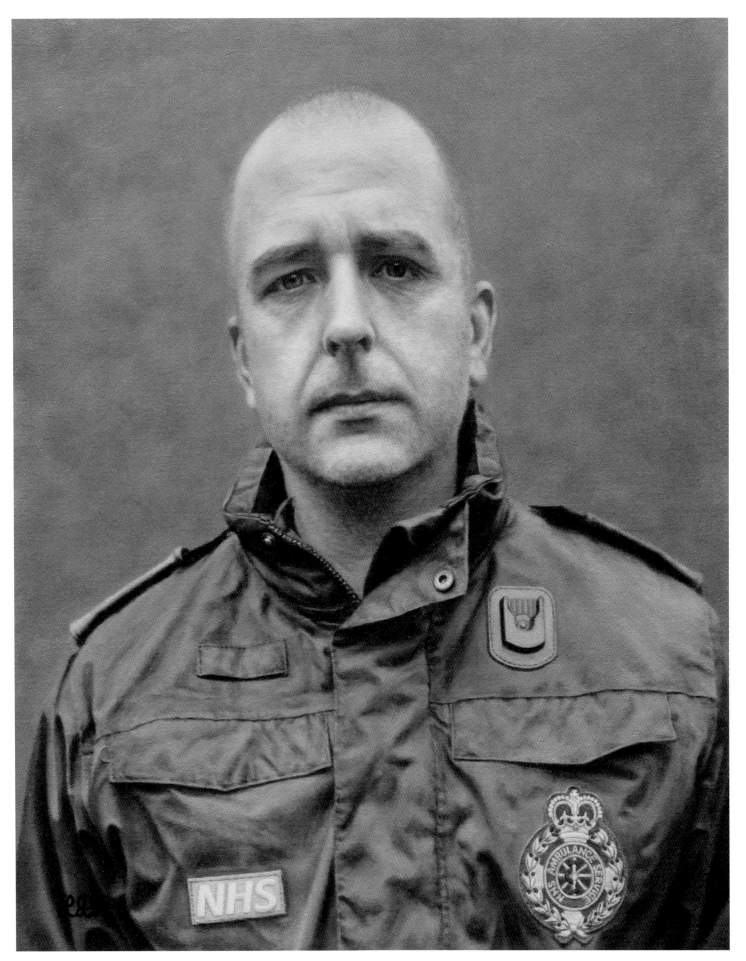

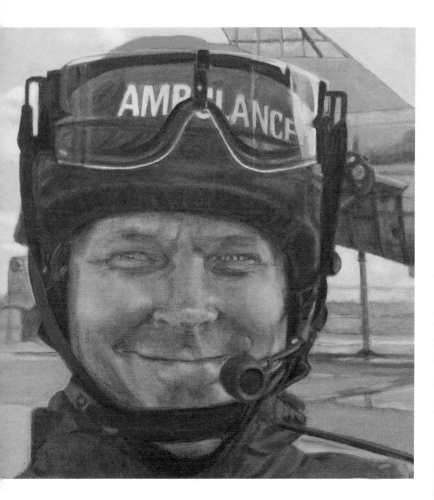

SAM STRUTTON by LILIAN McCANN

OIL ON BOARD | 42 × 42 CM

'It was a pleasure to paint Sam's portrait. The picture contrasts his friendly smile against the backdrop of the harsh reality of his work. Sam works as a paramedic in HART (the hazardous area response team). His job is to respond alongside other ambulance crews and he specializes in hazardous or mass casualty events. During the pandemic it has been part of his job to transfer Covid-19 patients between hospitals. Sam has been overwhelmed by the recent kindness of the public to the NHS. He felt it has reminded everyone why they wanted to do this type of work in the first place. Both he and his colleagues thought the painting amazing and felt privileged to have been part of this project.' LILIAN

CLAIRE by SIMON AUSTIN-BURDETT

OIL ON PAPER | 27 × 19.5 CM

'Integral to my process is getting to know my subject. I think this also helped Claire reflect on working in very stressful circumstances. Claire has been a paramedic for ten years. She sees her team as her second family, describing her job as very rewarding, even in these strange times. The ambulance service play the vital role of first contact when people are admitted into hospital with Covid-19. Whilst painting Claire's portrait I thought about how hard it must be for the ambulance teams when the patients' families were saying goodbye, not knowing if they would see their loved ones ever again.' SIMON

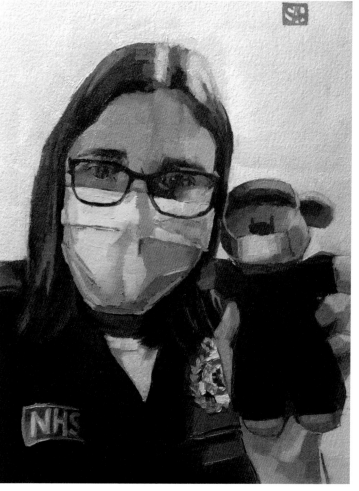

AJAY BHATT by DOMINIQUE GRANTHAM

OIL ON LINEN | 40 × 30 CM

'This is Ajay Bhatt, advanced paramedic practitioner for London Ambulance Service. His girlfriend Jane contacted me to nominate Ajay. I loved the picture she sent me of Ajay in the ambulance and knew it would be a good one to paint!' DOMINIQUE

'This was commissioned at a time when Ajay was working back-to-back shifts and isolating himself from his family and friends in NHS accommodation, to try and keep us all safe. We were apart for about eight weeks – it felt like forever, especially as Ajay ended up contracting Covid. Not being able to be with him as he suffered was pretty much the worst thing I've ever experienced. Ajay always stood by the fact that he wasn't actually a hero, he was just doing his job. I love the portrait, and he's proud of it too. Thankfully, we don't associate it with the dark days. Maybe because it's just such a beautiful, calm picture.' JANE

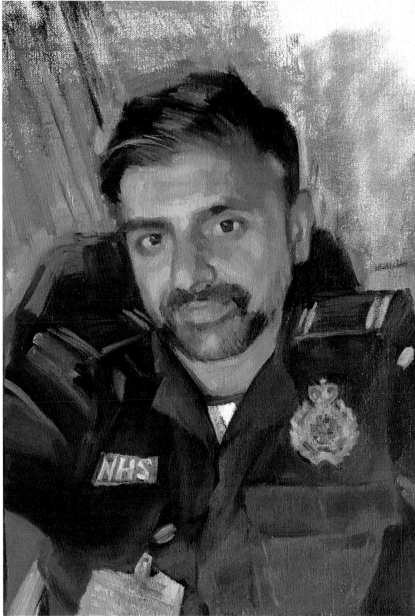

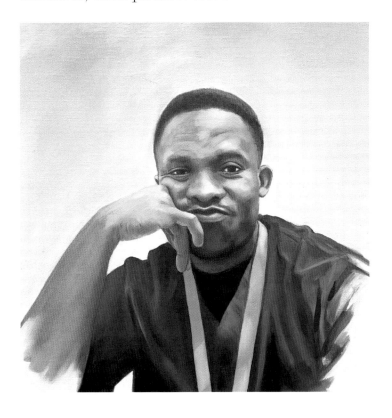

DR OGE IGWE by HEIDI HART

OIL | 40 × 40 CM

'My NHS hero is Doctor Oge Igwe at Furness General Hospital Barrow, who is currently working in the Covid ward. I hope I've done him justice! I feel privileged to be able to say thank you to our NHS heroes who continue to put themselves in harm's way for us.' HEIDI

'Thanks so very much. Coming in from a long shift to see this painting is one of the most beautiful feelings ever.' OGE

MARK by ANGE BELL

OIL ON GESSO | 17 × 12 CM

'Mark is a dedicated member of the ambulance service in Northern Ireland. The professionalism, compassion and devotion that Mark and his colleagues show on a "normal" day are exemplary, but during the pandemic they raised the bar further still.' ANGE

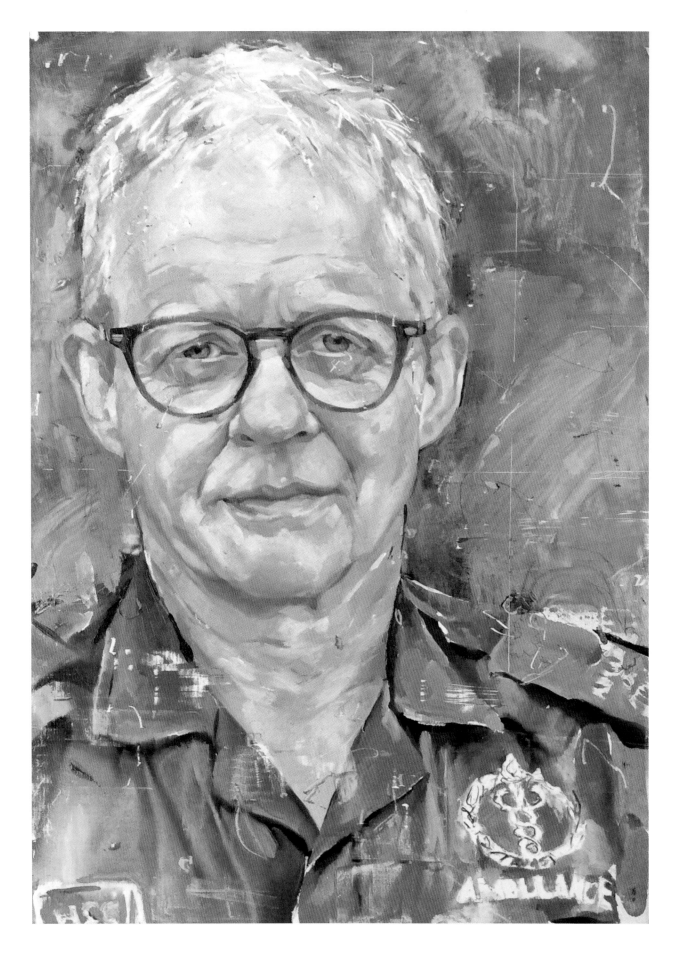

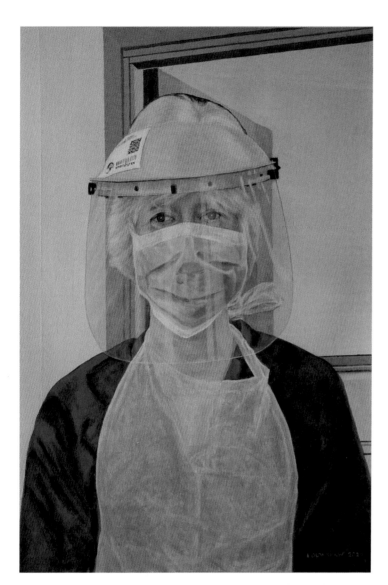

FIONA by ANDREW CRONSHAW

ACRYLIC | 42 × 30 CM

'The painting took me three weeks to complete, but I did not paint every day. It probably took me six hours over three days to balance the eyes and find the likeness. I felt the image needed a background so portrayed the clean clinical work environment. I painted the face shield last. I liked the untouched barcoded retail label on the helmet as it reminds us of the speed in which the PPE had to be resourced.' ANDREW

'Looks fab to me! I'm really impressed.' FIONA

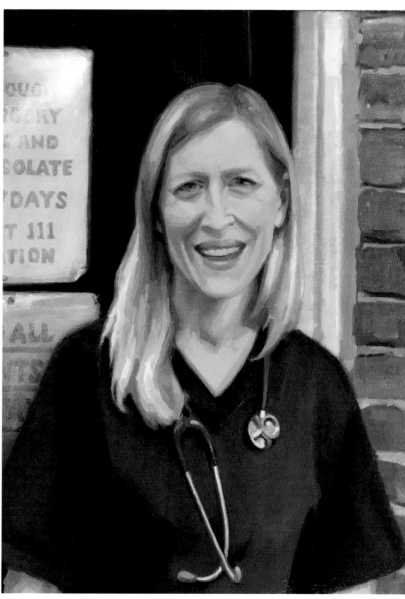

AMY WHEELWRIGHT
by GEORGINA BARCLAY

OIL ON CANVAS | 66 × 50 CM

NURSE IRENE DOUGAL
by JENNIFER MOLE

OIL | 57 × 38 CM

'I am humbled by the dedication and sacrifices made by all of the amazing healthcare workers such as Irene.' JENNIFER

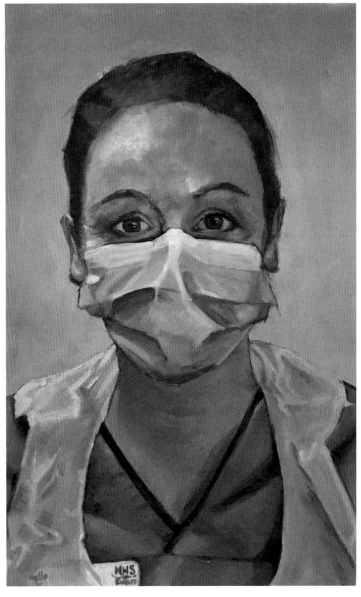

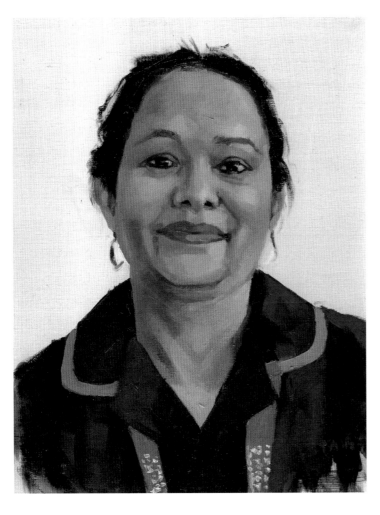

SHARADA by ALISTAIR LITTLE

OIL ON PANEL | 25.5 × 20.3 CM

NIKKI HEDGES & BECKY SHEPPARD
by DONNA MARIA KELLY

OIL | 42 × 59.4 CM

'This captures perfectly the emotion between these two sisters Becky and Nikki, who found themselves on shift together for the first time during the pandemic, at the Luton & Dunstable Hospital, and were able to give one another a hug. Even though they're covered head to toe in PPE, it's all in the eyes, and you can see they're totally filled with love. Simply beautiful. They completely stole my heart.' **DONNA**

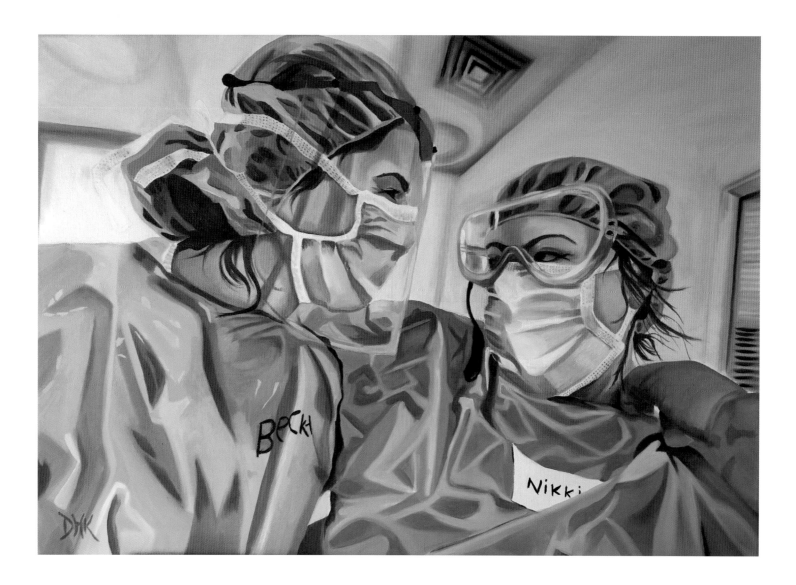

SAM & HARRIET by MICHAELA NORTON
ACRYLIC ON CANVAS | 40 × 30 CM

'This portrait reflects what the NHS is all about: the camaraderie and spirit of those working so closely together within this work family. This painting captures their last shift together working in the Intensive Care Unit at Luton & Dunstable Hospital during the Covid crisis. This portrait is for their patients: the hands they held when no one else could, the lives of healthy people that were tragically lost, and for all the patients they saved. Beyond the stress and strain of this particular shift, their personalities, compassion, strength, resilience and beautiful souls shine through. I felt incredibly emotional at times working on this portrait.' **MICHAELA**

DANIELLE IVILL by REBECCA LEE
ACRYLIC ON PAPER | 30 × 30 CM

'Dani was a theatre assistant at Ipswich Hospital undertaking a trainee nurse associate apprenticeship when the coronavirus pandemic hit the UK. She was redeployed to a mobile emergency rapid intubation team (MERIT) on the front line of the crisis.' **REBECCA**

OLIMPIA by LOUISA TEBBUTT
WATERCOLOUR AND PLATINUM GOLD LEAF DETAILING | 68 × 45 CM

'Some things cannot be expressed in words... This painting has a lot of meaning to me. It has given me that tiny bit of light, that tiny bit of hope and a smile on my face. That's enough to help me get through the difficult times as a nurse in a critical care unit. Going to work felt like going to a battlefield! A battlefield where the enemy is invisible. The enemy left us (NHS workers) with many scars that are not visible. Emotional scars.'
OLIMPIA

CAROLINA by MARY JANE ANSELL
OIL ON ALUMINIUM PANEL | 35.5 × 35.5 CM

'Born in Portugal, Carolina came to England five years ago and works as a critical care nurse at the John Radcliffe in Oxford. When I spoke with Carolina at the start of lockdown she asked me not to paint her in her PPE but to focus instead on making a really positive memory for her from this time. I was incredibly moved when she told me how upsetting it was that during such a frightening experience her patients couldn't see and be reassured by her smile – and that she'd taken to drawing a smile on her uniform and finding other ways to comfort her patients, however she could.' **MARY JANE**

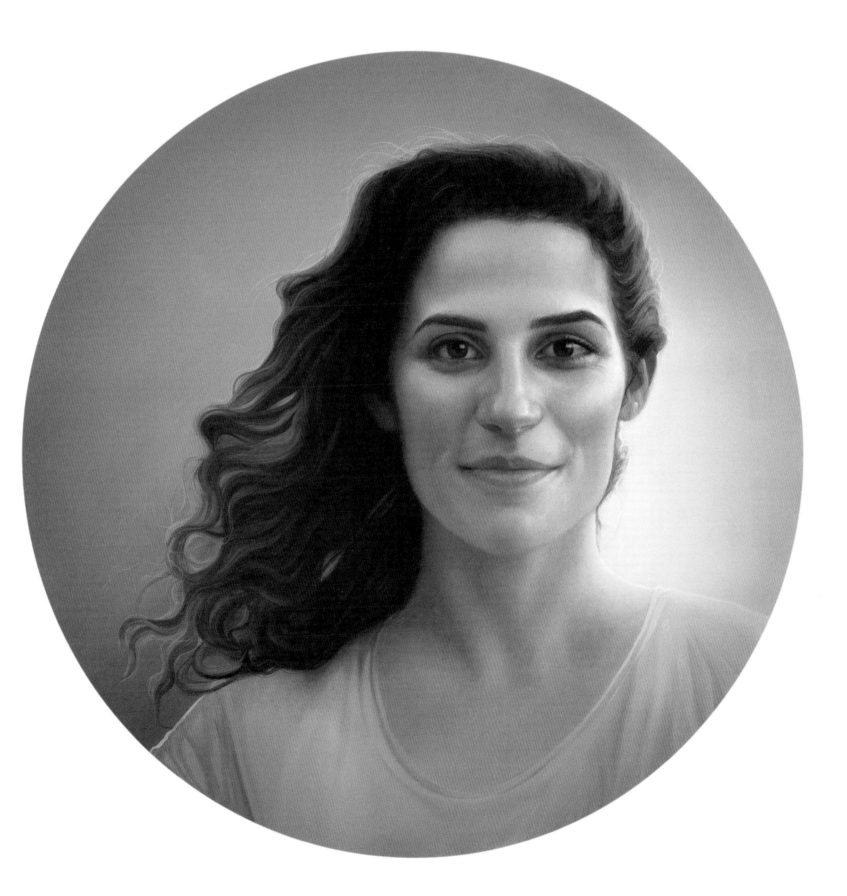

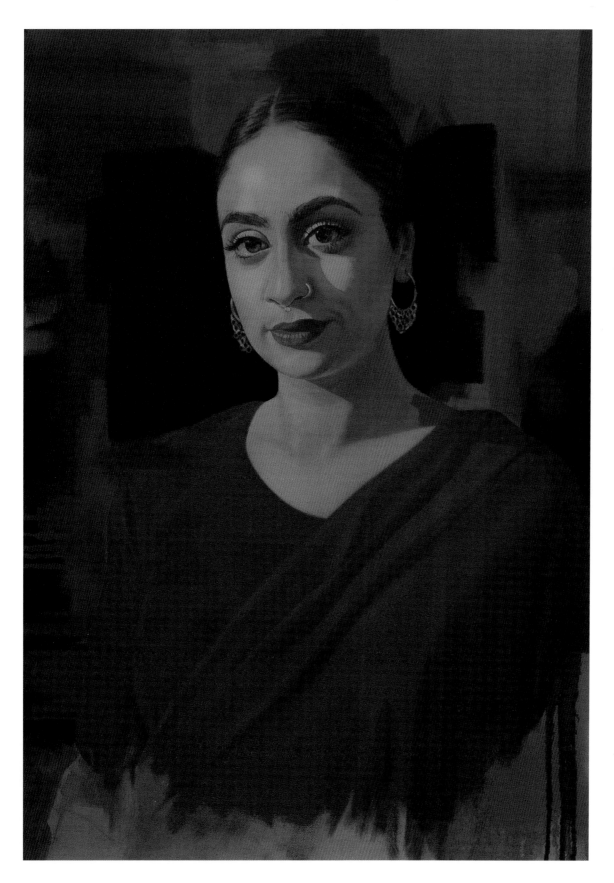

HIRAH by NEIL COLLINS

OIL ON CANVAS | 70 × 50 CM

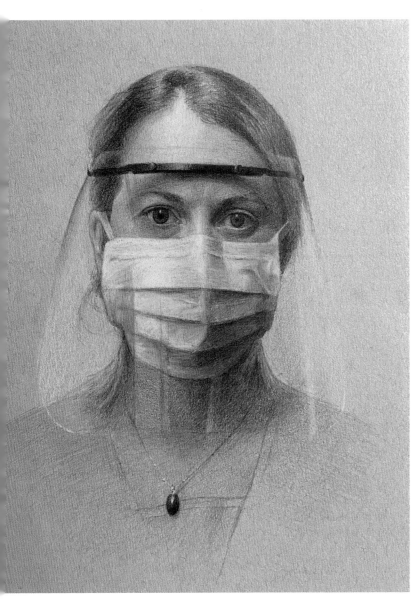

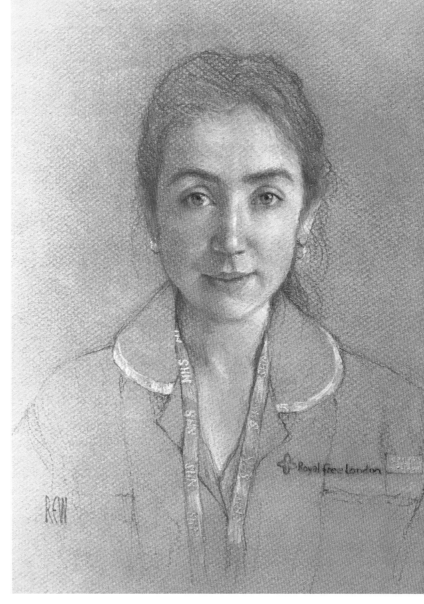

KAYLEIGH PEEL by STEPHANIE REW

PASTEL ON PAPER | 40 × 30 CM

'This is a pastel pencil drawing of Kayleigh, a nurse at the Royal Free Hospital, London. I wanted to capture her youth as well as her strength. As I don't know her personally, this was a challenge. It's lovely as an artist to be able to do something positive in this difficult time.'
STEPHANIE

'I love the portrait so much! Thank you from the bottom of my heart for making it for me! I really like it and you've captured me so well.' **KAYLEIGH**

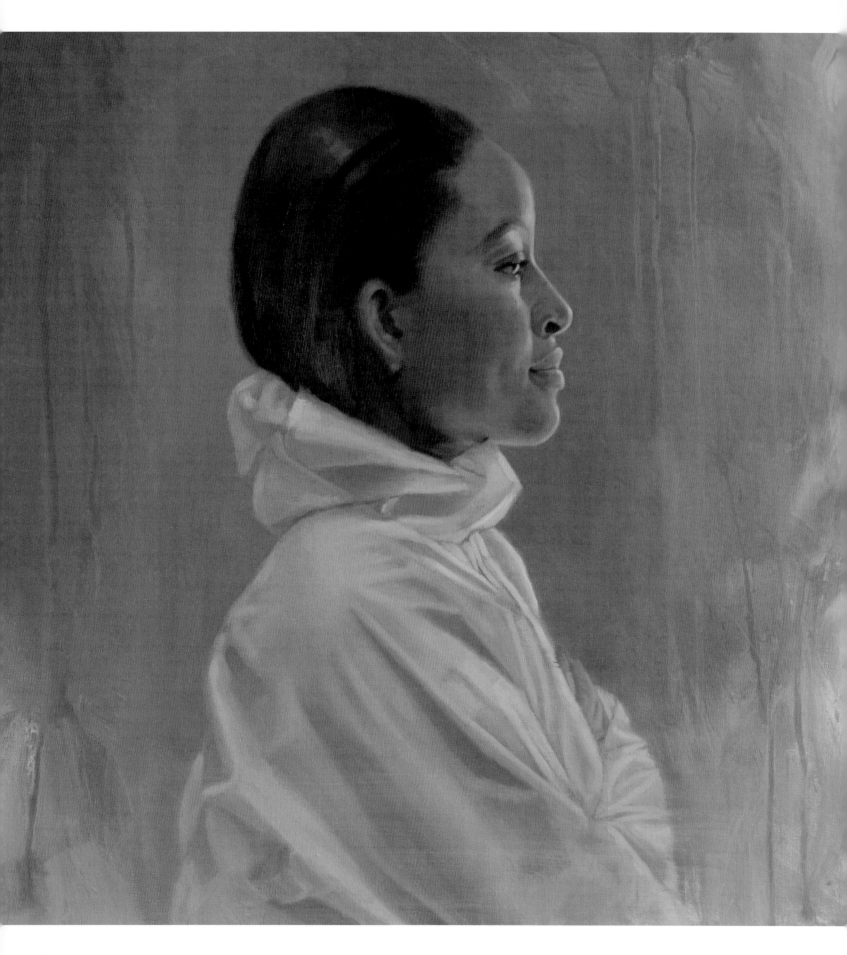

DR BAKARE by EMMA WOOLLARD

OIL ON CANVAS | 50 × 50 CM

'Dr Bakare works in the ICU at one of the worst-hit hospitals in London during the peak of the pandemic, working long days and nights whilst also looking after two young boys at home. She has wanted to be a doctor since the age of 5 and cannot imagine wanting to do anything else. I wanted to portray her inner calm, strength and serenity amidst the unprecedented chaos, intensity and uncertainty going on in the world around her. Not only is she a hero – I see her as a goddess.' EMMA

'Emma is truly talented. She accurately captures my defiance in the fight against Covid, immortalizing an expression many healthcare workers around the world can relate to.'
DR BAKARE

NIKKI CLARKE by CLIVE BRYANT

OIL ON LINEN | 50 × 40 CM

'Nikki is a frontline nurse in Nottinghamshire. It was her idea to do the heart-hands and just shows what a truly lovely person she is; as are so many key workers who continue to risk their own health in order to help others.' **CLIVE**

RUBY SHAIKH by LAURA GELSOMINI

OIL ON CANVAS | 50.8 × 40.6 CM

'Ruby is a specialist nurse, who assesses patients in the unique position of being able to help others through organ donation at the end of their lives. During the crisis she has been working as a sister in intensive care at St Thomas' Hospital. I found Ruby to be funny, lively, beautiful, compassionate and a true original! A post about her apprehension about wearing PPE on public transport inspired me to paint her without it. Like Botticelli's Venus, the wind captures her hair and mask, serving as a symbol of her work breathing life into needy recipients.' **LAURA**

ROCÍO by BECKY PATON

MOSAIC | 70 × 70 CM

'I wanted to look past the devastation of the situation and have hope for a positive future.'
BECKY

RACHAEL by JUDITH BOOTH

OIL ON LINEN | 40 × 30 CM

'Rachael is a dedicated young midwifc whose cousin nominated her for a portrait. I asked her to let her hair down when she took the selfie for her portrait, so that her eyes are framed by a cloud of stunning red hair. I'm a retired GP turned portrait artist, and it was an honour to be able to use my newfound skills to support and thank current staff.' **JUDITH**

'It went straight on the wall the second I received it! I have had such amazing feedback from those who have seen it through social distancing. I cannot wait to show it off to everyone in person when this lockdown is over. My husband comments on it daily, saying how he can't believe how lifelike it is, and it definitely helps me get on with the night shifts.' **RACHAEL**

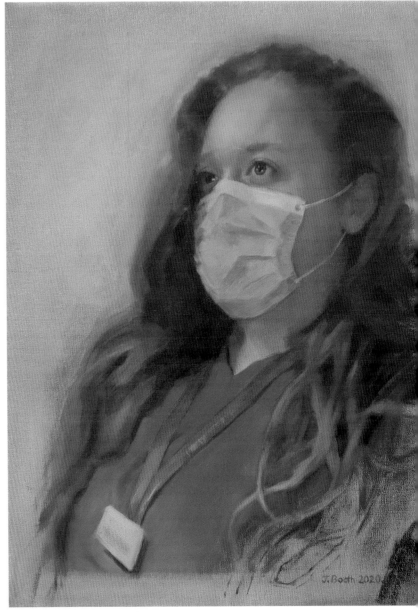

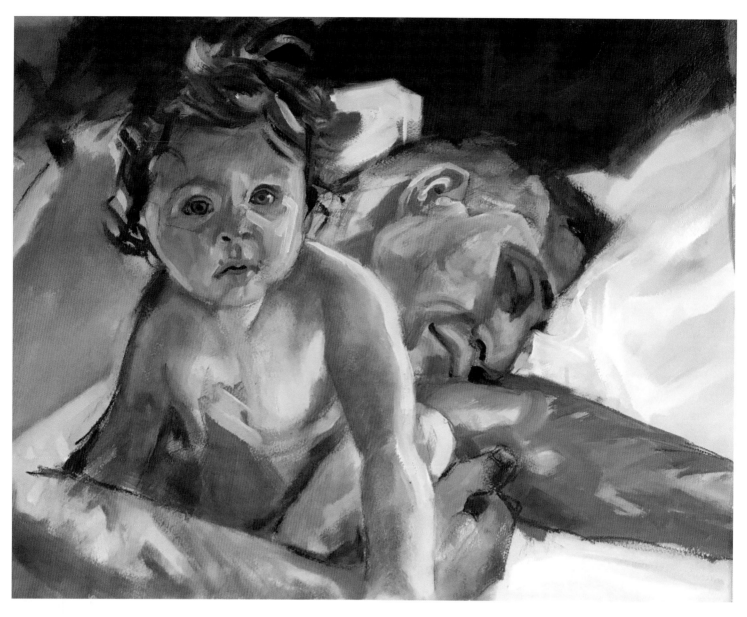

LEWIS by IAN WHYTE

ACRYLIC AND OIL ON PAPER | 40 × 60 CM

'In the midst of the Covid crisis I was struck by the humanity of this composition of an exhausted ITU doctor, Lewis, after working his night shift comforting and being comforted by his 8-month-old daughter. It expressed the need to safeguard loved ones and also escape from the hazards of working in hospital with full PPE. His wife Jo said "Lewis was the most surprised I've ever seen him on receiving the portrait and he's really proud to be part of #portraitsfornhsheroes."' **IAN**

VICKY by LAUREN CARTER-BRIDGES

OIL ON ALUMINIUM | 60 × 43 CM

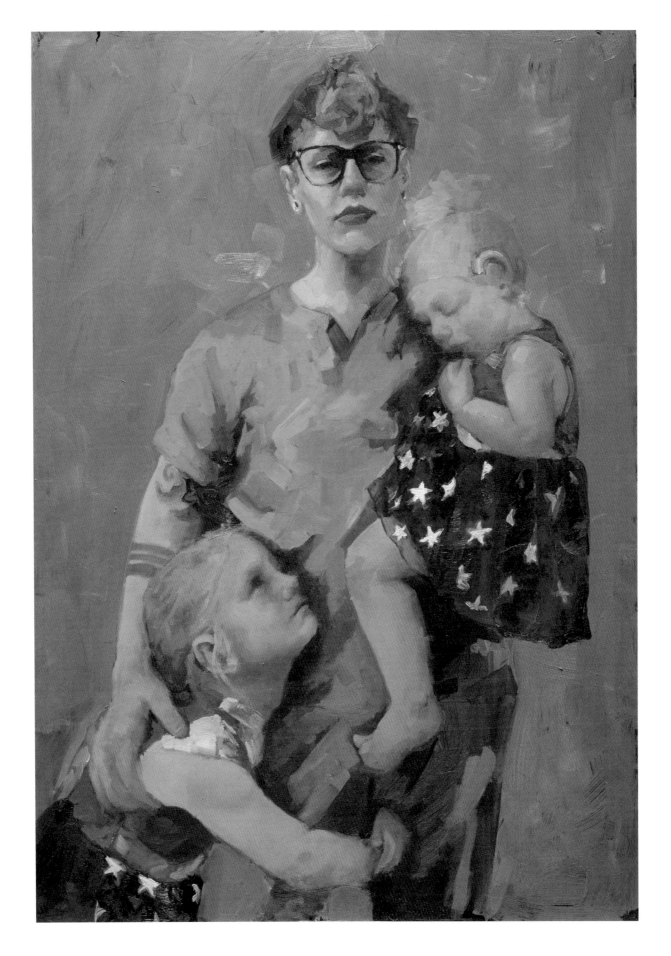

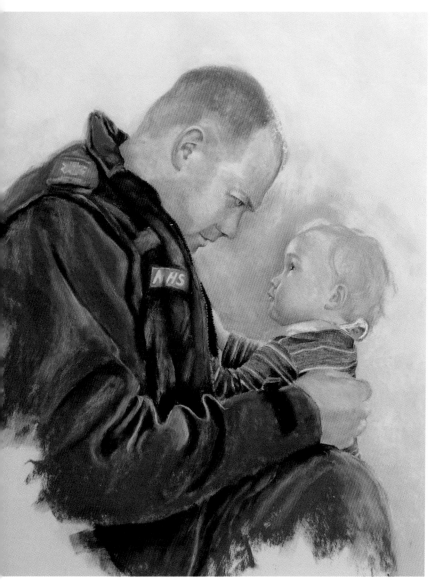

NEIL & HARRY by ESTELLE ROBINSON
PASTEL | 42 × 29.7 CM

'My husband is an emergency medical technician for East Midlands Ambulance Service, where he has done 15 years' service. He is doing 12-hour shifts and going into people's houses not knowing if they have Covid-19 or not. He is doing all he can to protect himself at work and not bring the virus home to us. I took this photo of him saying goodnight to our 1-year-old baby before he left for a night shift. For me it's very emotive the way our son is looking up at him, like his dad is his hero, and he is looking down like the protector, off to war to fight this invisible battle.' ESTELLE

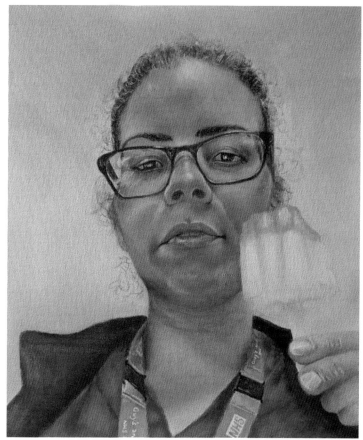

MARISOL by HANNAH GEORGE
ACRYLIC | 30.5 × 25.4 CM

SASHA & BABY JOSH
by DAVID WEEKES
OIL ON CANVAS | 60 × 40 CM

'Sasha is a GP working in East London. She returned to work early from maternity leave to help with the Covid-19 crisis. I am delighted to have had the opportunity to paint this portrait of Sasha and her baby as a thank you for all of the incredible work that she and her colleagues are doing.' **DAVID**

'Thank you so much for capturing us perfectly. This portrait is very sentimental to me, as Josh has spent half of his young life in lockdown. It was heart-rending to go back to work early, but I also felt a duty to do this. David managed to encapsulate how important it is for us all to sustain the NHS, for generations to come.' **SASHA**

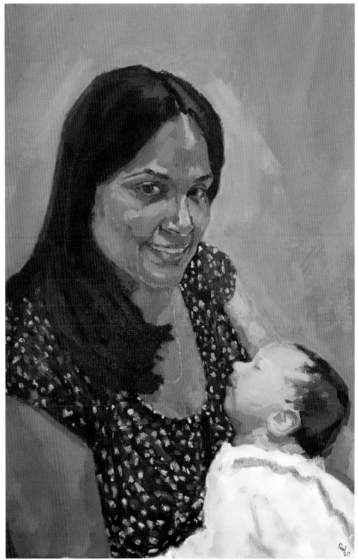

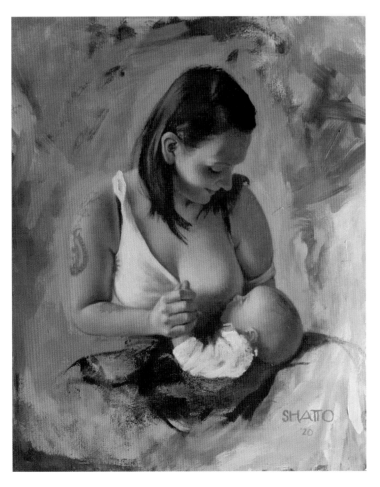

BRYONY & EIRA by MELISSA SHATTO
OIL ON CANVAS | 50.8 × 40.6 CM

'Artists are probably better equipped than most to be holed up for days on end, but during lockdown I was not being at all productive. Then I received the most wonderful enquiry from a midwife in Wales. Her maternity leave was about to end. She'd humbly asked if I would consider painting her breastfeeding her daughter to depict why she felt it was so important to go back to work and support other new mothers during the pandemic. Both Tom's initial gesture of thanks and Bryony's beautiful idea were truly inspiring.' **MELISSA**

VITOR & CLAUDIA GOMES
by HELEN STONE

OIL ON CANVAS | 45 × 60 CM

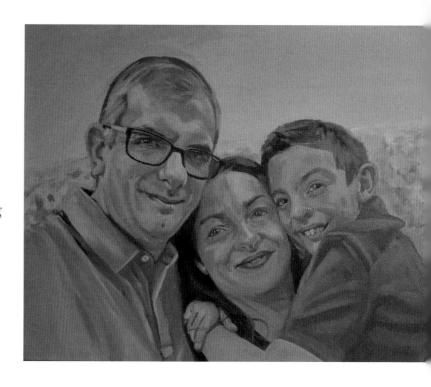

'It felt serendipitous to be paired with Vitor and Claudia for this project. One moment I was shelving the plans I had for a tour of Portugal, the next I was painting the lovely Gomes family. At the time of painting, Vitor was commissioning a new ICU while Claudia was waiting to be deployed to a Nightingale Hospital. Both had spent most of their careers in Portugal but were coming up to eight years working for the NHS. Their story brought home how tough it was to face such difficult circumstances day after day, arranging shifts so they could care for their son. When Vitor requested a family portrait he told me: "We have no family here so we live for each other and our son, whom we adore." True heroes and truly beautiful people.' HELEN

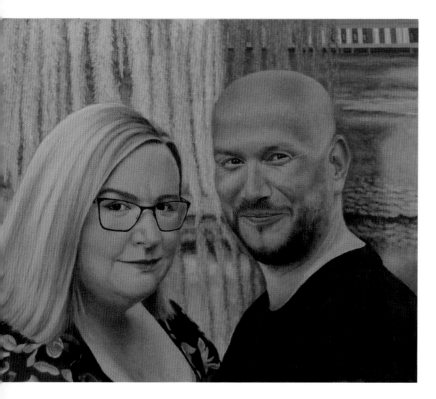

HEIDI & DAVE MARROW
by CLARE ROWAN

OIL | 46 × 56 CM

'I chose to have a picture with my husband, who is also an NHS worker. I wanted a picture that my children would want to keep in this time of uncertainty – to show them there was love and light in the darkness too. The painting shows our hospital in the background and shows the sunlight perfectly on the ground behind us. We are united in the fight at work and the protection of our family. The painting came the week Dave was suffering from the virus, reminding us of the light and boosting our strength in the fight. Thank you, Clare and Tom, for a memory of this time that will always be part of our story.' HEIDI

MATTHEW & SAMI
by LUCILLE SMITHSON

OIL ON BOARD | 36 × 28 CM

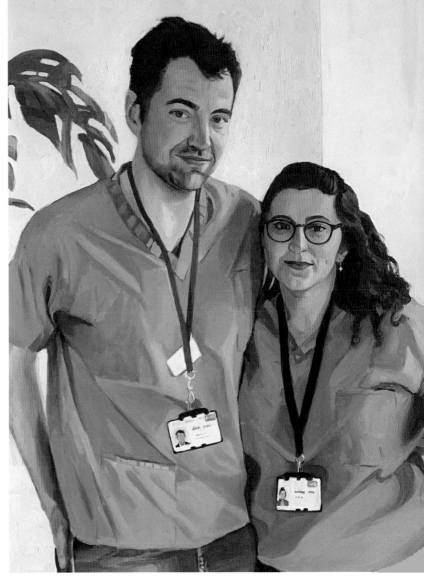

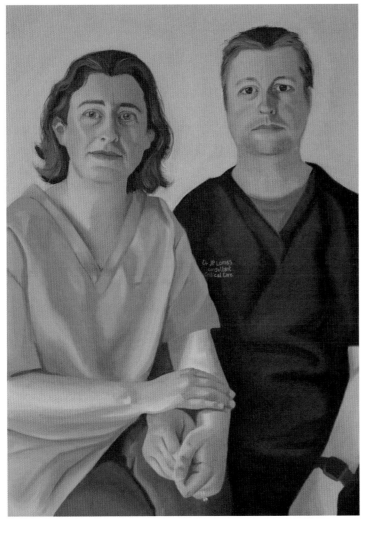

BERNADETTE & JP
by AMELIA WEBSTER

OIL ON BOARD | 84 × 59 CM

'Bernadette and JP both work as anaesthetists. Whilst speaking to Bernadette I was struck by her positivity and enthusiasm for wanting the piece to be something her children could look upon and feel a sense of positivity for the future.'
AMELIA

ABIBATU BARRIE by ANN HAWKSLEY

OIL ON CANVAS | 60 × 40 CM

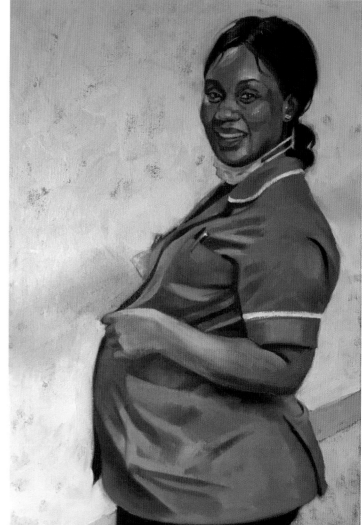

NATALIE by JULIET STOCKTON

ACRYLIC ON CANVAS | 40 × 40 CM

'Natalie is an NHS social worker in Scotland. At the time of painting she was around 26 weeks pregnant and still working. Here she is with her pet chihuahuas.' JULIET

UPEKA KARAISKAKIS
by EMANUEL DE SOUSA

ACRYLIC | 50 × 60 CM

ANDREIA & TIAGO by FLO LEE

ACRYLIC PAINT AND CHARCOAL ON CANVAS | 56 × 56 CM

'Andreia & Tiago met at their first year of uni in Portugal and came to the UK seven years ago. They are both nurses who have been working in the Covid-19 wards. The photo they gave for reference was from a pre-wedding photo shoot.'
FLO

MELISSA DOWN & FAMILY
by LUIS MORRIS

OIL ON CANVAS | 56 × 46 CM

'Melissa, a GP in Surrey, sent an array of photos for reference. Although these included one of her in scrubs at work, Melissa said that she would prefer to be portrayed with her husband and children, who she said had been her rock through good and bad days, and her NHS heroes.' **LUIS**

BECCA by CARRIE STANLEY

OIL ON CANVAS | 45 × 30 CM

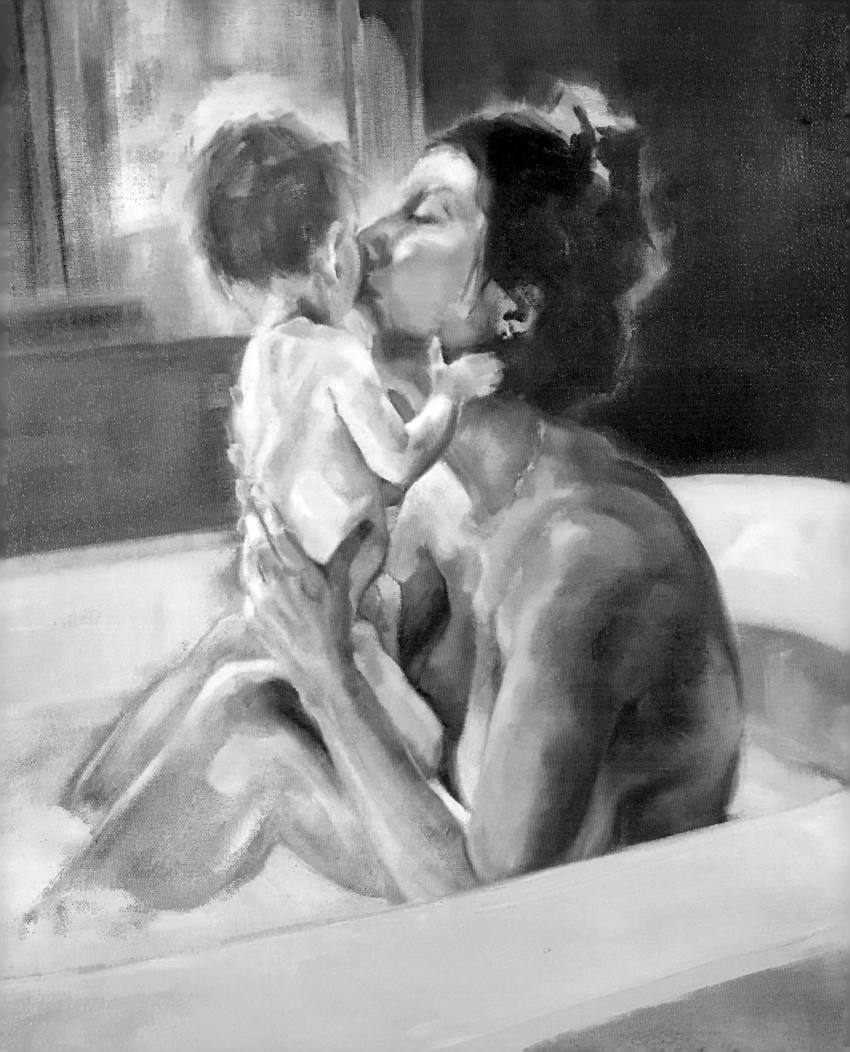

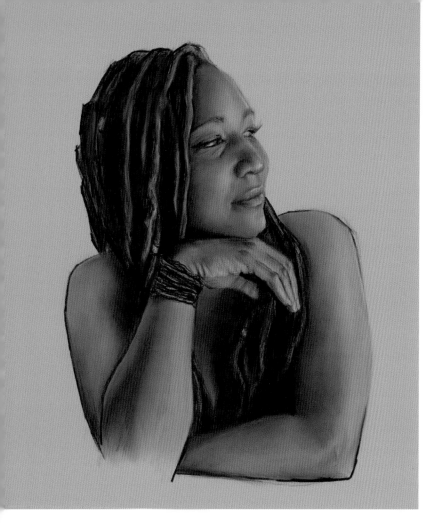

ROBERTA by PIPPA HALE-LYNCH
DIGITAL | 47 × 35 CM

'Roberta works as a health visitor and adult nurse, working in the community alongside families with young children to help them have the best start in life. This work is a thank you to Roberta and to all those working in the NHS for all of their hard work and dedication.' **PIPPA**

'It's been a challenging time as the virus and lockdown have impacted the families we work with. I have seen families with no income and mothers who have no way of feeding their babies. We are also very concerned about domestic violence and mental health. Many of the women we see have just had babies and this can be a challenging time in normal circumstances.' **ROBERTA**

DR HANNAH TEREFENKO
by JO WHITTLE
PENCIL | 30 × 42 CM

'Dr Hannah Terefenko is a GP in Hampshire who has been supporting and treating patients throughout the pandemic. This initiative has meant so much more to me than merely creating portraits; it brought smiles, heart-warming tales, positivity, distraction, connections (both new and old), and happily shone a light on our NHS heroes in their darkest hour.' **JO**

'It is beautiful, and my family and I will truly treasure it, such a thoughtful gesture during such challenging times.' **HANNAH**

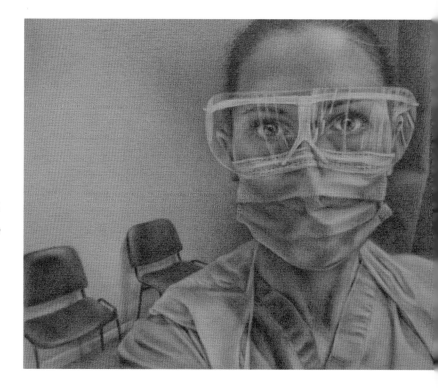

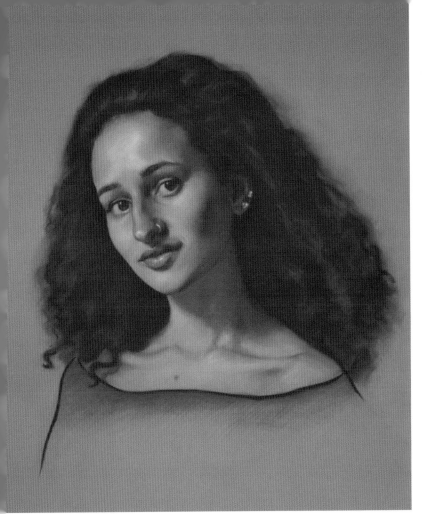

ELSIE CHAFULUMIRA
by PETER STALDER

GRAPHITE AND PASTEL ON TONED PAPER | 29 × 21 CM

'Elsie Chafulumira Sazuze was a nurse based in Birmingham. Sadly, she passed away from the complications caused by Covid-19 in early April, becoming one of the first care-worker victims of the virus in the UK. Nurses were amongst the most vulnerable and worst-hit group of workers at the start of the pandemic. Elsie, who came originally from Malawi, "always dreamed of being a nurse" and "she understood the risks of working on the front line but was happy to help people". This portrait was drawn as a gift to Elsie's family and as a tribute to her courage, to NHS staff, and to the devoted nurses around the world who have been putting their lives at risk on a daily basis to care for others.' PETER

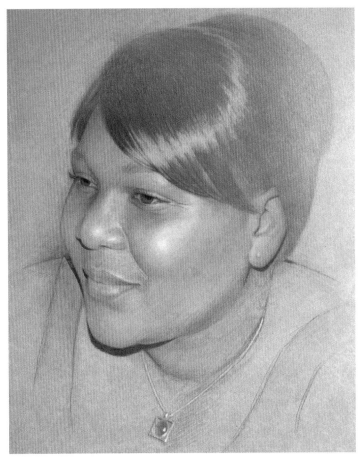

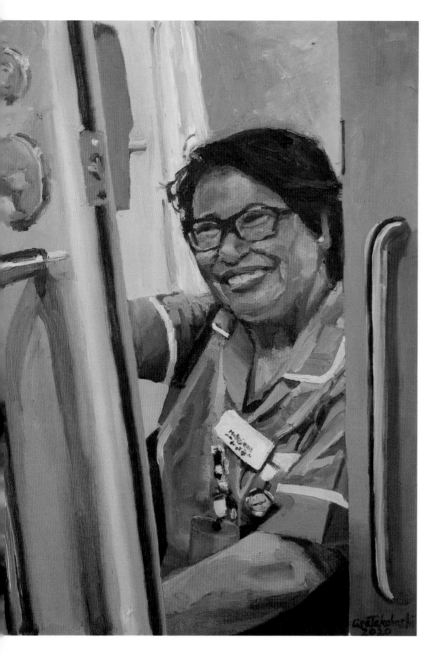

MELUJEAN BALLESTEROS
by LISA TAKAHASHI

OIL ON CANVAS | 30.5 × 25.4 CM

'I was paired up with Melujean Ballesteros, who had tragically passed away having contracted Covid-19. I had the privilege of speaking with a close friend and colleague of MJ, who told me all about her – a kind, warm lady who made you instantly feel like part of a family, the most professional nurse who was the best at putting in cannulas and famed for her incredible cheesecakes. The funeral procession passed by St Mary's Hospital, where she worked and where she died. I was sent a video and saw all her friends standing outside the hospital as she was driven past, my portrait being held by the hospital entrance. Although I never knew MJ the process of painting this portrait made me feel I could glimpse into her world. Her passing is a great tragedy and one that has brought grief to all who had the privilege of knowing her – by all accounts she brought kindness and warmth to everyone she met. Painting her portrait was a huge honour for me. If it helps people to remember those who have risked and sacrificed so much during this pandemic then my work is done. It is by far the most important painting I have ever made.' **LISA**

DR GANES by ANDREW HINGSTON

OIL | 42 × 30 CM

'I really enjoyed giving something back to the heroes at the NHS for everything they where doing. Especially Dr Ganes, who has come out of retirement to help out. Thank you.' **ANDREW**

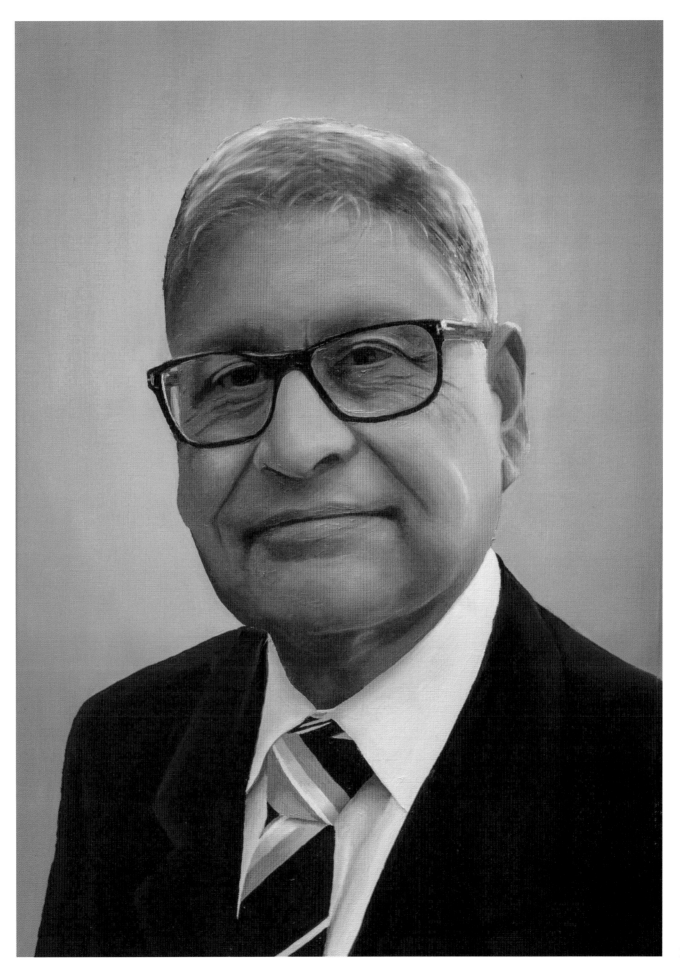

135

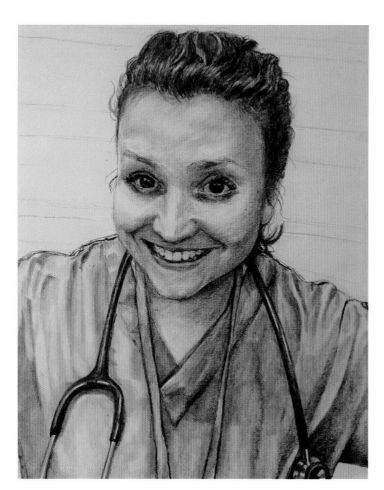

DR KATIE ROGERSON by KATIE PATEL

GRAPHITE PENCIL | 29.7 × 21 CM

'What an honour to draw Katie, an NHS inspiration and friend. As well as fulfilling her role as paediatric doctor throughout the pandemic, her insightful communications as co-director of @nhsmillion have brought comfort and understanding to many in difficult times. To me, her smile in this picture represents hope. It's been a privilege to be part of such a special initiative recognizing our heroes.' KATIE PATEL

'I was so touched to receive this incredible drawing. I think Katie has managed to capture the upbeat nature we need, in order to battle through what the NHS throws at us. It helps me remember in the tough days that I also have incredibly happy, joy-filled days at work and am so privileged to be able to offer care to my patients. I love this initiative in recognizing NHS staff. I hope it means more will realize they matter, and stay in the NHS. I am proud to be one of them.' KATIE ROGERSON

SUKHDEEP by DANNY BRANSCOMBE

DIGITAL PENCIL | 40 × 40 CM

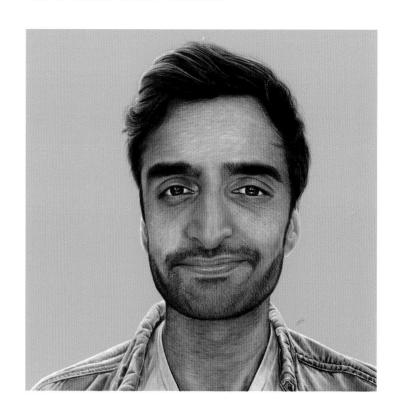

DORCAS BOAMAH by SARAH HARVEY

GRAPHITE ON PAPER | 48.3 × 32.9 CM

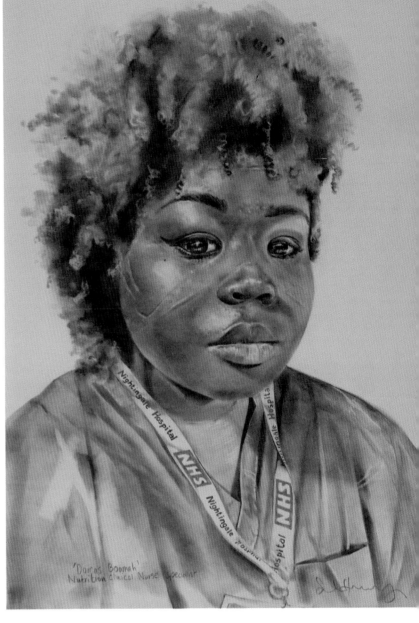

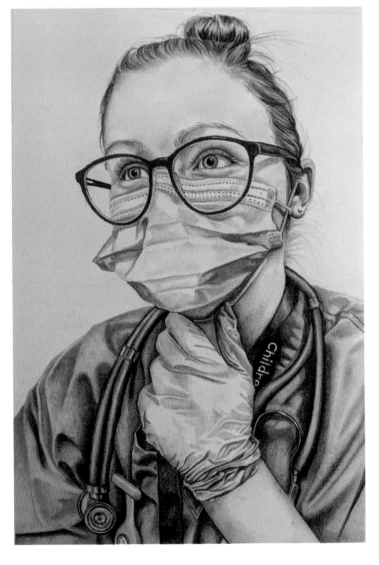

TILLIE FARMAN by AMY CARTER

CHARCOAL ON PAPER | 29 × 21 CM

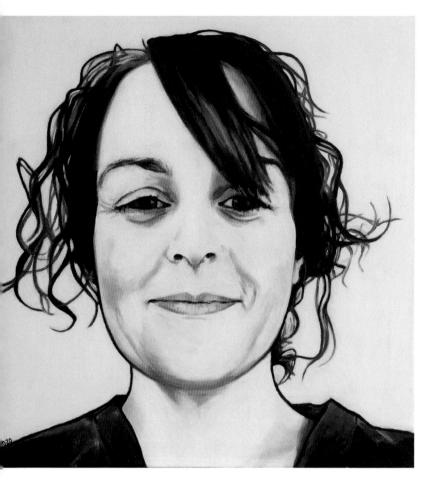

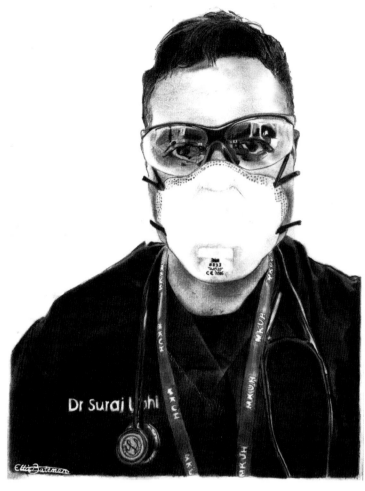

EMMA McLAUGHLIN by RONA

OIL ON CANVAS | 61 × 61 CM

'I was so pleased when I was paired with Emma, an anaesthetic and ICU doctor for NHS Lothian. She emailed me several photos with and without PPE and I fell in love with the freshness of the one I decided to use. I've been painting portraits and people in black-and-white oil for over thirty years, and during this Covid pandemic I was keen to take part in this great initiative.' RONA

DR SURAJ UBHI by ELLIE BATEMAN

GRAPHITE PENCIL | 29.7 × 21 CM

'I am so honoured to have been a part of the Portraits for NHS Heroes project. The NHS are doing an amazing job day and night, and we just can't thank them enough. Suraj Ubhi is the junior doctor I had the pleasure of drawing. He works at Milton Keynes Hospital in Bedfordshire. I chose to create a black-and-white pencil drawing, as I find this medium to be bold and extremely striking. This effect stands out much like Suraj, who risks his life, especially in these uncertain times, to help those in need. I want to say a massive thank you to Suraj and the NHS for all your hard work, and I hope this project shows just how grateful we are to have you.' ELLIE

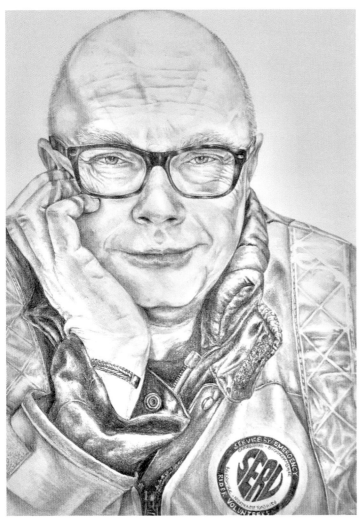

DAVID WILLIAMS by SUE SIDE

GRAPHITE | 25 × 18 CM

'David is a volunteer motorcycle rider, driver, controller and occasional fundraiser for SERVOBN: Service by Emergency Rider Volunteers for Ox, Bucks, Berks and Northants. The charity relies on an amazing group of people to deliver such things as blood, platelets and bone marrow samples to where they are most needed. It has been on call 24/7 throughout the pandemic, servicing hospitals and care homes. David modestly fails to mention he is also a full-time head of science and a stone sculptor. His quiet commitment to helping others whilst doing a full-time job is more than worth shouting about. I hope my portrait does a little of that.' SUE

SARAH MISTRY
by MERLIN BATEMAN-PARIS

COMPRESSED CHARCOAL ON PAPER | 84 × 60 CM

ASAM by MARNA LUNT

COTTON, LINEN, WOOL AND SILK THREAD ON COTTON | 15 × 15 CM

'When I create work with thread I approach the piece exactly as if it were paint. I see the thread simply as an alternative medium to watercolour or oils. I think about the layers, tones, values. I enjoy the mark-making and textures that the thread brings, and want them to mimic the brush strokes and paint textures I would usually build using oil paint. I am not looking to make a traditional embroidery picture: I want blocks of thread to create movement and a tactile surface. The aim of the game is to create portraits that make you look twice, that make you want to reach out and touch them, that challenge your traditional expectations of portraiture to question materials, mark-making and the tactile nature of both.' MARNA

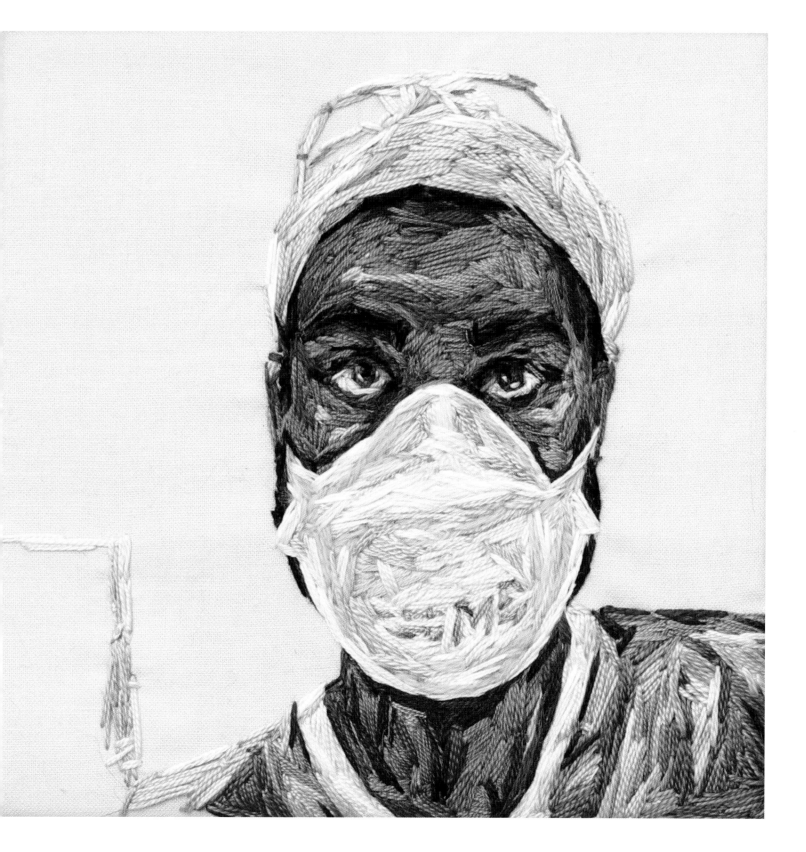

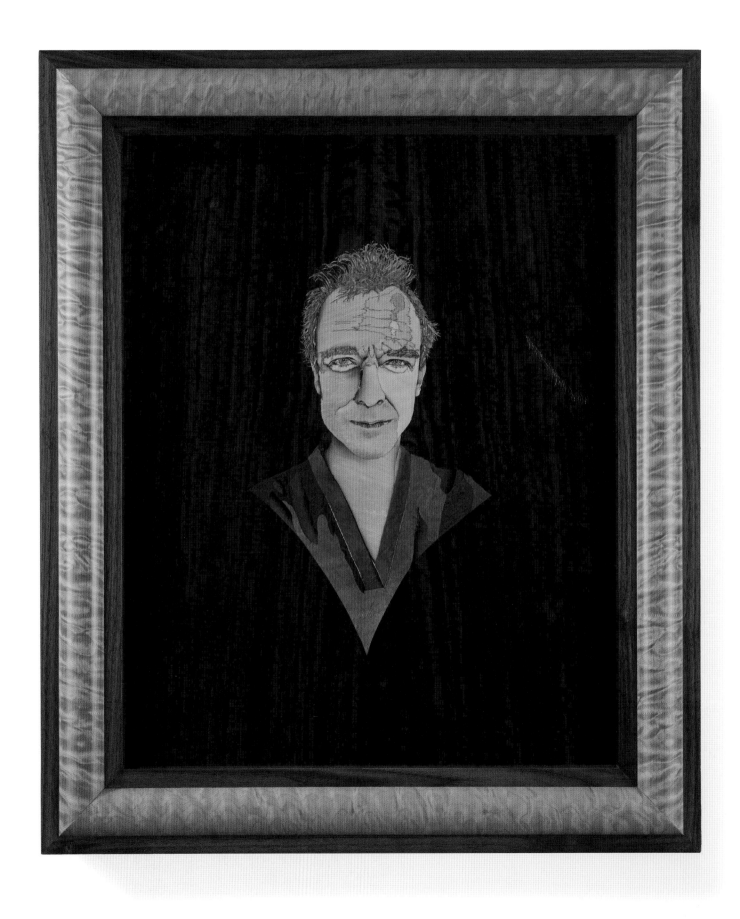

SAMUEL TURNER
by THE WHEATHILLS TEAM

1000S OF PIECES OF TIMBER MARQUETRY | 67 × 59 CM

'The marquetry portrait is of renal transplant surgeon Dr Samuel Turner, who was temporarily redeployed at the beginning of the pandemic to run a dedicated Covid-19 ward at Southmead Hospital in Bristol. It depicts Dr Turner aged 39, immediately after a long and arduous hospital shift, and fully conveys his fatigue and dishevelled appearance following the removal of his medical mask.

The 2-feet-tall portrait in micro-marquetry was based on an amalgam of Dr Turner's selfies and is a collaborative work composed by a trio of artists based at Wheathills, a creative hub in Derbyshire that specializes in making works of art marquetry, the art and craft of using wood veneers to form decorative patterns and pictures.

Made entirely from thousands of minute pieces of timber sourced from twenty different species, the image represents a total of four hundred hours of work by traditional and digital artist CAROLYN HARDY, marquetry specialist BYRON MOXEY and French polisher, cabinetmaker and artistic director NIGEL HELDREICH. Each member of the collaborative team worked in isolation: a challenging experience caused by national lockdown.'

BETHAN LINSCOTT by DAVID WILLIAMS

ANCASTER LIMESTONE | 38 × 32 × 10 CM

'In April 2020 Beth volunteered as a patient on the Oxford Covid-19 vaccine trials, risking her own health to save others and to further medical research. Meanwhile, in lockdown, she offered her services as an unpaid motorcycle courier for those unable to leave their homes as well as writing about her own research and her experiences on the vaccine trials as a STEM ambassador for schools. I was delighted to honour Beth's selflessness with a portrait in stone.' DAVID

AARON by KAREN TURNER

PENCIL ON PAPER | 30 × 22 CM

'Aaron is a deputy charge nurse on a respiratory ward at Pilgrim Hospital in Lincolnshire and was nominated by his wife Kylie.' **KAREN**

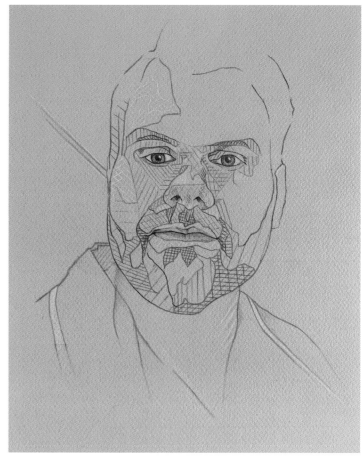

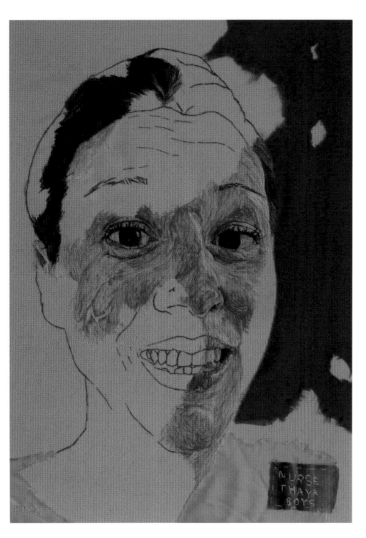

THAYA BOYS by EMILY TULL

HAND-STITCHED THREAD PAINTING | 35 × 25 CM

'I was blown away talking to Thaya. She is not only a mother, but also a community nurse who was also studying. Many of her days off were spent not with her family but on her old intensive care ward. This portrait captures the smile she says goodnight to her children with whilst on the ward.' **EMILY**

'Emily created my portrait in a very poignant time in my life. I have never experienced nursing like I did at that time and I hope I will never do again. I am only one of many nurses and key workers who are exhausted, but we are still dedicated and here to help everyone. The portrait is pretty amazing – so much detail and depth. I am really grateful Emily took the time to produce it for me.' **THAYA**

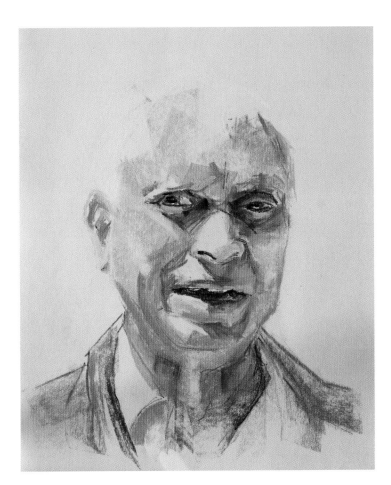

DR BOSE by CAI JIA ENG

CHARCOAL ON PAPER | 28 × 21 CM

'Dr Bose, my father, formally retired in 2018 but offered help during the current crisis. The family aren't too keen for him to plough straight in, but he doesn't see it that way. He arrived in the UK from India in the early seventies after his training. In those days GPs were on call 24/7, and I remember my dad frequently getting up in the middle of the night to visit patients. He would then run a full surgery the next day. Such devotion made him popular with his patients, and many he treated as newborns grew up to have families of their own whom he also looked after. His dedication inspired my brother and me to go on to join the NHS.' **KIRAN CHITRAPU**

DR G by CHRISTA HOOK

WATERCOLOUR | 42 × 30 CM

'It was a privilege to paint Dr G, an anaesthetist who works in intensive care at the forefront of this crisis – a dedicated worker going through difficult times and a loving family man. His wife, who commissioned the work, said it captured his two sides.' **CHRISTA**

DR LIZY TOWNSHEND by RUTH FILDES

OIL ON CANVAS BOARD | 20 × 20 CM

'Lockdown has given me a change of time and space to engage with my own artwork. It is hard to put into words how it feels to be able to say a heartfelt thank you to those who have worked tirelessly throughout this difficult period of time in all our lives. To be able to express my gratitude not only with words but through the powerful medium of art is so very special. I feel privileged to have been able to paint the amazing and beautiful Dr Lizy Townshend and I am thrilled that the painting is already hanging proudly in her mother's home.' RUTH

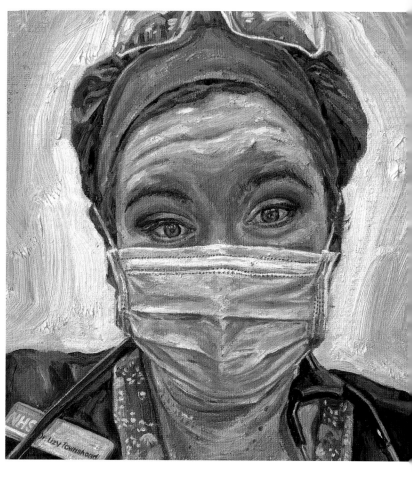

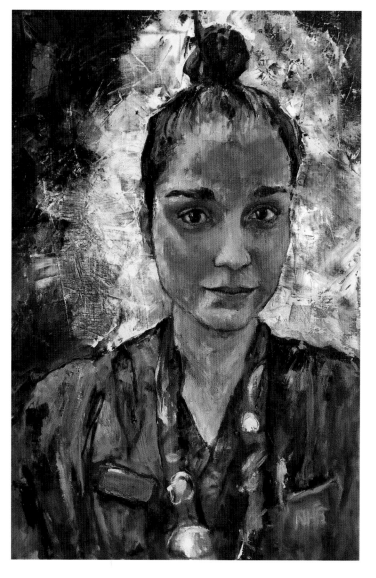

LUCÍA CASTRO by JULIE GALANTE

OIL ON CANVAS | 60 × 40 CM

LUCY SAMUELS
by JONATHAN ARMOUR

OIL | 25.5 × 19 CM

'My pleasure to be able to say thank you to Lucy for her commitment during the pandemic when her urology ward at QE Hospital in Edgbaston was changed over to cope with incoming Covid-19 patients. This Portraits project has connected nurses and artists across the country, resulting in a wider understanding.' JONATHAN

'Unfortunately the days of being a hero have passed. Now I'm not even a nurse, just a number on a spreadsheet, because that's how it feels, as they're redeploying everyone and I'm being moved from the job I love for no better reason than which division holds which budget.' LUCY

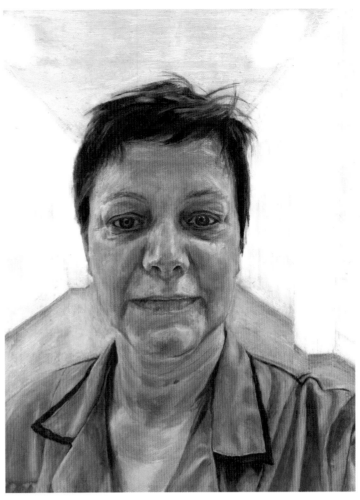

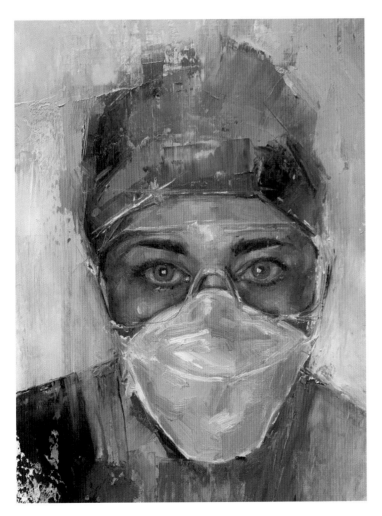

CORINA by NIKI TONG YUK YING

OIL ON CANVAS | 29 × 19 CM

'I am honoured to paint Corina, who is working on the NHS front line. I was moved when I heard her story, as she had to self-isolate from her daughter because of her job. The portrait was a gift to surprise her once they were reunited. I would like to say thank you to all the NHS workers who support their patients in this difficult time.' NIKI

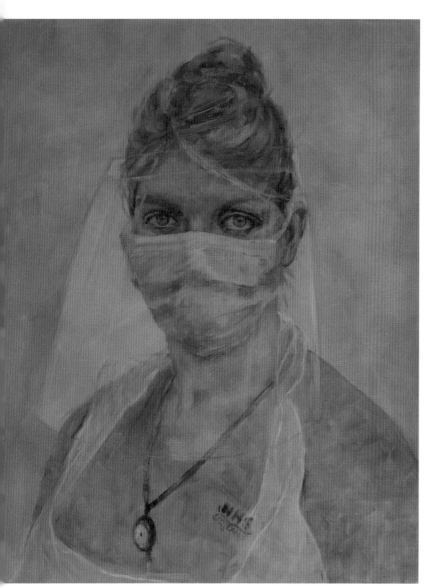

KIRSTY SWORDS by JOAN PRICKETT

OIL ON CANVAS | 51 × 40.5 CM

'Years ago I worked in the NHS as a nurse and midwife, so being unable to help in any practical sense during the pandemic felt very distressing. Tom Croft's initiative helped reignite my enthusiasm for painting and had me realize I could do something of worth after all. Community health workers like Kirsty are continuing their hands-on work with patients in their own homes, whether or not their patients tested positive for Covid, despite having less-than-perfect PPE. How courageous, caring and dedicated. These portraits are symbolic of the esteem with which the general public have held NHS key workers during this challenging time. I hope their vital work is recognized long after this pandemic is a mere memory.' **JOAN**

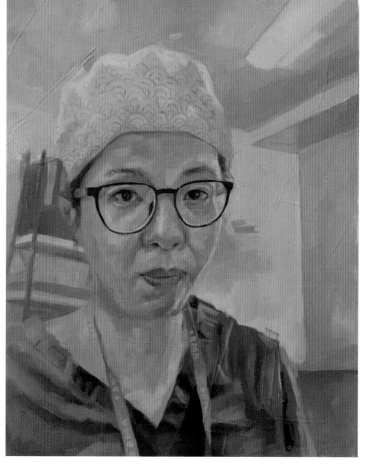

CK by CARYN KOH

OIL ON CANVAS | 26 × 20 CM

'CK is an elderly care consultant working in one of the hospitals in the north-west. I have always admired her intelligence and strength.' **CARYN**

'The Covid-19 pandemic has changed our lives completely. Every day is a challenge and also a blessing as we are still here for each other. Thanks to my family, friends and colleagues who have taken care of us and have tried to make such difficult times easier for us.' **CK**

LAURA by CAROLINE KANNREUTHER

OIL ON CANVAS | 24 × 20 CM

'Laura, an anaesthetic registrar, moved to ICU during lockdown, often working through the night and all the time juggling her roles. Being a mum to two young children was something we had in common and we bonded over the challenges of home schooling. I know that Laura enjoyed the whole portrait process and I very much enjoyed making direct contact with one of our NHS heroes. We chose to paint the portrait from a photo taken by Laura's husband, at home, out of her scrubs.' CAROLINE

'My 2-year-old boy was so excited when I showed him the picture. "Look, look, it's you Mummy!"' LAURA

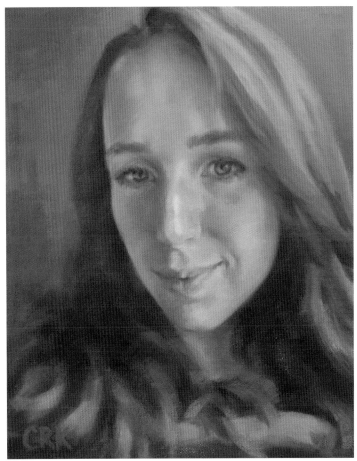

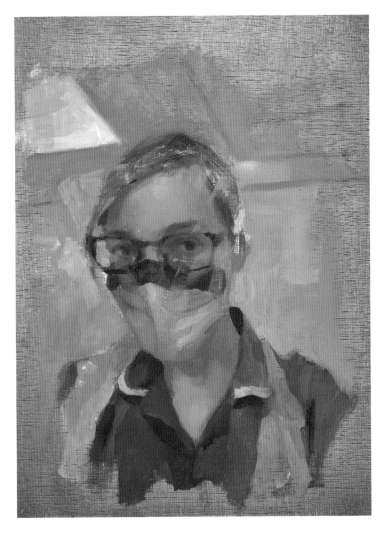

AMY by SOPHIE M. COOK

OIL ON PANEL | 25 × 21 CM

'Amy works as a paediatric nurse in Worcestershire Royal Hospital. I was struck by the intensity of her gaze and the saturated colour of her blue uniform. I also liked the perspective of the image; Amy appeared to be looking down at a patient with the yellow glare of hospital ceiling lights surrounding her head. I wanted to paint Amy in a moment of self-reflection during what must have been an incredibly challenging and emotional environment.' SOPHIE

HELGA FOYSTER by LYN AYLWARD

OIL ON CANVAS | 51 × 41 CM

'Helga is an infection prevention and control nurse. She was on the front line at the beginning of Covid screening in full PPE, never feeling worried for herself, but knew right from the start how serious this outbreak was. Helga said that she was working long hours, even when her young daughter was ill, having to put work first to safeguard staff and patients as they got ready for more NHS services. She said that having her portrait painted supported her when she needed a boost, and it was lovely to share a different side of her with work colleagues, friends and family. As an artist, I found the initial feeling of helplessness during the outbreak hard to deal with and getting involved in the Portraits for NHS Heroes project a perfect chance to give something back to those who work tirelessly to keep the public safe.' LYN

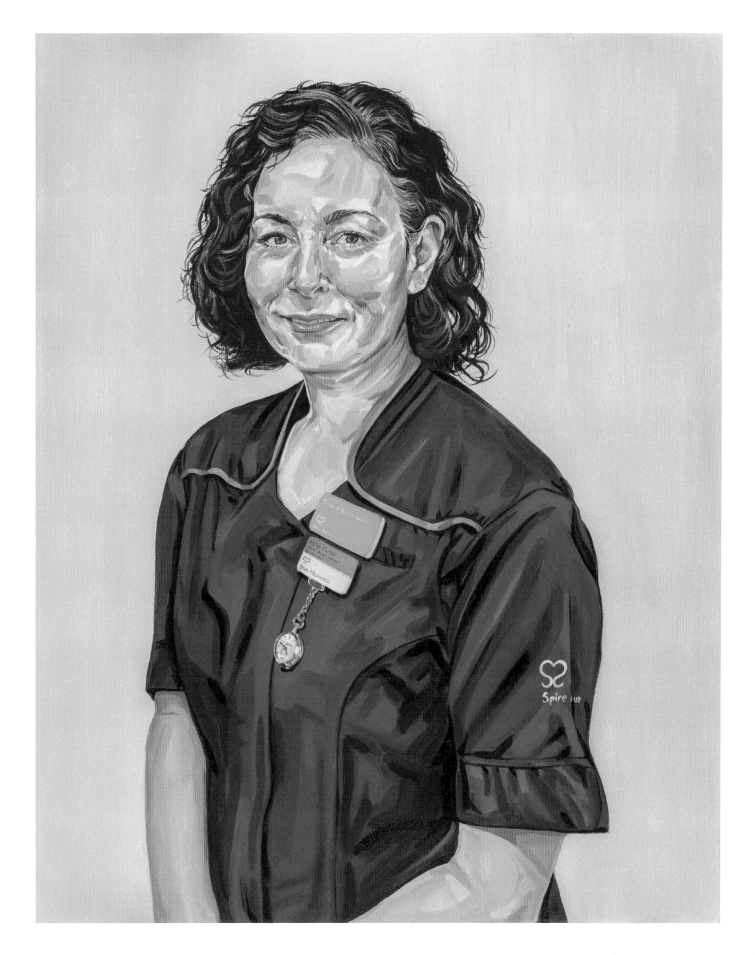

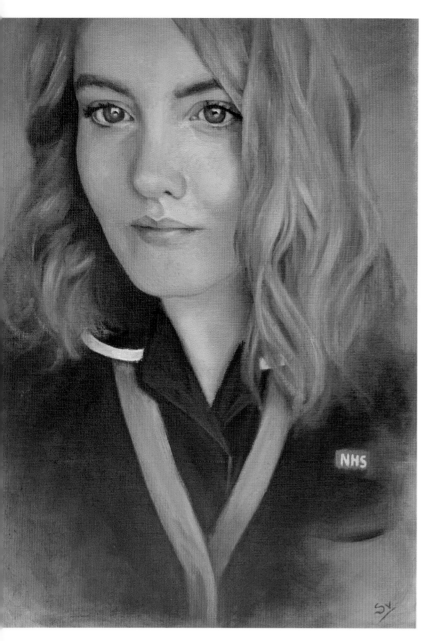

CHARLOTTE COOPER
by TEREZA BARNARD

OIL ON ALUMINIUM BOARD | 42 × 29.7 CM

'I am a neonatal intensive care nurse. Working throughout the pandemic was a totally new experience for us all, bringing new challenges every day, but together as a team we have achieved so much. It is a part of our careers that we will remember forever. It was an honour to be a part of this project and I will cherish it always.' **CHARLOTTE**

SANDY by SVETLANA SEMENOVA

OIL ON CANVAS BOARD | 35 × 25 CM

'This image makes me feel proud to be a nurse. On the day lockdown was announced, I had started my new role as specialist community nurse, and the pressure to protect patients felt overwhelming. These worrisome times have also shown many acts of kindness: we have had face masks and laundry bags hand-made and donated to us; local food outlets have provided meals for us; and a wonderful collective of artists gave up their time to create the most fantastic pieces of art of us. My portrait will always hold a memory of the resilience, compassion and determination the NHS has to succeed, and I am proud to have been a part of that.' **SANDY**

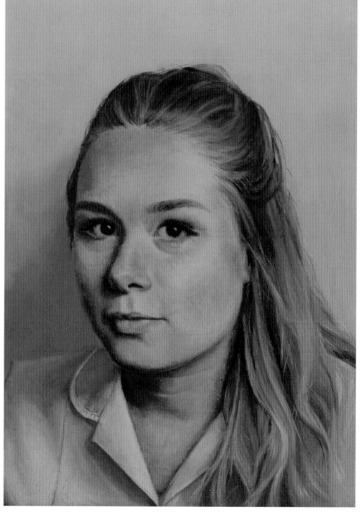

SARAH by LOUISE VINCENT

OIL ON CANVAS | 50 × 40 CM

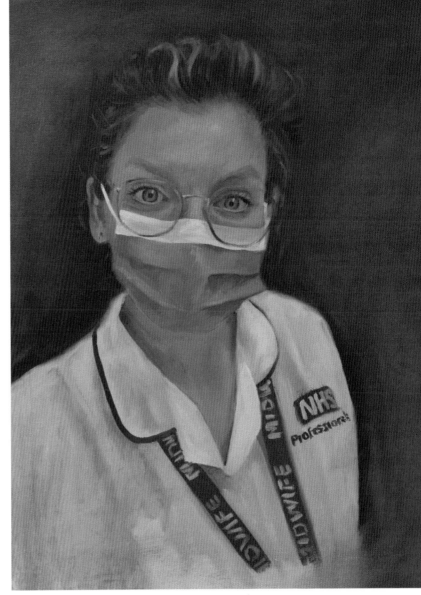

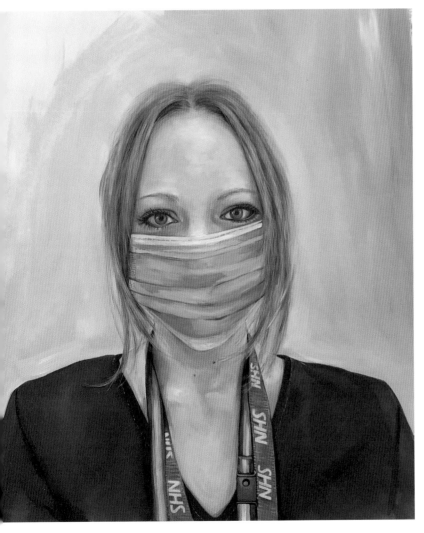

BEE by KATIE JONES

OIL | 40 × 30 CM

'Bee is an NHS nurse working in Camden Town, London, with vulnerable adults and the elderly. She went back to college and completed a nursing degree whilst her youngest was 3 years old and her eldest 5 years old. What a woman!'
KATIE

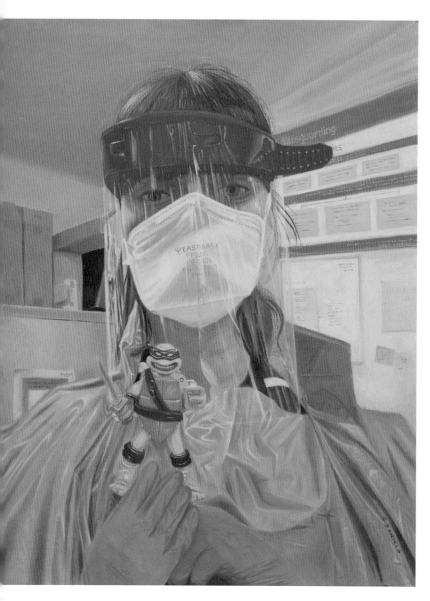

NURSE GRACE DANIELS
by STEVE DANIELS

OIL ON PANEL | 50 X 40 CM

'For my first hero portrait I felt compelled to paint Grace, my superhero daughter, who graduated last year as a mental health nurse after previously earning a degree in psychology. Grace works with superhero energy with her colleagues at Leeds Seacroft Hospital looking after the needs of people with eating disorders. I included the Teenage Mutant Ninja Turtle toy in the painting after my son observed that Grace's red face shield resembled Raphael's red bandana. The replacement of one of Raphael's weapons with a little bottle of hand sterilizer seemed fitting for the times, and reinforced with humour the good practice necessary in the battle against Covid-19.' **STEVE**

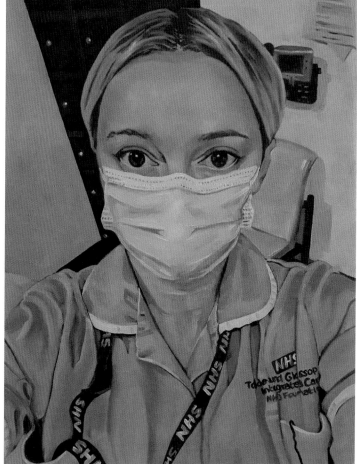

STEPHANIE by ALLISON WILD

OIL ON CANVAS | 30 × 23 CM

'Stephanie is getting ready for her shift at Tameside and Glossop Integrated Health.'
ALLISON

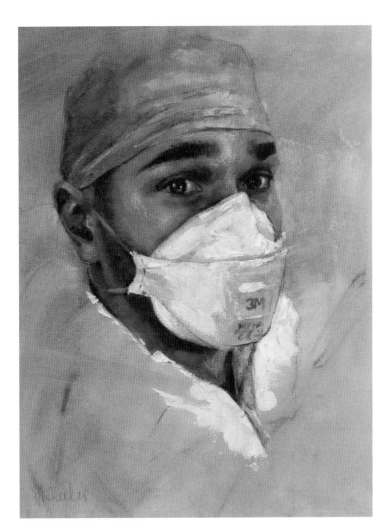

ROGER by HANNAH WHEELER

OIL SKETCH ON CANVAS | 45 × 35 CM

'I kept it as a simple oil sketch. It felt appropriate in the rapidly developing events that the portraits would be loose and painterly; scratching into the surface and using quick strokes of a palette knife to reflect the transient nature of the situation we found ourselves in.' **HANNAH**

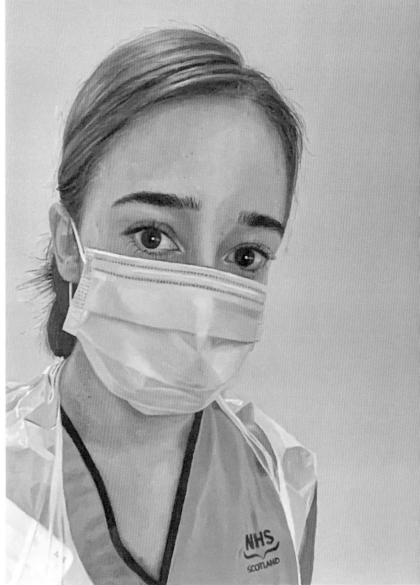

BETH by LES DONAGHY

OIL ON PANEL | 40 × 30 CM

'When Covid broke, the support for all NHS staff was amazing. As a former NHS worker, I understood that more experienced workers would take this in their stride, but my thoughts went to the new workers. Beth, at the time, was a newly qualified midwife. She spoke of the long hours, and the tasks involved in taking care with births, before they had instituted separate wards for Covid-19 patients. For one so young, she took this in her stride. I wanted to be able to mark her sensibility and bravery with this portrait.' **LES**

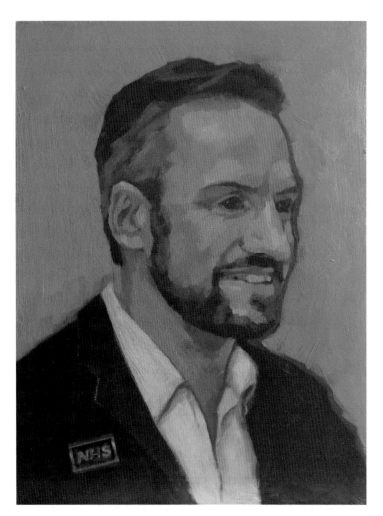

ANDREW by SIOBHAN WARD

OIL ON WOOD PANEL | 30 × 23 CM

'I work as an NHS speech and language therapist, but I am also a keen portrait painter. When I learnt about this project I wanted to participate as it combined two things which are close to my heart. Andrew told me about his role in supporting the distribution of oxygen to NHS Trusts across England. He sent me some pictures to work from and made a request for me to include his rainbow NHS badge, which he wears with pride at work, not only as a symbol of pride for the LGBT+ community but now also a symbol of hope in the fight against Covid-19. Andrew put it so well when he commented that "this project has given the NHS a face, in fact many faces" and I feel privileged to have been able to paint one of the many people who make up this incredible workforce.' **SIOBHAN**

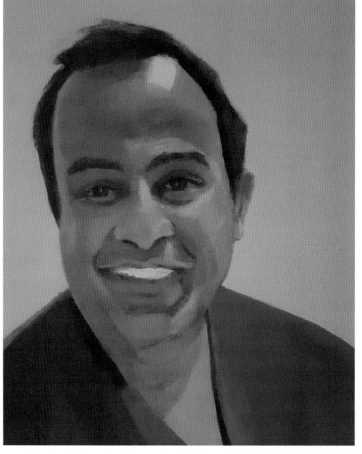

RAJ by ELIZABETH LAKE

ACRYLIC ON CANVAS | 40 × 30 CM

'Dr Raj Sekhon is part of a coronavirus "hot site" team assessing and treating suspected Covid-19 patients at Leatherhead Hospital to ease the pressure on A&E departments, as well as being a GP trainer.' **ELIZABETH**

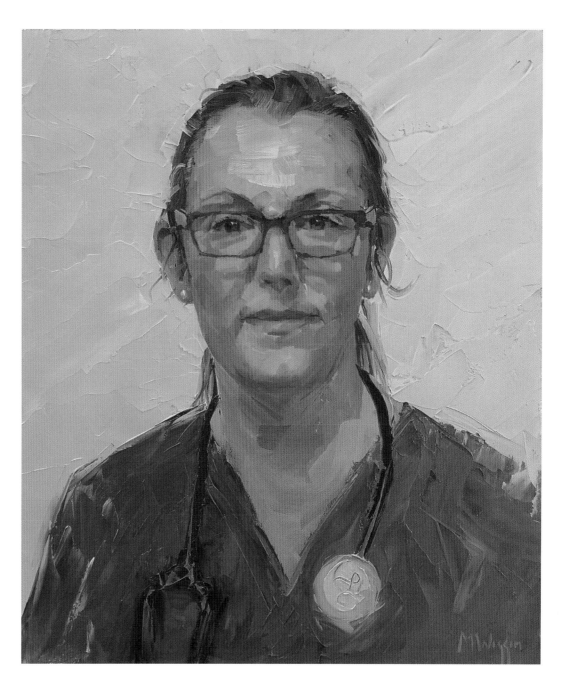

DR CLAUDINE ANSTEAD
by MARK WIGGIN

OIL ON WOODEN PANEL | 43 × 36 CM

'As I proceeded with this portrait I tried to comprehend and express the enormous demands of balancing her working life with that of her family, to capture the portrait of a real NHS hero.' MARK

'Working through the Covid pandemic was one of the toughest parts of my career. I was really struggling emotionally when a friend nominated me to have my portrait painted. Little did I know what an amazing experience this would be. Mark took the time to get to know me and this is reflected in my portrait: the emotion involved for both of us is evident. He managed to capture my fear, and yet at the same time my resolution. I feel truly blessed that Mark painted me. Thank you is just not enough.' CLAUDINE

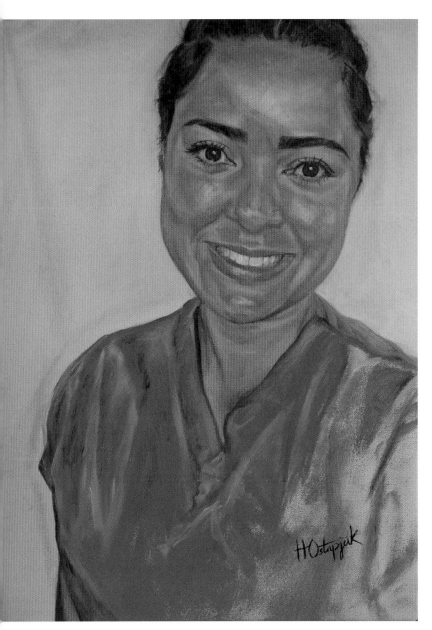

BLUEBELL by HANNAH OSTAPJUK

OIL ON CANVAS | 30.5 × 25.4 CM

'Honoured to paint Bluebell, there's a glow about her, a brilliant light that shines from within. That strength and beauty is what I aimed to portray as that represents Yorkshire and the wonder of doctors, nurses and key workers all over the world who have been forces of nature throughout this crisis.' HANNAH

'My job can be very stressful but seeing people recover, smiles returned, families reunited, lives touched, is a fresh reminder of why I'm a nurse. For every patient suffering in their hospital bed I make the most of my own life, go a little further, enjoy the simple things and feel blessed for what I have.' BLUEBELL

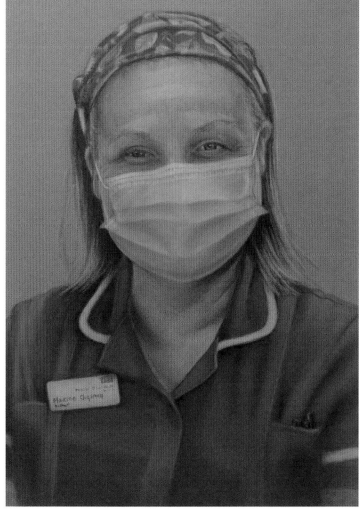

MAXINE CHAPMAN by DOTTY EARL

PASTEL | 29 × 20 CM

'Maxine is a sister on Creaton Ward, Northampton General Hospital NHS Trust.' DOTTY

MEGAN CAVANAGH by ROSIE MARK

ACRYLIC | 30 × 24 CM

'Megan is a student nurse at Aintree Hospital near Liverpool. Her emails of what she and her colleagues were dealing with were stark. We agreed on this powerful image following a very emotional shift on a red (coronavirus positive) ward at the height of the pandemic. She was physically and emotionally drained and I felt her eyes told the story of what she had just been through. Since her portrait was completed, Meg has qualified and I'm sure will have a long and fulfilling career in nursing, being the compassionate and caring person she is. I loved Meg's comments in one of her messages, "There will be a rainbow at the end of the storm." We will be forever indebted to Megan and all NHS workers.' **ROSIE**

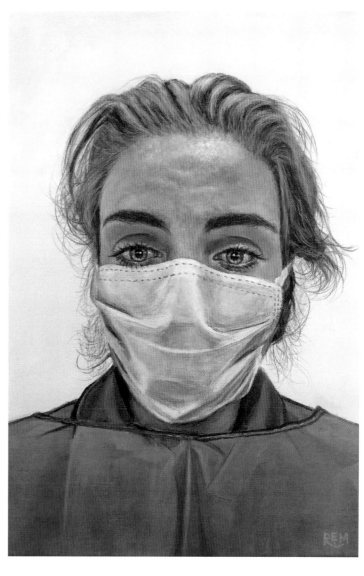

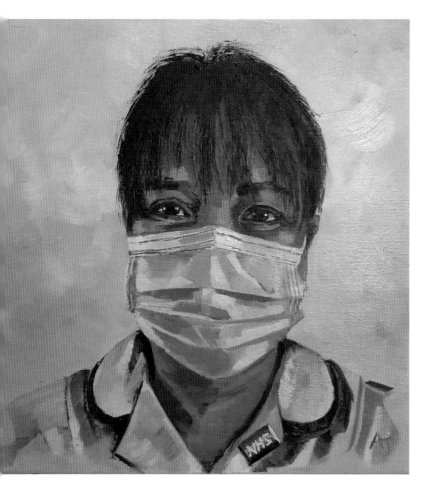

ARLENE DELOS SANTOS
by ANDREW JOHNSON

OIL ON CANVAS | 30 × 30 CM

KELVIN O'MARD by LUCILLE DWECK

OIL ON CANVAS | 51 × 41 CM

'I got involved straightaway when I heard about this project. I couldn't have been happier when I saw Kelvin: I instantly felt we were connected, and was excited to try to convey the deep humanity I saw in his face. He sent me photos to work from and I organized video sittings. My painting flew out of me. There was a socially distanced street party happening for the VE day celebration, but even in the middle of lockdown, when I was starved of social interaction, I ran away to continue painting. It was done quickly and Kelvin was delighted. He posted an image of it on his social media and said he had never had such a response from any other post. Kelvin is an amazing person who works with mental health patients. His astonishing warmth and understanding are reflected in his face.' **LUCILLE**

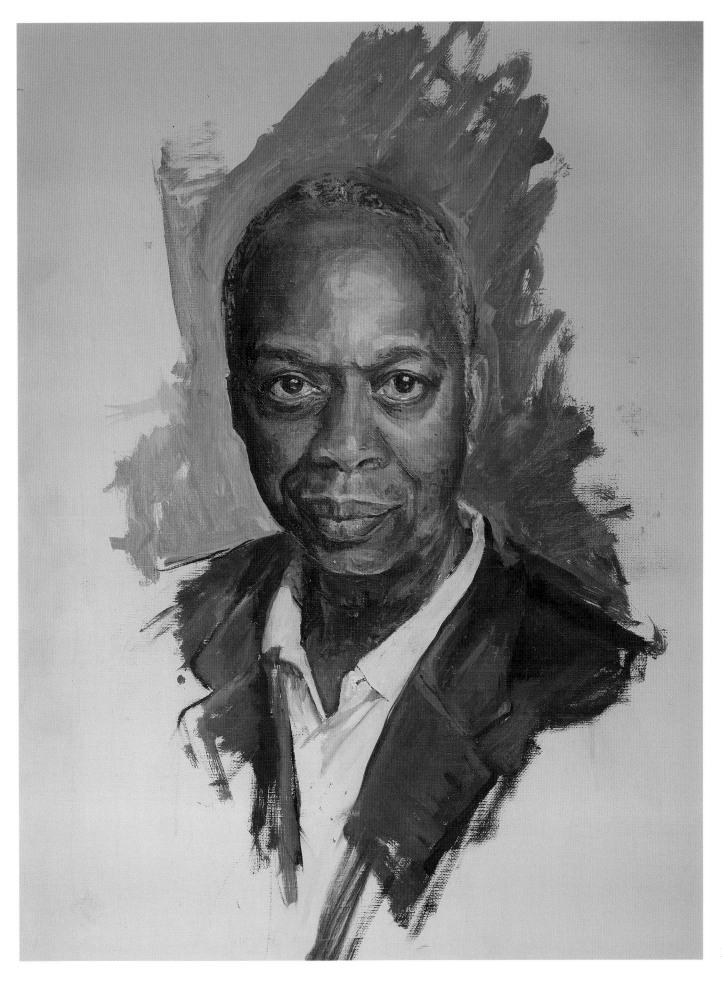

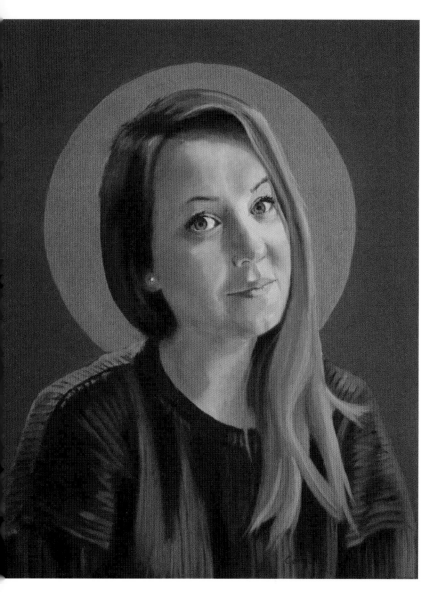

DARCELLE HALL by LISE POULSEN

OIL ON CANVAS | 60 × 40 CM

DR VICKI ROBERTSON
by ALAN CARLYON SMITH

OIL | 60 × 50 CM

'Vicki struck me as being a very dedicated and brave young doctor who, although working on a Covid ward, was not despondent or afraid. I found this to be very uplifting and inspiring. We talked about how she wanted to be depicted and she decided that she would wear her normal clothes. Painting the person behind a uniform is very important to me because it's individuals that matter. My interpretation of Vicki was to show her as an angel and an icon to society. Angels and icons have been painted by artists throughout history – during a world pandemic the images of NHS workers deserve to be raised to another level.' **ALAN**

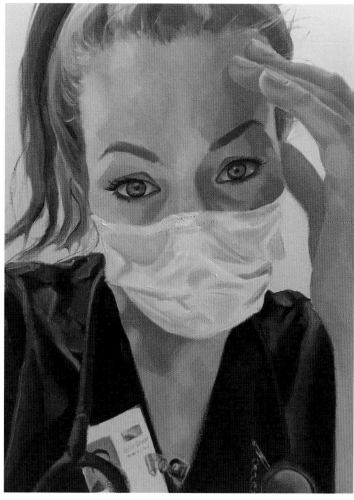

NAOMI by SALLY WARD

OIL ON CANVAS BOARD | 30 × 30 CM

'This is Naomi, a senior staff nurse who was deployed to work on a Covid-positive adult intensive care unit during the peak of the pandemic. She spent her time caring for extremely sick patients, wearing PPE for up to 13 hours a day. Naomi and I got to know each other a little over an online sitting. I was able to get a feel for Naomi's warmth and sense of fun. Despite the challenges she was facing, it is this warmth which I tried to capture. This initiative has enabled me to give something back to Naomi and the NHS during a time when it has been easy to feel helpless. The touching and overwhelming response to Portraits for NHS Heroes has demonstrated the power of art to bring joy in difficult times. It also provides an important historical visual record of those caring at the front line during the pandemic.' SALLY

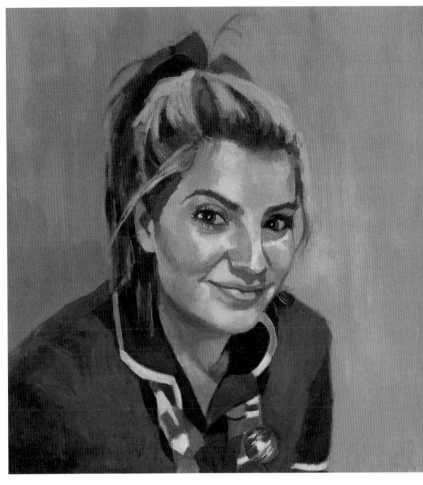

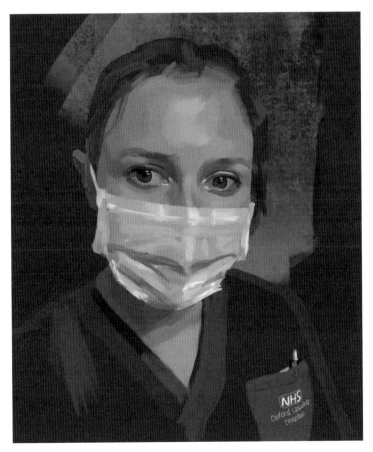

JENNA by ALASTAIR BROADLEY

DIGITAL | 38 × 30 CM

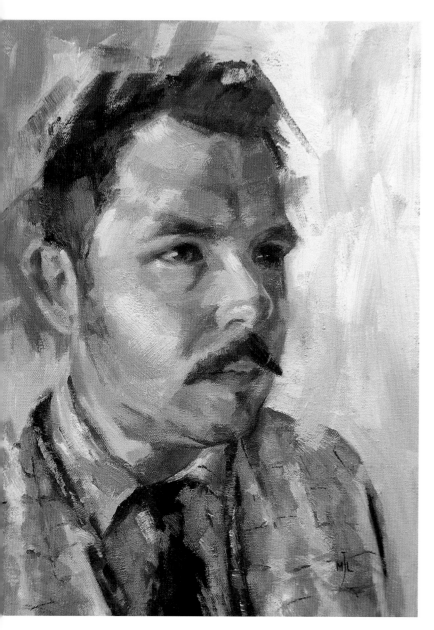

TOBY VISHOLM
by MICHAEL JULES LANG

OIL ON CANVAS | 40 × 30 CM

'Toby is a registrar in oral and maxillofacial surgery. Through the Covid pandemic he has stepped down to a junior role to cover for doctors who have been redeployed. During this time he has been treating patients for traumatic injuries to face and severe infections of the head and neck. Due to the need to wear a full face mask to operate during Covid, Toby shaved his beard down to a moustache with other doctors to raise money for NHS Charities.' MICHAEL

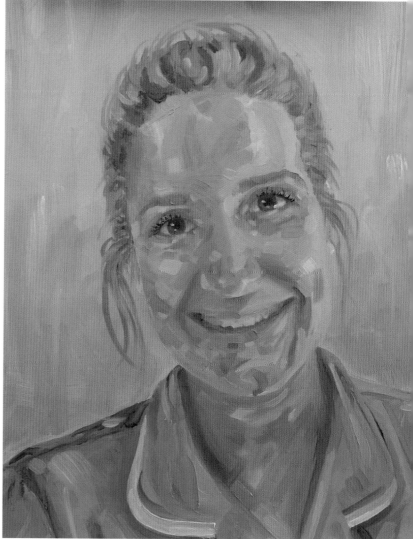

EMILY RUSSELL
by GEORGINA WESTLEY

OIL | 40 × 30 CM

ROBERTA JO PURBA by JO HAY

OIL ON CANVAS | 35.5 × 28 CM

'I am so glad that I could participate in thanking the incredible and brave NHS workers who continue to put themselves in harm's way every day. To paint a midwife during this pandemic that has taken the lives of so many seemed to have an extra layer of hope attached to it: thank you so much for your courage and compassion as you continue to assist mothers bringing new lives into the world at this really precarious time. It was an honour to paint you.' JO

'Captured exactly in the moment... I am overjoyed and honoured to have been painted during such uncertain times. It's been a small ray of sunshine for me and my family. Thank you Jo, and your wonderful art.' ROBERTA

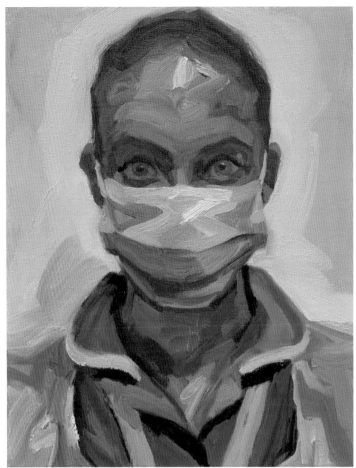

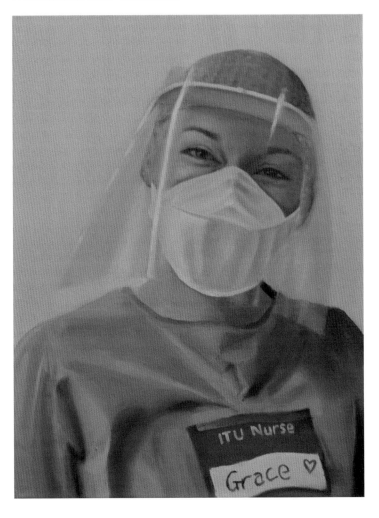

GRACE HARDING by HELEN THAIR

OIL ON CANVAS | 40 × 30 CM

'Grace is one of our hardworking nurses who has been at the front line during this pandemic on the large and busy ICU unit in Birmingham. It was a real honour to paint her, and so good and humbling to hear that this small contribution of my painting made a difference to her.' HELEN

'Thank you so much, it is absolutely stunning, just what I need to brighten up my day.' GRACE

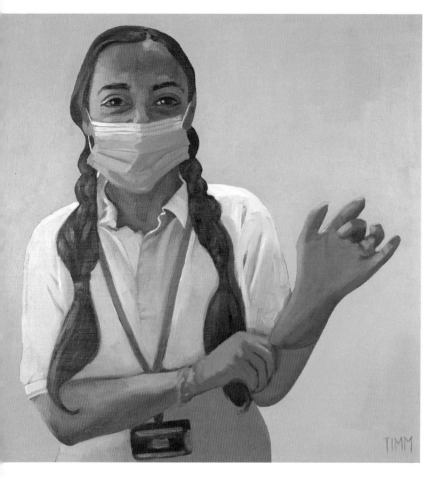

FUZZY by LISA TIMMERMAN

OIL | 50 × 50 CM

DR SMITA BHAT by HAZEL BLUE

OIL ON BOARD | 50 × 40 CM

'I feel so privileged to have been able to contribute to Tom Croft's Portraits for NHS Heroes initiative. Dr Smita Bhat was such a pleasure to work with and to paint. Her kindness shines through her face, and I hoped to capture that in this portrait. I have so much respect and gratitude for her and all the NHS workers who have worked so selflessly through this pandemic.' **HAZEL**

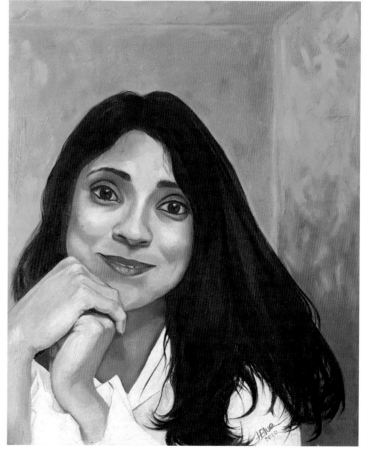

MADHAVI by TOM CHAPPLE

WATERCOLOUR, WAX PENCIL AND ACRYLIC ON PAPER | 49 × 34 CM

'With this portrait I wanted to see behind the PPE, to catch a personal moment between the life-saving efforts, to capture a breath of reflection and rest. Madhavi and her husband Parmesh had recently married. However, to allow Madhavi to continue to work on the wards, they were having to spend their first months of marriage apart. Therefore as well as being my muse for this portrait, we also find her musing on that separation – an outward look through an unseen window, a rare moment away from windowless wards, a brief opportunity to reconnect with the outside world and to reflect on how she misses her new husband. The original piece was sent directly to Parmesh as a gift in her absence.' **TOM**

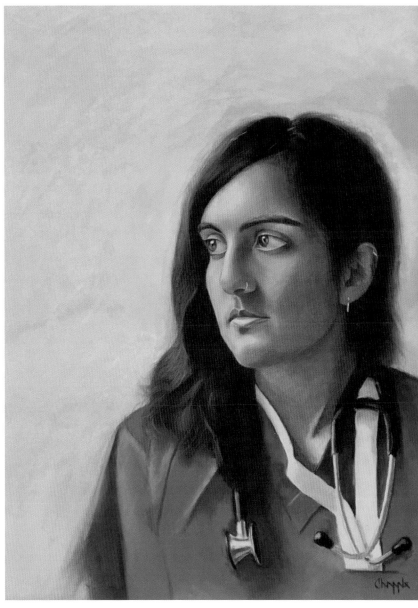

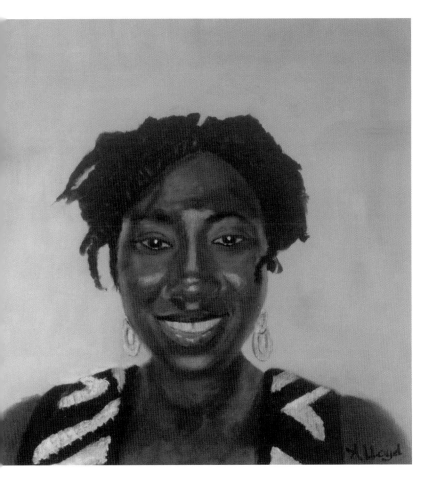

DR COLE by ADRIAN LLOYD

OIL ON WOODEN PANEL | 30 × 30 CM

'It was a real honour to paint Dr Cole: she has led and continues to live such an inspirational life. Originally from Sierra Leone and brought up in a religious family, Dr Cole began her career as a nurse but soon decided to become a doctor and is now a GP training other GPs.' **ADRIAN**

167

SUSAN by JAMES EARLEY

OIL ON CANVAS | 60 × 90 CM

'Susan is a nurse at St Bartholomew's Hospital in London. The NHS struggled enormously but showed heroism to battle this coronavirus against all odds. I wanted to create a painting that shows all sides of Susan, the happy, relaxed and easygoing side and the fearful side, knowing full well she was to fight on the front line against such a threat. It is this fear that I wanted central to the painting. Just behind Susan is a blurred figure – faceless, a monster, a threat, a virus. Almost invisible around the painting are the face masks that were not visible at the start of the pandemic but proved crucial in this battle.' **JAMES**

TASHA RAINSLEY by IAN GOLDSMITH

OIL ON PANEL | 30 × 24 CM

'I want to thank you so much for doing this, it really captured me and how I was feeling. You can see the marks from the PPE as I'd just come out of critical care. It's been a really amazing and challenging time and its been an honour to know how much effort, time and love have gone into this portrait. I am very proud, thank you.' **TASHA**

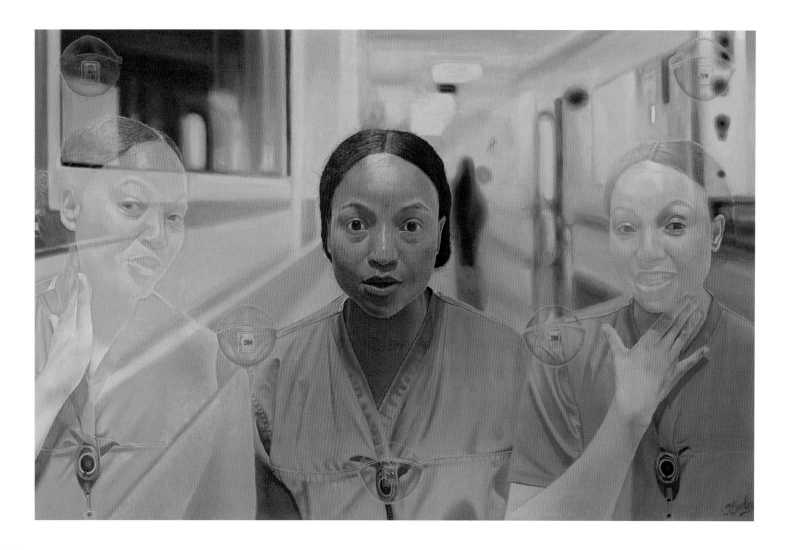

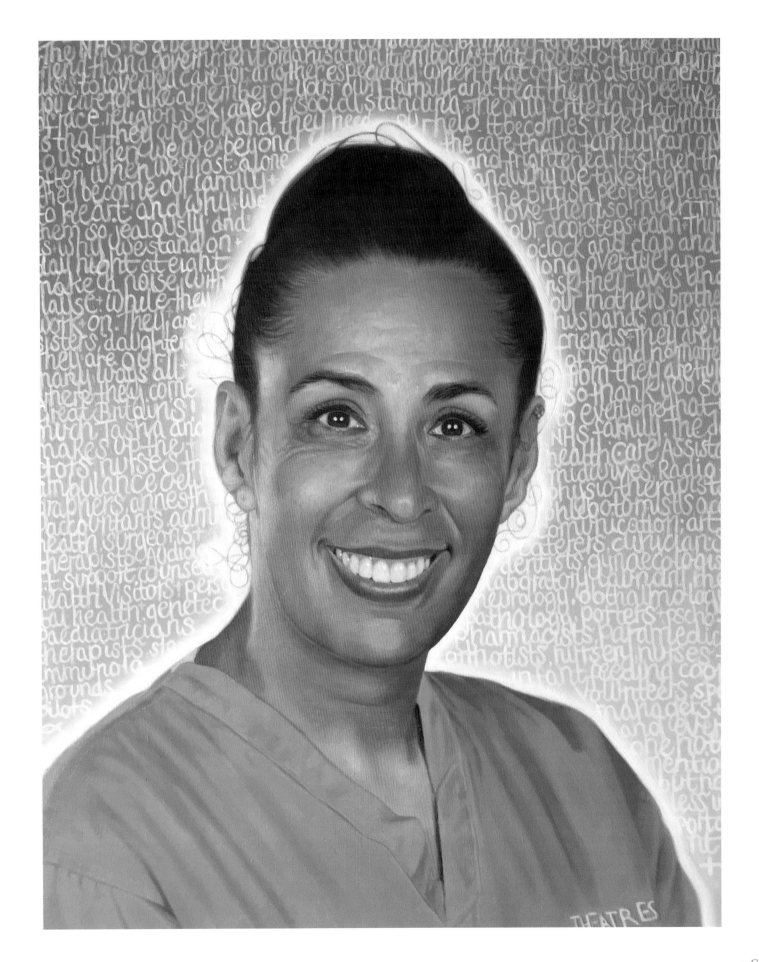

JOSEPH by HAYLEY SMITH
WATERCOLOUR PENCIL | 24 × 17.9 CM

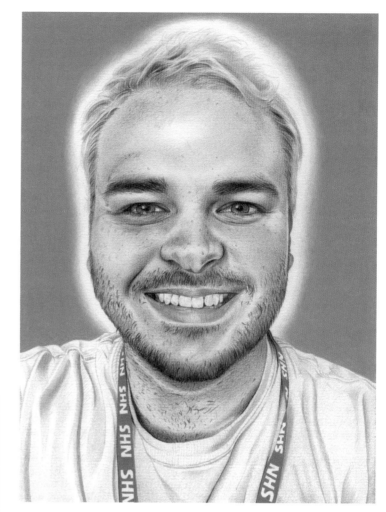

SARAH WINFIELD-DAVIES
by ELOISE WINFIELD-DAVIES
DIGITAL | 29.7 × 21 CM

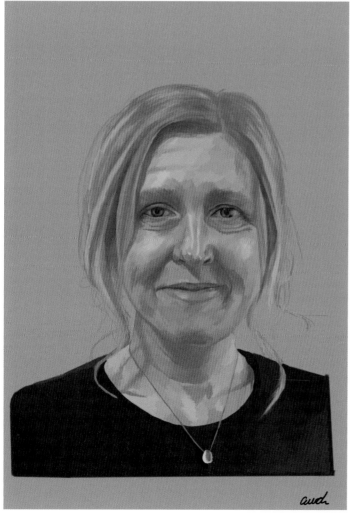

'This is my mum Sarah Winfield-Davies, who works as a safeguarding nurse in North Devon. During lockdown she also supported many of her community nurse and care-home colleagues while continuing to give her support to members of the Royal College of Nursing. She has worked tirelessly to ensure the safety and happiness of her patients throughout the pandemic and is my true NHS hero.' ELOISE

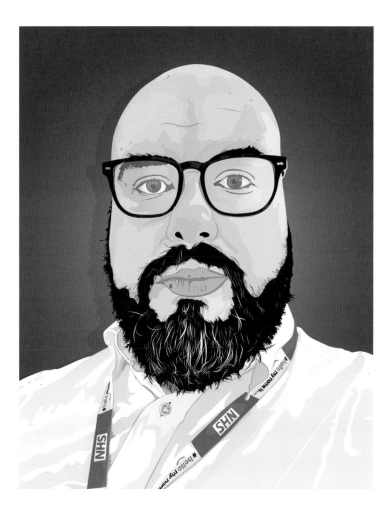

ANT by PHILIP GRUNDON
DIGITAL | 51.6 × 40.5 CM

'I was delighted to create this portrait of Ant as just a small thank you for the work he and his colleagues have been doing during the coronavirus pandemic.' **PHILIP**

'I've been working on the admin side of ultrasound. Helping patients with enquiries of their appointments and calling them up.' **ANT**

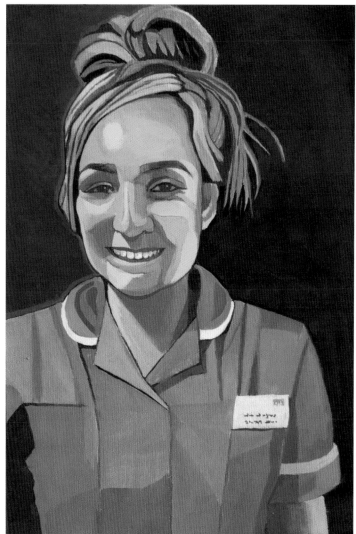

HANNA by JANICE WAHNICH
GOUACHE ON CANVAS BOARD | 30 × 20 CM

'Hanna approached me at the height of the pandemic, when she was working as an NHS staff nurse for the Mid Yorkshire NHS Trust. Since the lockdown she has been working as an A&E nurse.' **JANICE**

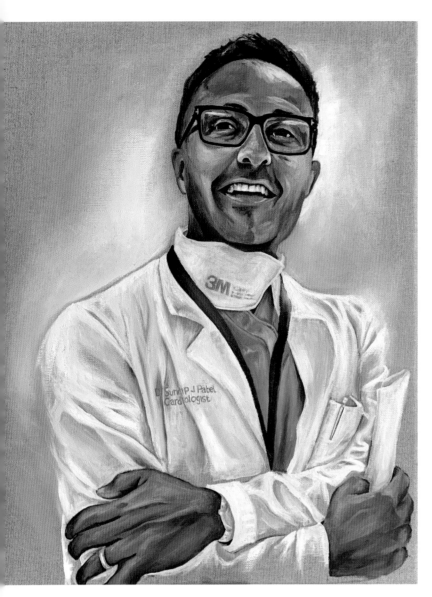

DR SUNDIP PATEL by PETER WHITAKER

ACRYLIC AND OIL ON CANVAS | 50 × 40 CM

'This is Sundip Patel, consultant cardiologist at the Queen Elizabeth Hospital Woolwich, Guys and St Thomas'. He has been on the front line in the Covid/ICU wards and dealing with other emergencies as they come in. People like Sundip continue to put others first, often in very difficult conditions, leaving little time to see his own family. I hope this portrait goes a small way to show my gratitude for the amazing work you and all the other NHS heroes do daily. Thank you.'
PETER

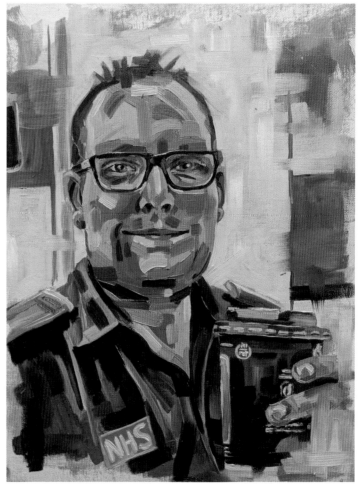

SAMUEL NEWMAN by LUCY ROSTRON

WATER-BASED OIL ON CANVAS PANEL | 35.5 × 28 CM

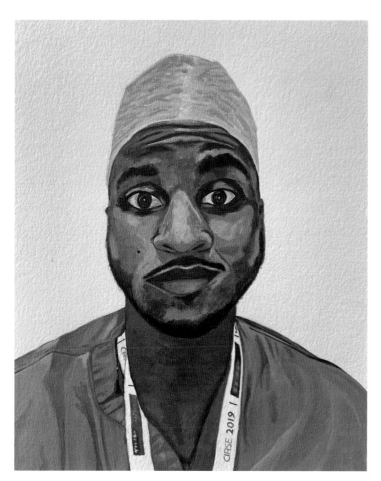

ELFADIL ELMAHDI by DEEPTI ARORA

ACRYLIC | 29.7 × 21 CM

'Elfadil Elmahdi is a radiologist from Liverpool. I was contacted by his friend from New Zealand to do his portrait. What a lovely gesture and how small this world seems!' DEEPTI

'I'm an interventional radiologist. Thank you to all the members of the public who sacrificed and stayed at home. You've made my job easier than it would have been!' ELFADIL

MAXIMIN PERERA by MARIE ROBINSON

OIL ON CANVAS BOARD | 40 × 30 CM

'It's strange painting someone you have never met but I felt I got to know him by working so closely on his image.' MARIE

'I wanted to let you know first-hand how much this painting means to me. I've been trying for a long time to put into words how touched I am at the portrait. You did an amazing job. But what matters more is what a warm feeling it's given me. To go to work every day is great and I love every second but it can be stressful. To know that there are people out there appreciating you and people like you – who not only appreciate but go the extra 1,000 miles to show it – is the best reward anyone could get.' MAXIMIN

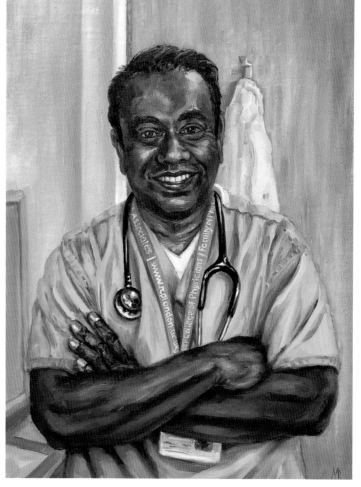

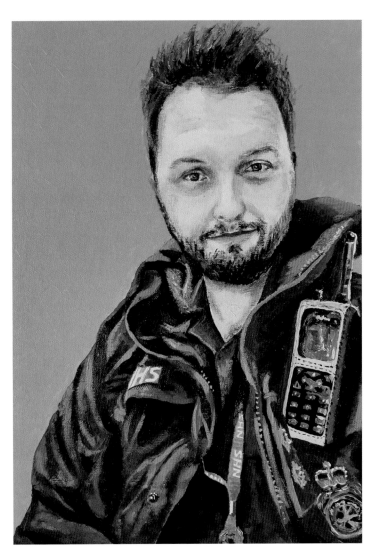

CAMERON McVITTIE
by NICK COCKBURN
ACRYLIC | 42 × 30 CM

'Cameron is an operations manager for West Midlands Ambulance Service and has worked for them since he finished his paramedic science degree. He's currently acting up as a tactical commander for the region during the Covid-19 crisis. This portrait is my small thank you for Cameron for everything he is doing in these challenging times.' NICK

'Wow what can I say! Thank you so much for this. Will give me something to be able to look back on when we are telling the stories in years to come. Thank you.' CAMERON

'Just seen your portrait of Cameron. It is amazing... brought a tear to my eye. He is my son and I am so so proud of him!' CAMERON'S MOTHER

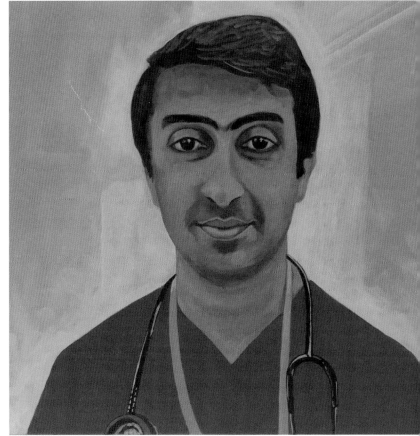

AMREEK DHINDSA by FRANCES BRAY
ACRYLIC ON CANVAS | 50 × 50 CM

'The fresh-faced young doctor in my painting is Dr Amreek Dhindsa, who follows in the footsteps of his father, local GP Dr Amarjit Dhindsa. The family have been my neighbours for 20 years and we both have sons. Amreek qualified in 2018 and worked long hours throughout the current Covid-19 pandemic at Milton Keynes University Hospital as a member of the A&E team, and very occasionally managing short breaks at home, to visit his concerned but proud parents.' FRANCES

LAUREN by KEVIN HINTON

OIL ON CANVAS | 40.8 × 30.5 CM

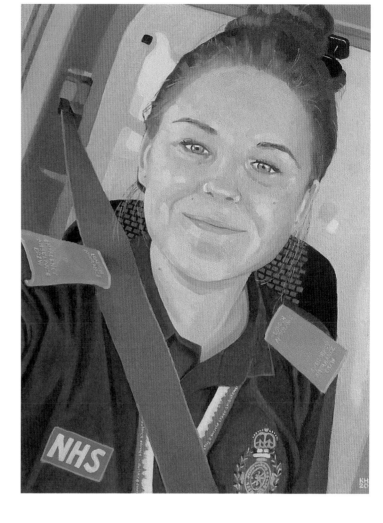

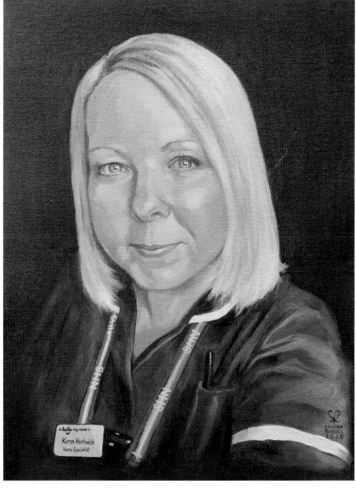

KAREN HERTWICK
by SANDRA RUSSELL

OIL | 40 × 30 CM

'I wanted to capture Karen's kind and caring nature without the PPE she has to wear when visiting her patients.' SANDRA

'Thank you Sandra, you are an amazing artist. I'm proud to say I am a nurse and have been for almost 30 years. I work with amazing professionals that devote their lives to care for others and I think through these times people are starting to understand what the brilliant NHS does along with social care. May we always remember and learn.' KAREN

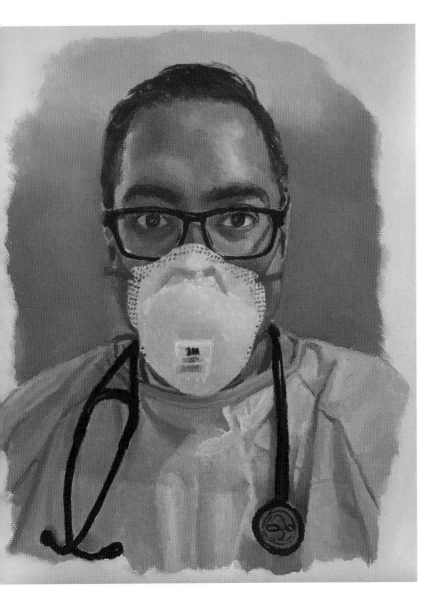

SUNIL PARMAR by JASON NUNN

OIL ON CANVAS | 29.7 × 24 CM

'When lockdown was announced, like many, I was furloughed. Initially it felt like we were taking a short holiday; however, as the weeks went by and the lockdown extended, I started to experience episodes of anxiety. I never thought in my lifetime I would experience living in a pandemic. I made the decision to channel my energy into something positive and creative. The NHS staff working tirelessly on the front line were never far from my thoughts. It was a real privilege to paint a portrait of ED Registrar Sunil Parmar in recognition of the work he and millions of other NHS workers were doing during the peak of the pandemic. I am proud to have been a part of the Portraits for NHS Heroes project.' JASON

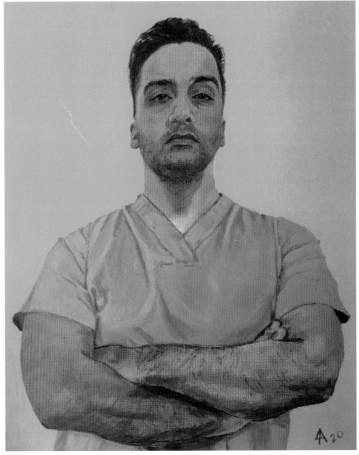

UBAID by LINDSAY ANDERSON

ACRYLIC | 50.8 × 40.6 CM

CHRIS MARTIN by JACKIE GWYTHER

OIL ON LINEN BOARD | 40 × 30 CM

'Chris has been working on ambulances for about nine years, starting out as a Red Cross volunteer before qualifying as a paramedic. During Covid, he spent his time on both frontline emergency ambulances with the London Ambulance Service and in the control room as a clinical advisor. This painting captured him at the end of a gruelling 12-hour shift.' **JACKIE**

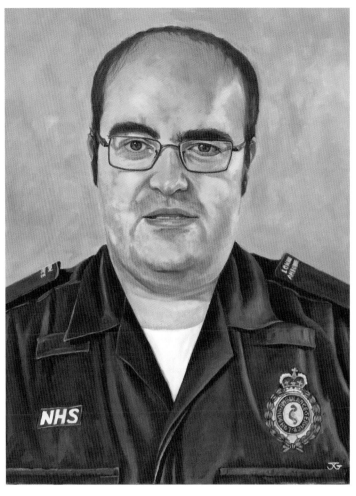

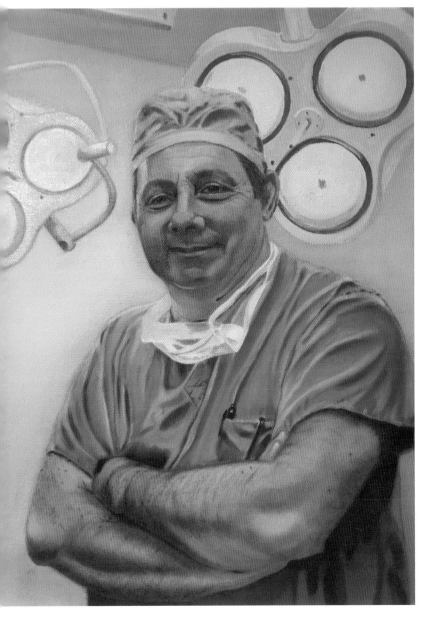

ANESTIS IOSSIFIDIS
by AFSHAN CHELLIAH

OIL | 40 × 30 CM

'I felt apprehensive, excited and humbled when doing this piece. I wanted to do my best as a small gesture of my heartfelt gratitude to Anestis and all our frontline workers, who literally have kept us going.' **AFSHAN**

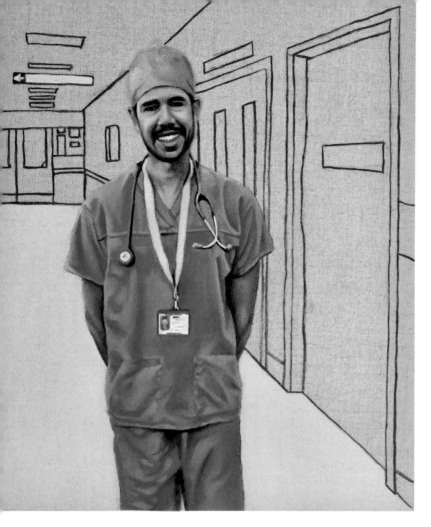

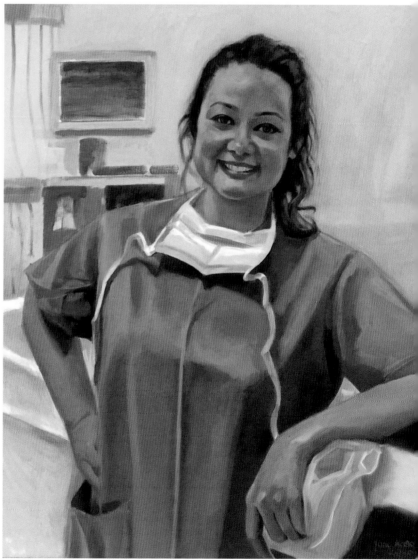

ADAM by JULIA HALL

OIL | 27 × 21 CM

SIAN by JANE MASOJADA

OIL ON CANVAS | 65 × 54 CM

'In the early days of the pandemic I was beside myself with worry for my daughter, who was working as a doctor in London. This project provided a much-needed outlet. Sian, a nurse originally from New Zealand, is working in a Covid isolation unit in Edinburgh. We got to know each other via video conversation. A warm smiling Sian in her painting radiates her calm warmth and positivity.' JANE

'This project and painting have been such a journey for me, culminating in meeting you and seeing the painting for the first time. When I first saw it I was quite amazed and delighted to see a nurse who had a quiet confidence, true passion and a calm willingness to put others' needs before her own. I feel immensely proud that person is me.' SIAN

DR BARBARA BRAY by PAUL STARNS

OIL ON CANVAS | 46 × 36 CM

'My portrait is of Barbara Bray, consultant anaesthetist at East Surrey Hospital. During the pandemic, and with the reduction in the numbers of operations, Barbara has been busy as a medical examiner within the bereavement team liaising with the families of patients suffering with Covid-19. My reference photo showed Barbara sitting at her work station and I've endeavoured to focus on her permanent happy demeanour highlighted by her bright red Crocs.' PAUL

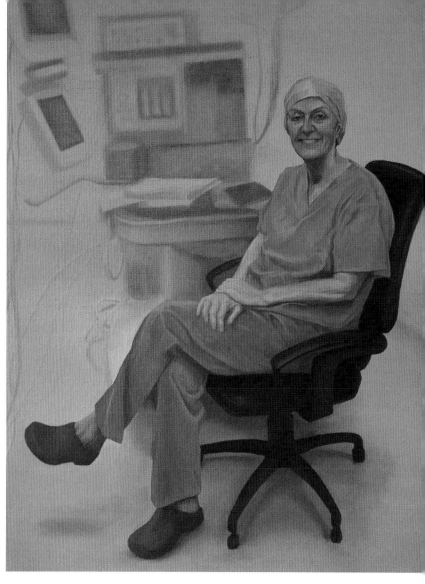

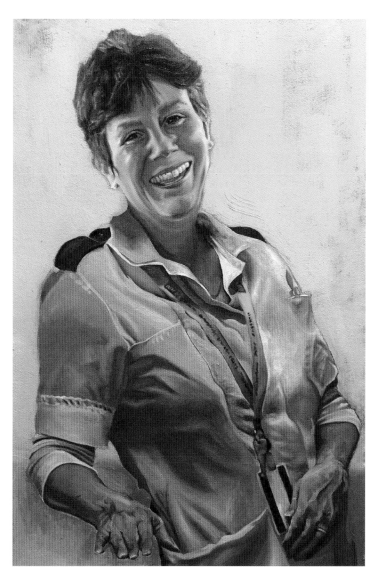

SUSAN LEE by ABIGAIL McGOURLAY

OIL ON CANVAS | 59 × 42 CM

'This is Susan, an intensive care pharmacist, whom I painted after I was partnered with her daughter Natasha, two amazing women who have been working tirelessly on the front line of our NHS during this pandemic. I want the focus to be not a piece of my art but an image and symbol of the amazing work they and hundreds of others are doing and how much gratitude I and the art community have towards them.' ABIGAIL

HELEN BROOKER by JO LILLYWHITE

ACRYLIC | 40 × 30 CM

'This is Helen – she's a sister in A&E at the Queen Elizabeth Hospital in Birmingham. Helen says the Covid pandemic work has been surreal – it has made her question everything in life and she does wonder about the longer-term repercussions. She is glad to be part of a very supportive team who look out for and care for one another. I wanted to do a portrait which showed the person beneath the specialist clothing, who is at the coalface, caring for patients. Thank you NHS and thank you Helen.' JO

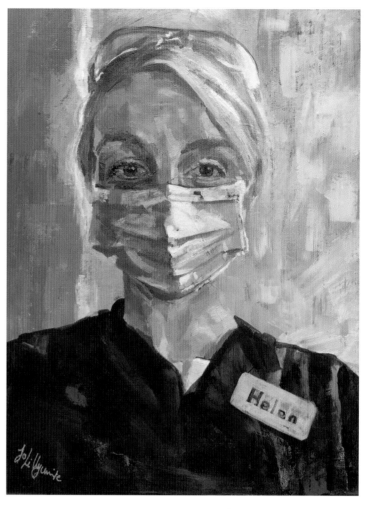

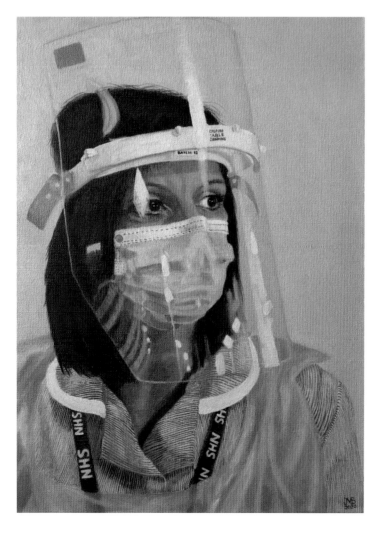

SARAH FORREST
by JANE MOLINEAUX BOON

OIL ON CANVAS | 40 × 30 CM

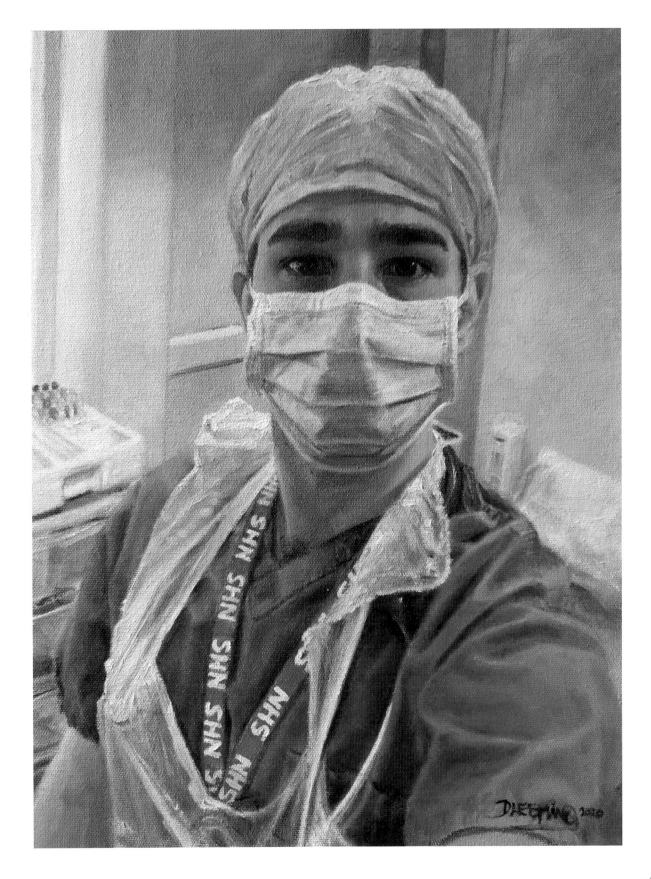

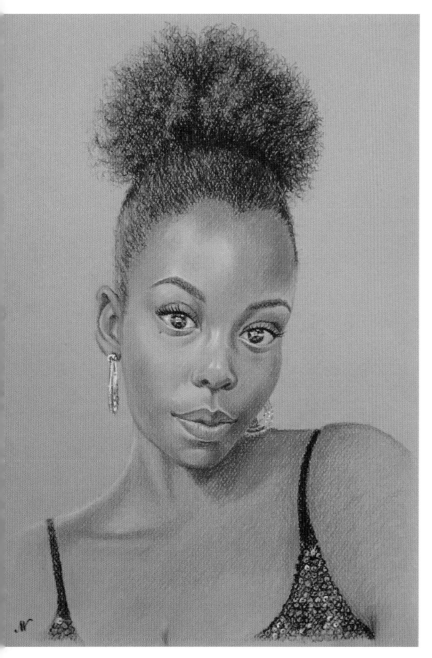

MARIA DA SILVA
by ROSSO E. CRIMSON

OIL ON CANVAS | 28 × 28 CM

TENISHA by ALEXANDRA VERES

PASTEL | 40 × 32 CM

'The face of the NHS: gentle, loving, selfless and compassionate. It was a joy and an honour to paint Tenisha and express my heartfelt gratitude to our health service: an institution which, for me, is the single most civilized thing about the UK. I salute all the frontline staff like this beautiful nurse who have not only worked inhuman hours but risked their very lives to care for the sick during the pandemic. I don't think I've ever been more inspired by a portrait commission; the subject's heady combination of heroism and radiant beauty was so potent, I just poured my heart and soul into it.' ALEXANDRA

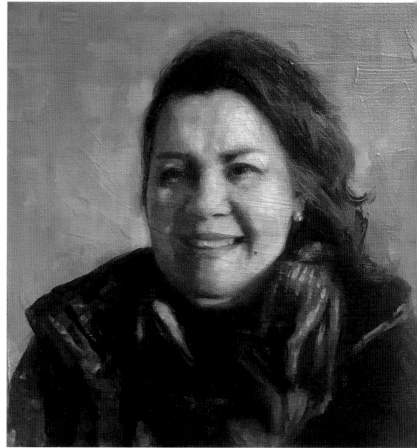

DR SOPHIE THORROLD by KATIE NICE

PENCIL | 42 × 29.7 CM

'When I first heard about this project I knew immediately that it was something I wanted to join in with. Hearing about the work the NHS heroes have been doing and the situations they have been experiencing on a daily basis is inspiring. Dr Thorrold has done an outstanding job in extremely tough conditions to boost morale and save lives. Creating this portrait for Dr Thorrold is the least I can do to say thank you.'
KATIE

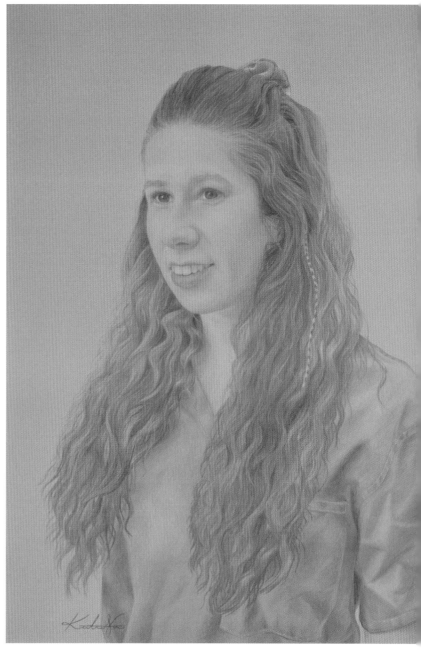

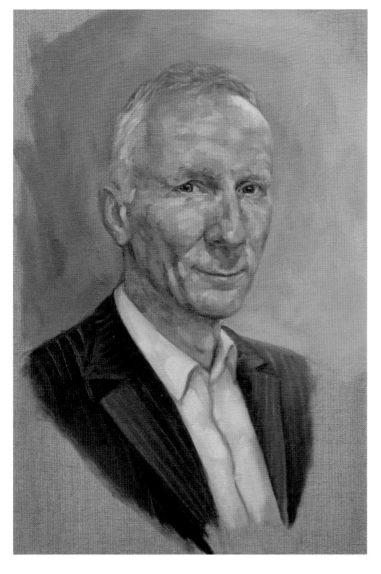

DR BOYD PETERS by SOPHIE CASTLE

OIL ON LINEN | 60 × 40 CM

'I believe in teamwork, and I am so very proud of all the people who make up Team NHS Highland.' BOYD

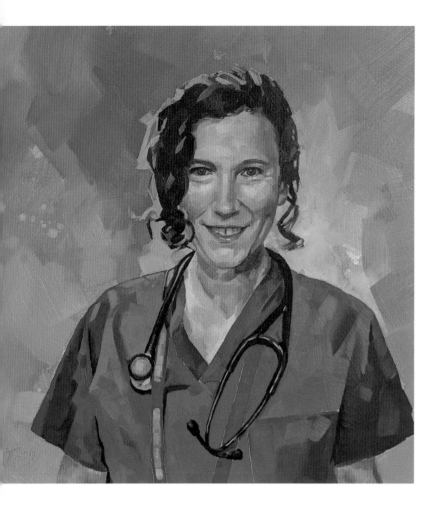

DR VICTORIA HENDERSON
by NICK FEAR

OIL | 25.4 × 25.4 CM

'As someone who has family who work in the NHS I wanted to show my appreciation for the crucial and often dangerous work hospital staff are undertaking on our behalf. I wanted the portrait to counter some of the fear and uncertainty NHS workers were inevitably feeling and instead give a sense of energy and positivity. Above all I wanted to produce something that would hopefully give a bit of joy to someone during difficult times.' **NICK**

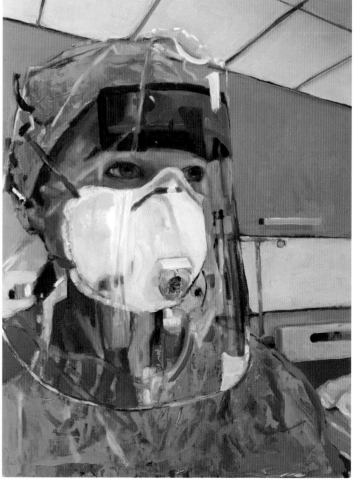

DR SARAH MOLL by SARAH FOYSTER

OIL ON BOARD | 40 × 30 CM

'The PPE is very hot to wear – I think the nurses suffer more as we don't tend to be in with patients for as long as they are. It is scary for kids in an already scary environment. In ICU they are not allowed a parent in with them.' **DR SARAH**

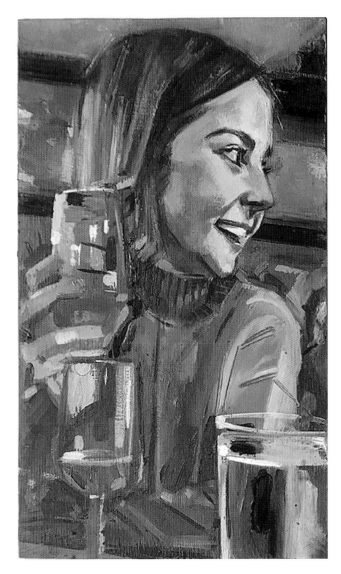
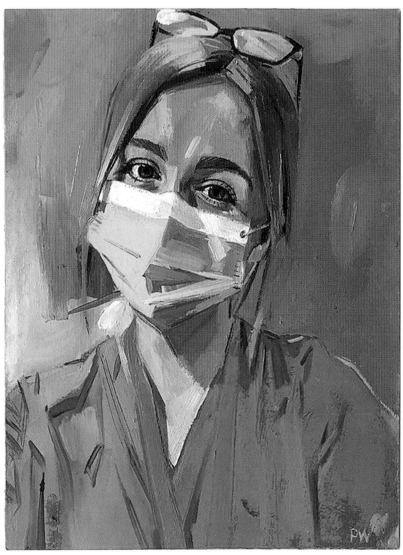

DR LILLY RYAN HARPER by PRISCILLA WATKINS

OIL ON CARD | 40 × 40 CM

'I am working with recovering Covid patients at the Dragon Heart Hospital at the Principality Stadium in Cardiff. We are rehabilitating patients and building their strength. I've been a doctor for near to two years and this experience has been like nothing I imagined I'd be facing. I feel lucky to be able to help these patients but it's overwhelming and frightening.' **LILLY**

'I suggest a double portrait because she is so near to graduation and has gone straight into this. "Here are some recent photos of me" she writes. "One of me having a beer with my sisters. That's the first thing I'm going to do once this is all over." When I had finished: "The painting arrived today. I love it! Thank you. It has brightened up a difficult week. I will always have something to look back on to remember these strange but rewarding times."' **PRISCILLA**

CHARLOTTE by WENDY STANDEN
PASTEL | 36 × 28 CM

'Lockdown had sapped my creativity and I was finding it difficult to paint. But I was inspired to offer my services as a way of thanking our wonderful nurses and doctors. Charlotte's mum contacted me asking for her daughter to be included. Charlotte is a children's nurse visiting seriously ill children in their homes. I thought her lovely expressive eyes say it all, even with a mask. Both Charlotte and her mum were over the moon with their portrait and said it was a fabulous reminder of the times and the gratitude of the patients.' WENDY

BRINTHA by MAGDY ROZEIK
OIL ON PAPER | 30 × 23 CM

'It has been a wonderful opportunity to be a part of this and a pleasure to be able to give back to the NHS workers for all they have done for us.' MAGDY

CARLY GRANDIDGE
by NATHALIE BEAUVILLAIN SCOTT

OIL ON CANVAS | 40 × 25 CM

'Carly is a neurosurgeon in Oxford. She is doing an amazing job in extremely difficult conditions. The emotions and feelings of this significant moment in history are captured in the portrait through the eyes of Carly.' NATHALIE

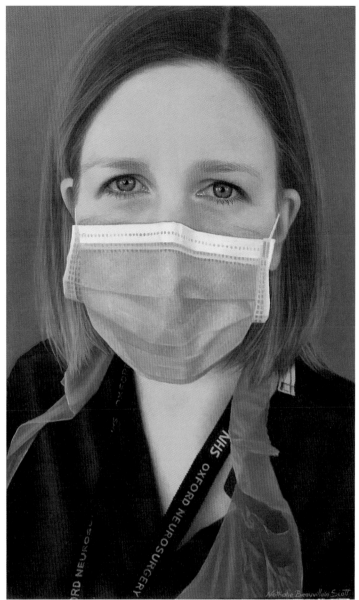

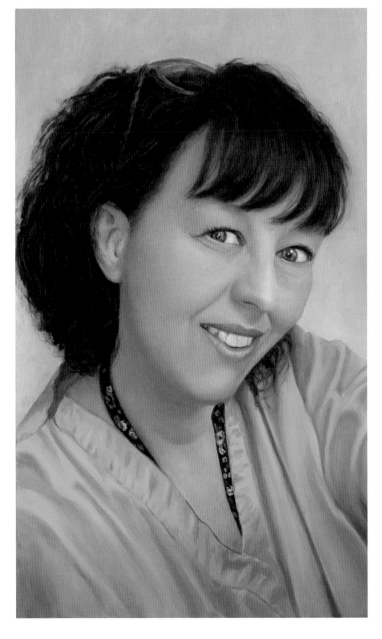

NURSE TINA BEDFORD by VIC HARRIS

OIL ON LINEN | 50 × 30 CM

'I have worked in neurotheatres, recovery at Addenbrooke's Hospital for the past 26 years. I never envisaged a pandemic such as this, which has brought with it many challenges and adaptations in our way of working. I am supported and encouraged by my family, friends and the great team I work with, and have been touched by the kindness of the public. I feel honoured to have been chosen by Vic (a very talented artist) to have my portrait painted.' TINA

FRANCISCO by SUE TILBURY

OIL ON CANVAS | 30 × 30 CM

'This is Francisco, who worked on the front line in an intensive care unit throughout the Covid-19 pandemic. He works at the John Radcliffe Hospital, Oxford. I wanted to paint him without a mask to show the kindness in his eyes and heart. With the required PPE, all his patients could only see his eyes but not his reassuring smile. I put him in blue to represent the NHS.'
SUE

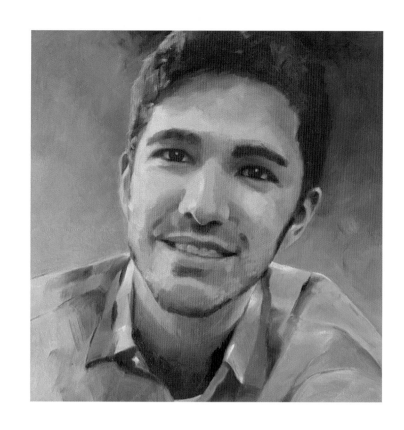

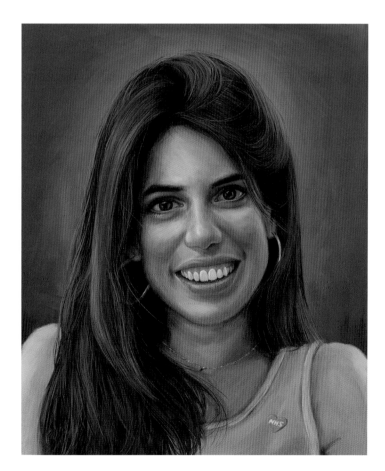

JUDITH MERCADER by KAY LAM

DIGITAL | 26 × 21 CM

'It has been a great pleasure and honour to paint Judith Mercader, an ICU nurse who worked on the front lines of a Covid-19 ward at John Radcliffe Hospital in Oxford. Back in April, she told me it has been really stressful but having a good team and with all the people's support she had the energy to carry on. She said that this initiative was a beautiful idea, and an altruistic act has helped to bring some light to those dark days. I am grateful to play a small part in this positive energy, getting to know Judith and to have the opportunity to give thanks to our NHS heroes.' **KAY**

DR ANUSHA CHOUHAN MEARKLE
by GEOFF GODDARD

OIL ON CANVAS | 30 × 30 CM

'Anusha is a GP registrar employed by BSUH
Brighton & Sussex University Hospital.' GEOFF

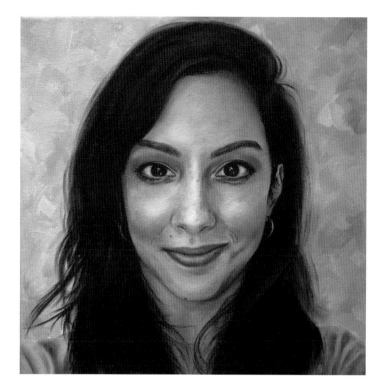

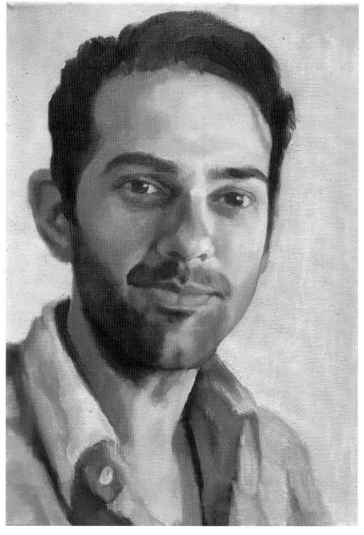

ASMAT by GEORGIA MALLIN

OIL ON CANVAS | 35.5 × 25 CM

'During this crisis Asmat has been operating
on trauma patients but also working in
intensive care to help turn Covid patients on
their front – it takes about six people each
time. His wife Tazeen, who is also a doctor,
asked me to paint her husband's portrait as a
surprise, because he's been working so hard
on the front line. To paint someone as an act
of recognition and gratitude for their work is a
wonderful thing. I was relieved and delighted
to hear that he loved it!' GEORGIA

WARREN & IAN by PAM HUNTER

SOFT PASTEL | 29.7 × 42 CM

'Warren and Ian are ICU nurses and partners.
I couldn't think of a more deserving couple to
offer my gratitude to for their hard work during
this pandemic. I've just started drawing and
painting for the first time since school and
have never done any portraiture before, so this
project has awoken my creativity and given me a
positive purpose. Thank you to Ian for choosing
and believing in me and thank you to Tom for
enabling and encouraging me to grow as an
artist.' **PAM**

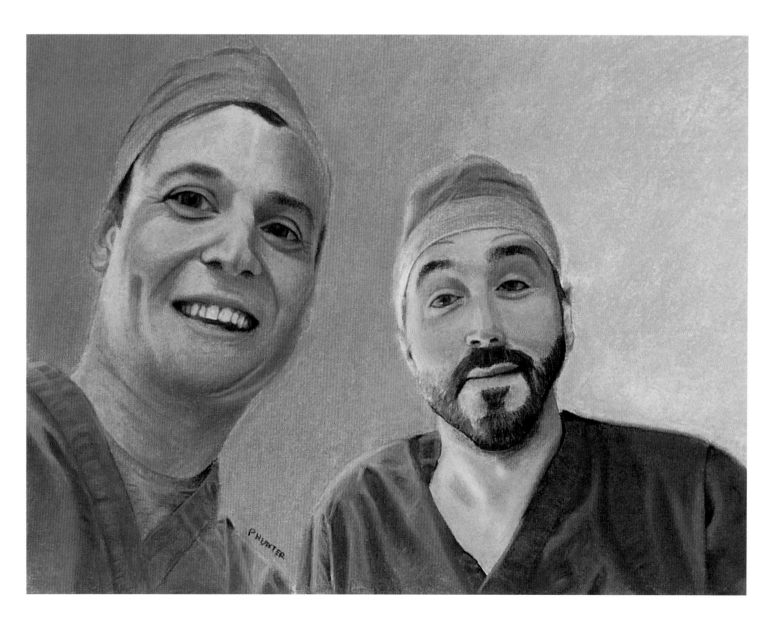

OWEN by ELISE WALLBRIDGE

ACRYLIC ON CANVAS BOARD | 30.5 × 25.5 CM

'It's an honour to paint someone who is doing so much for us all. I hope I captured the commitment and the selflessness of Owen.'
ELISE

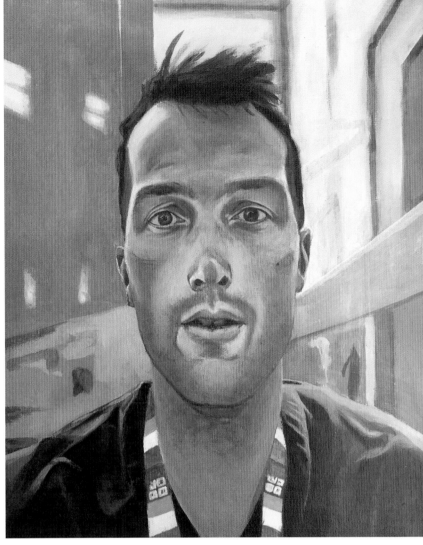

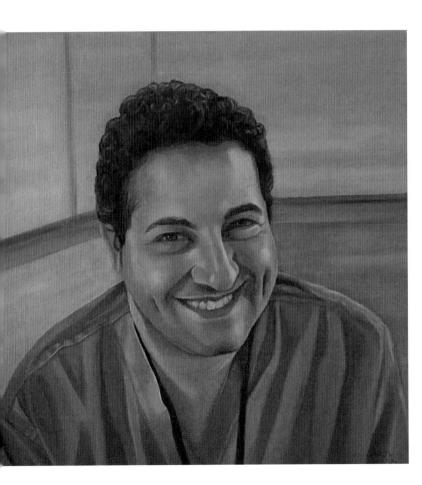

DR BEN MULLISH by CAROL TARN

OIL ON LINEN | 38 × 38 CM

'Ben Mullish is an NIHR academic clinical lecturer in the department of Metabolism, Digestion and Reproduction at Imperial College London and an honorary specialty registrar in Gastroenterology and Hepatology at St Mary's Hospital, London. The photograph that his fiancée Hilary sent of Ben caught him in a relaxed moment having just come off duty on one of the Covid wards at St Mary's. It was a pleasure to paint his portrait.' CAROL

CLOVER DELANEY by WENDY ELIA

OIL ON CANVAS | 31 × 25 CM

'Clover Delaney is a London-based midwife. She has delivered around 30 babies since the crisis began (so many she can't remember the exact number).' **WENDY**

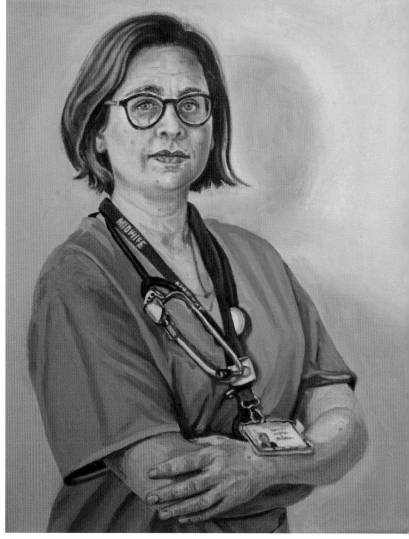

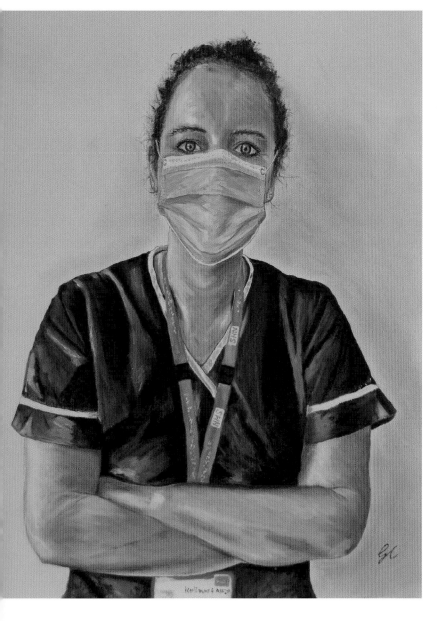

EMILY by GEMMA CLYDESDALE

OIL ON CANVAS | 50 × 40 CM

'My wonderful friend Emily has been working on the front line as a nurse throughout the pandemic. We have been close friends since we were children, so painting her portrait has been a personal and emotional experience for me. I admire her resilience and feel humbled by her courage. I enjoy the permanence and strength of oils, the perfect medium for a portrait of one of our NHS heroes. Thank you to all our key worker warriors who have kept everything together during these challenging times – you're an inspiration to us all.' **GEMMA**

KATE LAFFERTY
by CAROLINE FORWARD

OIL ON CANVAS | 40 × 30 CM

'Despite the challenge of working from just a photograph and meeting Kate "virtually" rather than in person, this has been an emotional experience. Kate's generous and compassionate character and her desire to go above and beyond her normal clinical role during Covid-19 have shone through.' **CAROLINE**

'Thank you from the bottom of my heart for this wonderful portrait. It's everything and more – you made me feel very special. A gesture I will never forget. Having a painting of yourself, working in the job you love, amidst a moment in time nobody ever expected. Well, it's just something else.' **KATE**

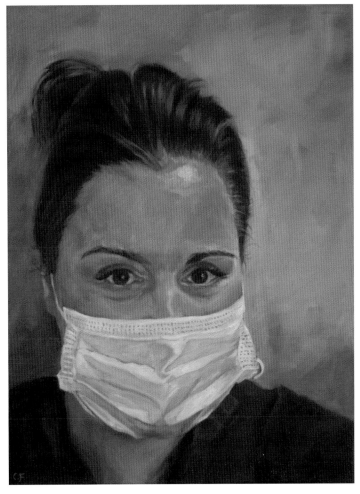

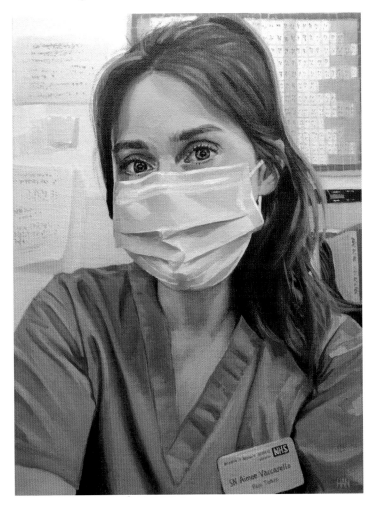

AIMEE by HAN HAN

ACRYLIC ON CANVAS | 40 × 30 CM

'Right before the pandemic, my 3-year-old son had pneumonia. It was terrifying to sit next to the hospital bed, waiting for him to come back to consciousness. What comforted me most was to see how professional and caring all the doctors, nurses and paramedics were. They gave me confidence that my son would recover well under their care, which he did. When the coronavirus started, I kept thinking about the friendly faces I met during that time. Aimee is a staff nurse working with Covid-positive patients in an assessment ward. Thank you for keeping us safe.' **HAN**

ALFRED GONZALES by SHERI GEE

OIL ON CANVAS | 30 × 26 CM

'It was an absolute pleasure to be able to give back, to salute the hard work and dedication of all NHS and key workers around the country. As the portrait took shape we exchanged emails from the front line – sometimes sad but always full of strength and hope.' SHERI

'What an amazing portrait. A wholehearted appreciation to you and to all your hard work, as we together are fighting for a better future, and hopefully we will have our normal lives soon.' ALFRED

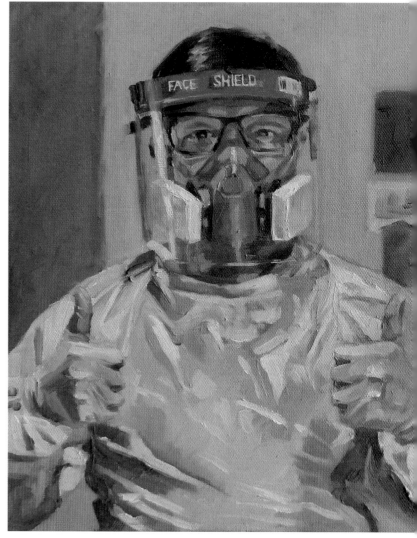

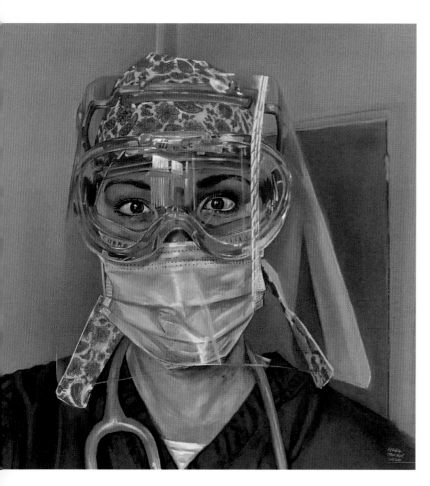

KATE PARE by MARK HOOLEY

DIGITAL | 18 × 18 CM

'Kate Pare is a GP in North Wales. She thinks the whole idea of #portraitsfornhsheroes is just amazing and feels very lucky to have been a part of it! It was a challenge to paint her paisley-style PPE and the reflections on her masks. Of the portraits I managed to create during lockdown this took the longest and I think is the one I'm most happy with.' MARK

TINA by DAVID SANDELL

OIL ON LINEN PANEL | 50.8 × 40.5 CM

'This painting is based on socially distanced photography taken while Tina was off shift at Kettering Hospital intensive care unit. The chaotic typographic arrangement is intended as personal response to this whole extremely challenging Covid-19 period.' **DAVID**

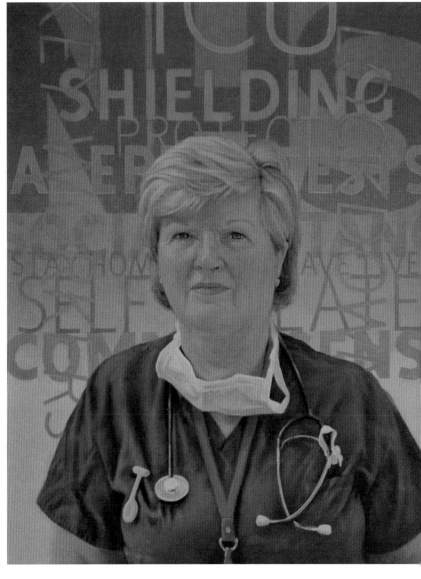

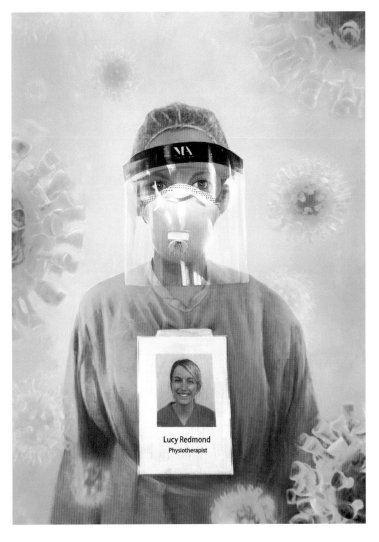

LUCY REDMOND by DOMINIC LAVERY

DIGITAL OIL | 48 × 34 CM

DREW by EMILY GRILLS

ACRYLIC | 36 × 28 CM

'A painting to make an "unsung hero" sung.'
EMILY

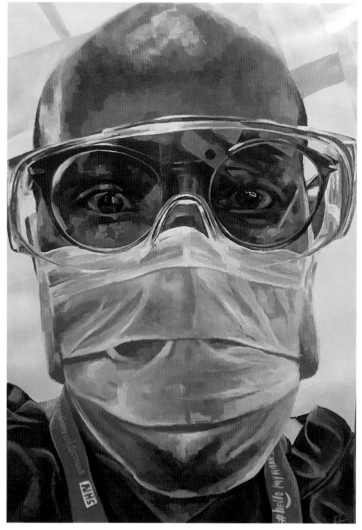

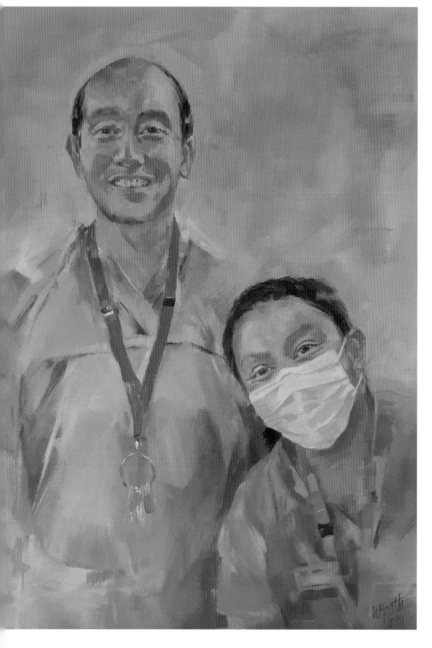

NOR EEN & MATTHEW
by WENDY HEATH

ACRYLIC | 60 × 42 CM

'It was a real pleasure being able to give something back to the wonderful NHS workers who were on the front line. I was contacted by Matthew and Nor Een, who were both ICU nurses. I just loved their beautiful smiles bringing light to the very dark situation we found ourselves in. They must have been such a comfort to those in their care.' WENDY

MR JOEL DUNNING by VICKI DAVIDSON

ACRYLIC ON LINEN CANVAS | 40 × 60 CM

'Whilst busy with my own job as a clinical matron, I observed with interest the wonderful NHS portraits; an ever-increasing gallery of inspiring and poignant artwork. Before long, I couldn't resist. However, I decided to pick my own 'NHS hero'! I approached my colleague Joel Dunning as I was impressed by his positive response to the pandemic. Joel, a brilliant cardiothoracic surgeon, quickly realized that – with routine theatre lists cancelled and high numbers of patients expected in critical care – it was nursing hands we were likely to be short of, as critically ill patients in intensive care require a 1:1 nurse/patient ratio. Joel put himself forward to receive training in critical-care nursing and started his gruelling 12-hour shifts in PPE. I was so impressed by Joel's willingness to do whatever was required and by his brilliant leadership. What a remarkable role model – thank you Joel!'
VICKI

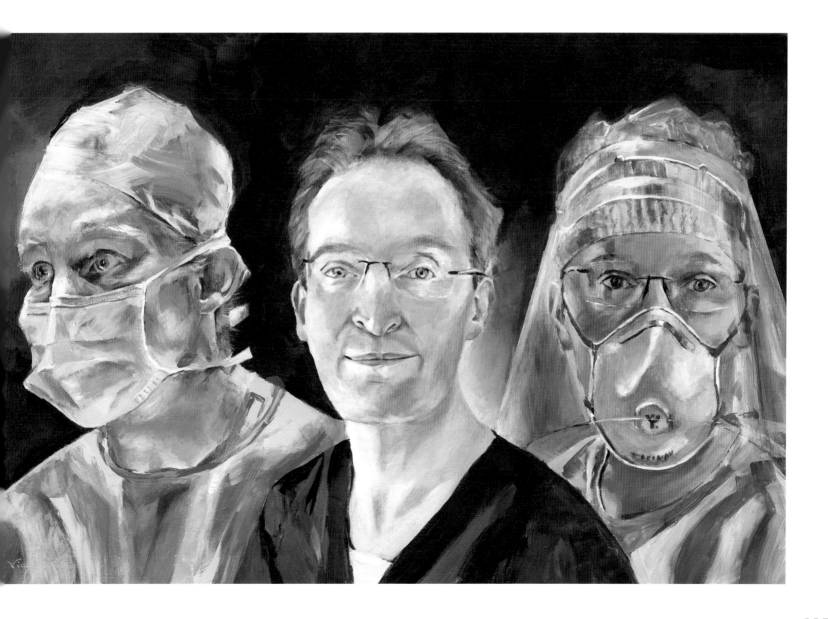

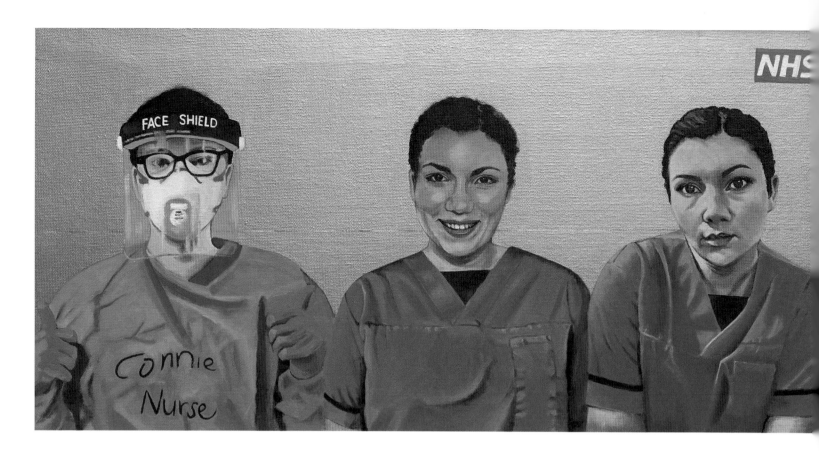

NURSE CONNIE LANE
by ANGELA BEATSON WOOD
OIL | 30.5 × 61 CM

'Connie is a nurse in the ITU ward in the
Queen Elizabeth Hospital, Birmingham. I
decided to paint three aspects of an ideal nurse:
Connie in the Covid PPE in which she had no
identification; happy in her nurse's uniform;
and concerned and caring, still wearing
uniform. The portraits are painted on a gold
background to give the effect of a religious icon,
with NHS written in the upper right corner,
rather like the Greek lettering found on icons.
Connie now has the painting in her home in
Kings Norton, Birmingham, where my father
was a doctor for most of his life.' ANGELA

AARTHI by CHRISTOPHER LLOYD OWEN

OIL | 30 × 23 CM

'Aarthi was working flat-out as an obstetrician when I was painting this. I think this image shows her quiet calm during a very difficult time. I had a new granddaughter born during this time, which made her particular role more poignant. Painting a portrait of somebody wearing a mask was a new experience for so many of us, and I guess we all knew that the eyes are everything. The last thing I did was her earring – something you might not notice normally – but it was one of the first things my eye was led to when I first saw the photograph. One day I hope I can meet this impressive and lovely person.' **CHRISTOPHER**

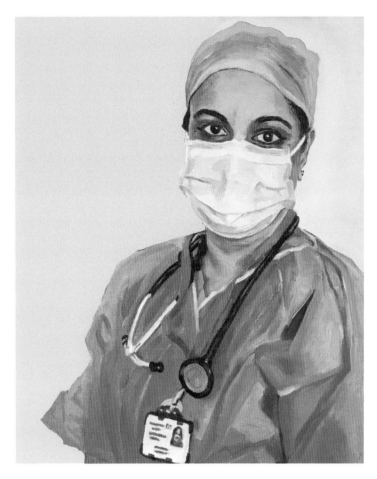

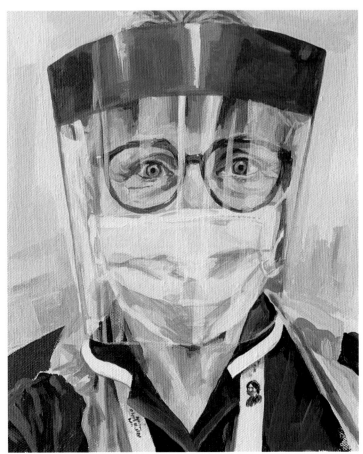

ANID PATCHETT by JOY GOSNEY

ACRYLIC | 38 × 30 CM

'A mutual friend put Anid, who is a deputy sister in an infectious disease ward in Nottingham, in touch with me. I just felt compelled to make time to be part of this incredible project and to offer what I could to show my appreciation to the NHS. Being able to mark this moment in Anid's career for her, knowing that it had given her a lift, was the most wonderful feeling. It was an absolute honour to paint her.' **JOY**

DR ASHTON
by DEVON OSBORNE

OIL | 40 X 30 CM

'Dr Ashton has been doing a wonderful job as an anaesthetics doctor in Swindon. I was so happy to be involved in this project, to show appreciation for those that take such good care of us and to give them something tangible as a thank you. I sincerely hope that our current government can see fit to raise the wages of those hard-working NHS and care staff, so that they too, are giving something tangible.' **DEVON**

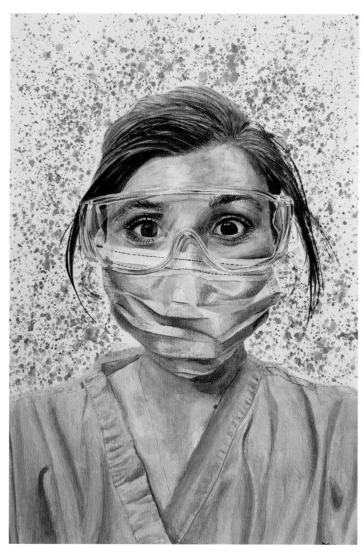

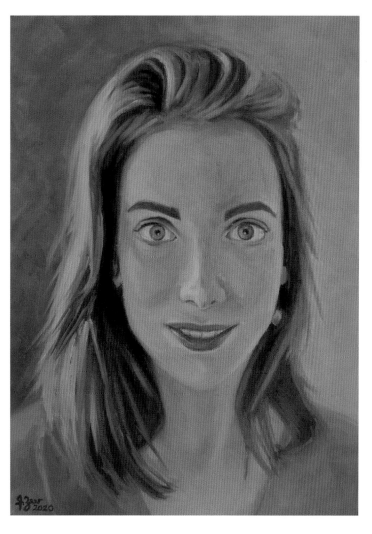

DR SOPHIE GREGG by JUDITH ZUR

OIL | 40.6 × 30.5 CM

BETHANY by OTIS MARRIOTT

OIL ON CANVAS PAPER | 29.7 × 21 CM

'I started to paint consistently when lockdown started, as I found it therapeutic and it helped to provide me with some routine and a sense of normality, for which I am thankful. Bethany initially nominated a friend for a portrait, who then returned the favour, saying Bethany had been a blessing to so many. Bethany is proud to have had her portrait painted.' OTIS

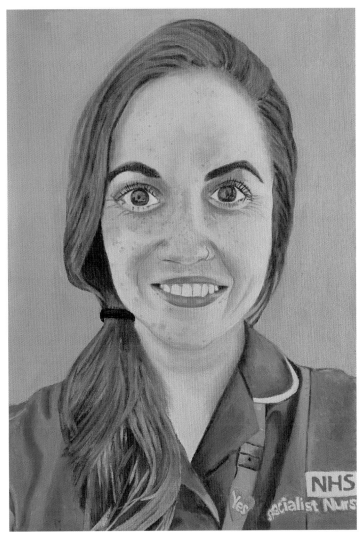

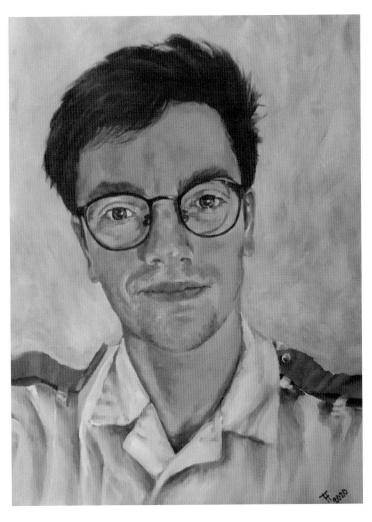

CHRIS BRENCHLEY by PAT DEAR

ACRYLIC | 42 × 29.7 CM

HARRY ROBINSON by NNEKA UZOIGWE

OIL | 53 × 48 CM

'Harry is a dietician at the Salford Royal Hospital and is currently helping the team with ICU patients. He is pictured here with his Wolverine claws. I'm so pleased I had the opportunity to paint his portrait and enjoyed his input on how he would like to be depicted. I'm sure he will enjoy this painting for years to come!' NNEKA

'I love it! I loved how you have done the blades, and how it looks so real. I've always wanted to be Wolverine and you've pulled it off in such an amazing way. I am super thankful for that.' HARRY

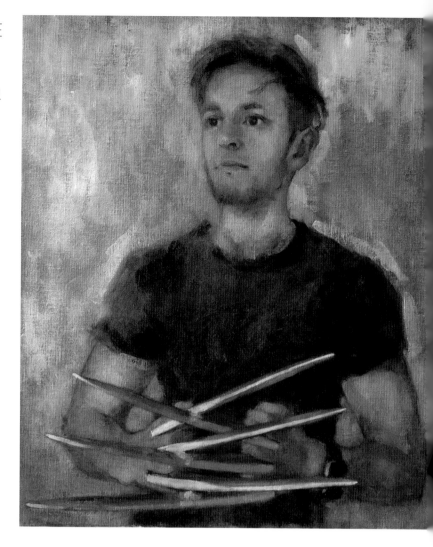

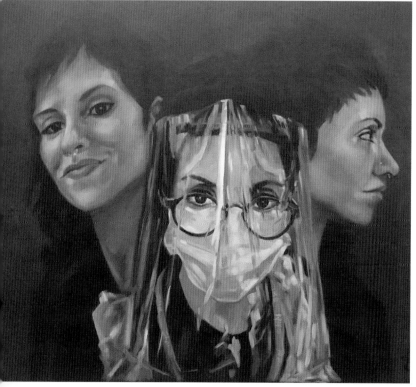

CLAIRE WAREHAM
by MONICA CALLAGHAN

OIL ON CANVAS | 50 × 60 CM

'When lockdown started and we all slowly became aware of what our healthcare workers were facing, I felt, like so many others, a real frustration at not being able to do something useful to help. This portrait felt like something I could do to honour someone for the risks they were taking while we all hid inside our homes. Claire is a community mental health nurse working in Northamptonshire. We connected on Skype and have stayed in touch. In July I met her in a park and gave her the painting in person – it was so special.' MONICA

DR IMOGEN CULLEN by SAL JONES

OIL ON CANVAS | 40 × 40 CM

'The painting is of Imogen, a recently graduated junior doctor who, after gaining a job with South Tyneside Hospital, was immediately working on a Covid ward. Talk about being thrown in at the deep end! This portrait is based on a montage of photos she sent me and aims to tell a story (her lovely smile and exuberance, surrounded by images of selfies taken at the hospital in her scrubs and PPE). I wanted to show that feeling of her vibrant personality and youth mixed with the stark reality of her very new career in this critical situation and at the time of isolation.' SAL

CAITRIONA RYAN
by BERNADETTE DOOLAN

OIL | 20 × 20 CM

EMILY by ANGELA BURDON

OIL ON CANVAS | 30.5 × 20.3 CM

'It was an honour to get to know this wonderful young nurse and I wish her all the best in her nursing career.' ANGELA

'I currently work in the paediatric day surgery unit. It's been pretty exhausting as I'm a final-year student nurse. We had to start our final placement quite abruptly, and last minute, whilst also still writing our dissertations. The ward has been so supportive and it's not too bad, I'm just struggling getting used to nights, but I'm getting there! Thank you so so much. I absolutely love it, I can't tell you how truly thankful I am!!!' EMILY

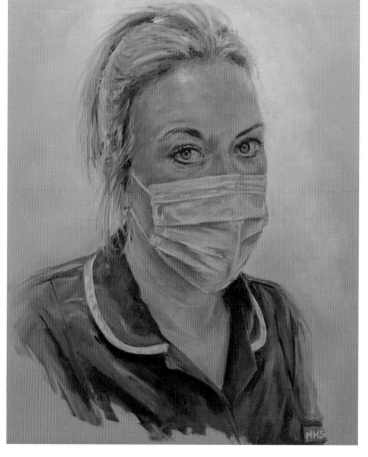

AMY SCHOLES by BARRY MILLER

OIL ON CANVAS PANEL | 30 × 25 CM

'Amy is a ward manager on a medical ward at Calderdale and Huddersfield NHS Foundation Trust looking after Covid patients (ICU step-downs, sick patients and end-of-life individuals). BARRY

TARA by JASON CARR

OIL ON CANVAS | 46 × 36 CM

'This is my sister Tara, a support-care night nurse on the dementia wards until they switched to Covid-19 wards overnight at the PRUH Bromley. Tara has been a passionate carer for over 21 years but this is a nightmare neither she or any of the frontliners were prepared for. At best she is strong and motivated by caring, at worst her heart is breaking for the astounding amount of death around her. She is struggling for PPE and dealing with helping everyone but herself. (I'm doing that by listening to her and fighting her cause.) I love her, she is the country's hero and I'd love her to feel elevated from this nightmare for just a while by having her portrait for life. Thank you.' **DONNA**

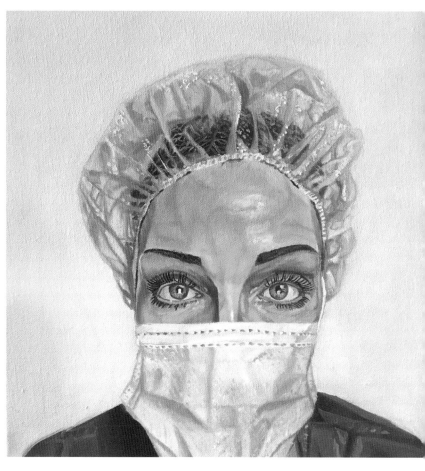

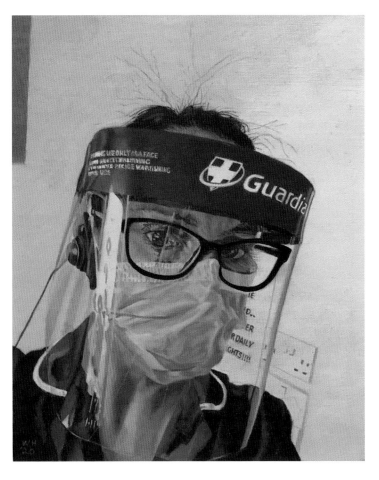

BRIONY by WILLIAM HEARD

OIL ON PANEL | 25 × 20 CM

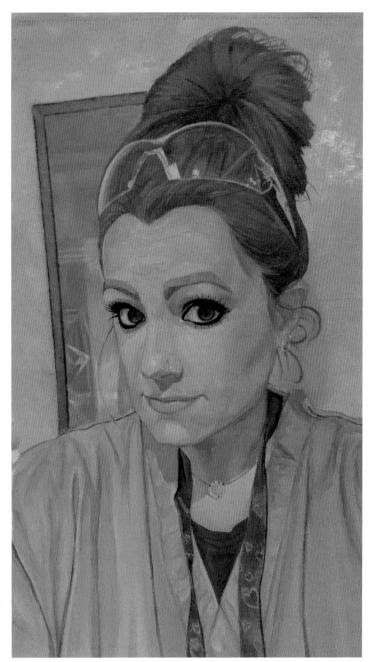

LORRAINE by STEVE CANNON

OIL ON PAPER | 42 × 30 CM

'It was a profound pleasure and honour to create a portrait for Lorraine. After losing a leg due to a maritime accident in 2001, I saw first-hand just what these amazing people do for us, and what they have done for me personally. Now for them to face a pandemic, and to risk their lives for us day in and day out – a portrait does not even start to pay back their sacrifice, but hopefully lets them know how much they are appreciated.'
STEVE

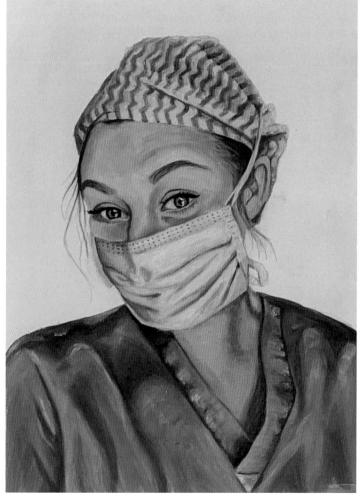

ASHLEIGH RHODES by FFION JONES

OIL | 30 × 21 CM

'Ashleigh opted during the pandemic to complete her nursing degree on the front line. No key worker was prepared for the harrowing realities of Covid-19, but it takes an exceptional individual to volunteer their skills on the front line when they are still a student. Ashleigh's portrait was given to her as a graduation gift.' **FFION**

DR MADDISON GRONAGER
by BRIGID BRIND

ACRYLIC ON CANVAS | 50.5 × 40 CM

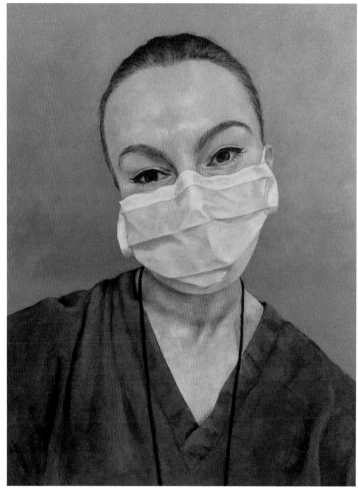

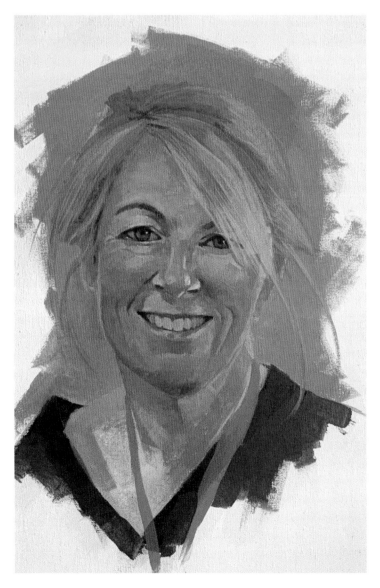

DR PENELOPE LAW by NEIL ROGERS

ACRYLIC ON CANVAS | 40 × 30 CM

'When I joined this project I never expected to
be painting a countess. This is Dr Penelope Law,
Countess of Bradford. She is an obstetrician at
Hillingdon Hospital, who has worked to acquire
PPE for her hospital from a variety of sources
from Primark to the Queen's couturier! She even
managed to get a tour bus in the car park so staff
could stay overnight if they needed to isolate
from their families. A remarkable story and a
pleasure to paint her portrait.' NEIL

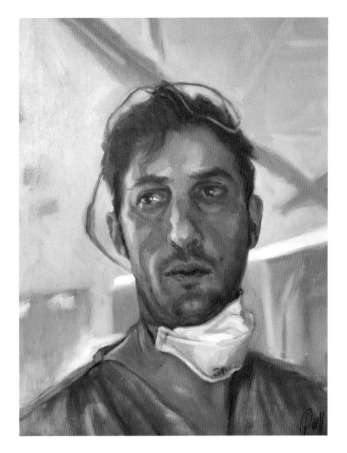

BEN by COLLEEN QUILL

OIL ON CANVAS | 60 × 50 CM

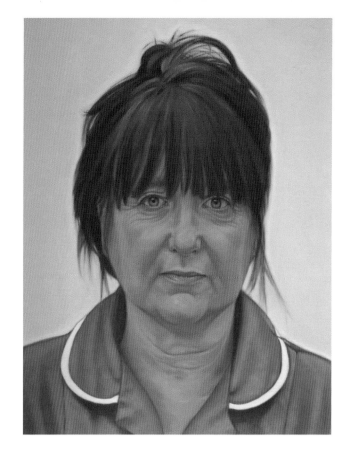

LIZ by JEREMY ANDREWS

OIL ON BOARD | 30 × 23 CM

AARON NUTTER by NICK HITHERSAY

OIL ON CANVAS PANEL | 40 × 30 CM

DREW MEIKLE by RORY MAGUIRE

OIL ON CANVAS | 50 × 40 CM

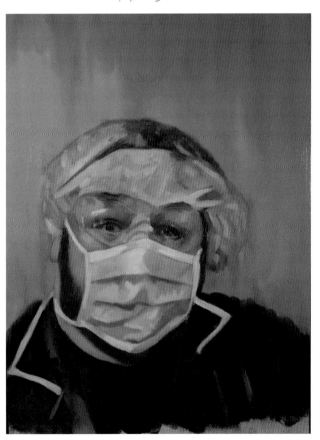

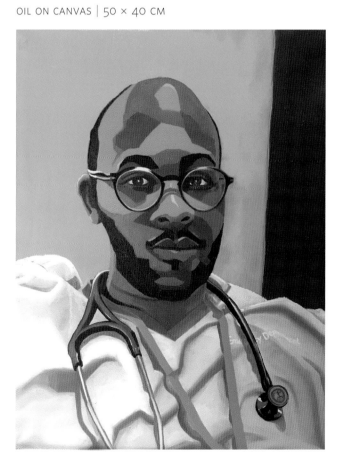

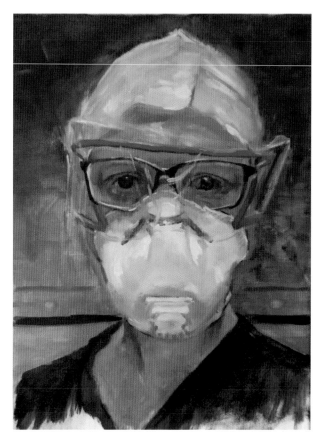

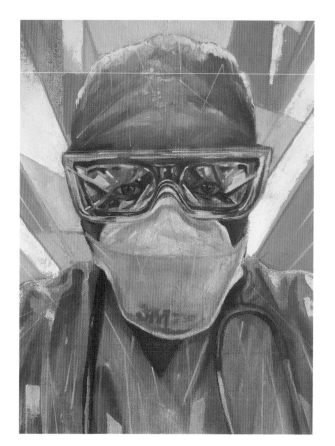

TOM DAVIS by LINDA BRETT

OIL ON LINEN | 40 × 30 CM

DR ABOLAJI ATOMODE
by DAN CIMMERMANN

OIL ON CANVAS | 40 × 30 CM

JEN by MARK BONELLO

OIL ON BOARD | 25 × 20 CM

NURSE KAT by EMMA-LEONE PALMER

OIL ON CANVAS | 65 × 45 CM

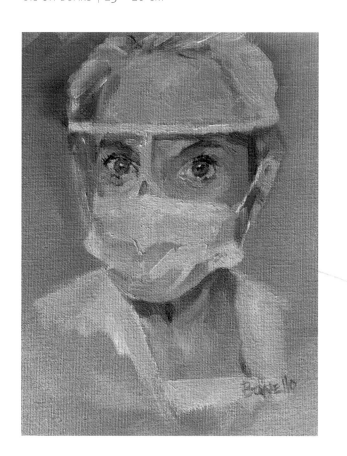

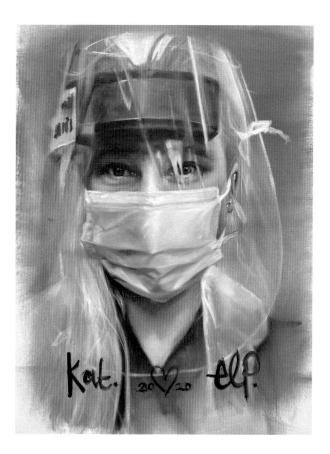

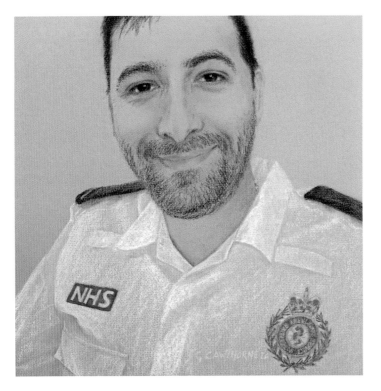

CHRIS HYAMS by GILLIE CAWTHORNE

PASTEL | 30 × 30 CM

'Chris is a paramedic with Yorkshire Ambulance Service and has left teaching to return to the front line.' GILLIE

JENNA JOINER by ZOE FOX

PASTEL | 35 × 25 CM

'I am an immunology nurse specialist at Aberdeen Royal Infirmary, looking after a very vulnerable group of patients with immune deficiency, who must continue their treatment so they can continue a "normal life". So working at the moment can be quite stressful. Keeping our patients safe and healthy is our number one priority – but also for me, being a single mum of two, keeping my family safe is my main priority.' JENNA

'I loved creating this portrait of Jenna. You can see how serious the Covid situation is, but also an air of love and care shows in her eyes. I am sure she provided hope and security to those around her. It felt amazing being able to show gratitude to our heroes.' ZOE

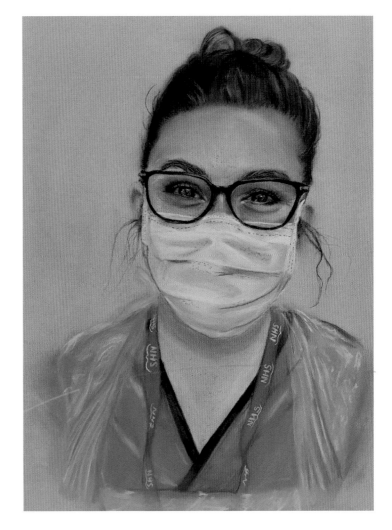

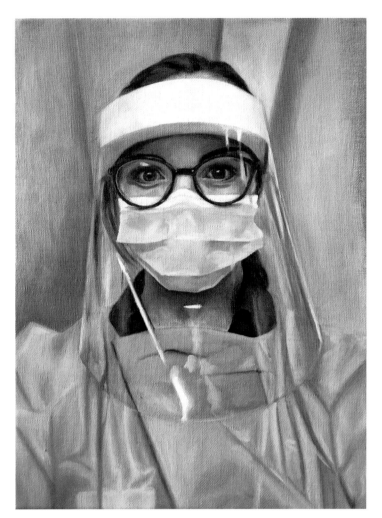

JESS SUMNER by NINA JENKINS

OIL ON CANVAS | 40 × 30 CM

'Jess works at City and Sandwell Hospitals in Birmingham – straight from university and starting her career as a speech and language therapist during the Covid-19 pandemic. Jess took this all in her stride, saying "there's nothing quite like being thrown into the deep end!" Thank you for what you do, Jess. Thank you to our NHS.' **NINA**

'I can't thank you enough... You are making such a difference by using your talent. It's amazing having people supporting the NHS and raising awareness of how hard we work! It really does help keep us all going.' **JESS**

DESI by FIONA FENG

OIL ON CANVAS | 40 × 30 CM

'Desi is my neighbour. When I contacted him to propose painting his portrait he was hesitant at first. However, his partner persuaded him, and took this photo of Desi after a long night shift working in intensive care. I was struck by the photo. I could see a mixture of different emotions in his eyes: concern about the future, yet a strength and determination despite what he was facing every day. This is something I wanted to capture in this portrait, along with what I know of his personality. His intelligence, warm-heartedness and humbleness.' **FIONA**

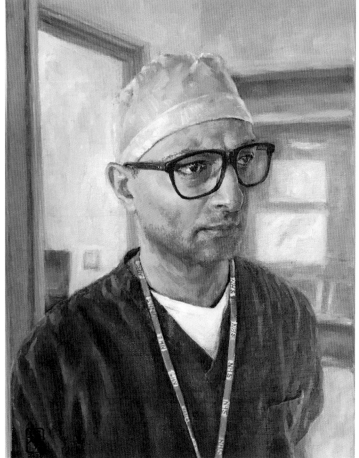

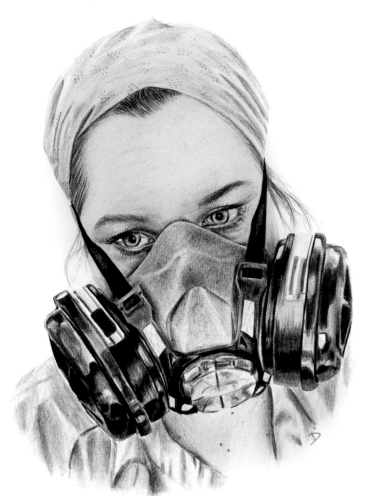

HAYLEY TRAVERS by DANIELLE COX

COLOUR PENCIL | 29.7 × 21 CM

'Hayley is an operating department practitioner, called back to the hospital theatres to assist the most vulnerable Covid-19 patients, working mainly night shifts. Whilst a mask may hide the face, the eyes reveal a personal story of service and sacrifice, for which we must be forever grateful. At the start of the lockdown my week-old daughter spent two weeks in hospital with a serious illness. During this time the staff were nothing short of phenomenal, and did everything they could to ensure that we went home safely. It has been a privilege to be able to give something back – a small gesture for a huge achievement! Thank you to all of the NHS staff who saved my daughter's life and have given so much.' **DANIELLE**

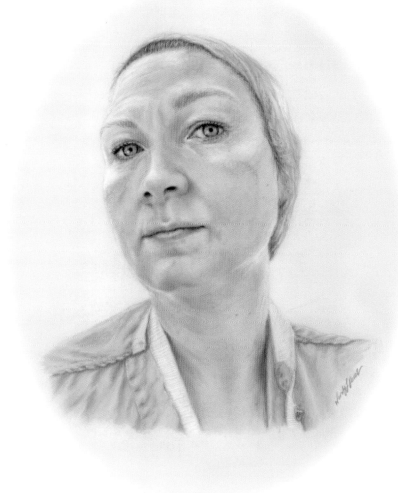

SAM HANCOCK by WENDY PEREZ

COLOUR PENCIL ON DRAFTING FILM | 30 × 21 CM

'It was such an honour to draw my amazing friend Sam, who works as an assistant team leader and senior operating department practitioner in the vascular team at the Princess Alexandra Hospital in Harlow's main theatre, which became an extension to ITU to care for Covid-19 ventilated patients. Thank you to the selfless and dedicated staff for all the work they did and continue to do.' **WENDY**

DR ZOÉ PUYRIGAUD
by JENNY MATTHEWS

WATERCOLOUR | 35 × 35 CM

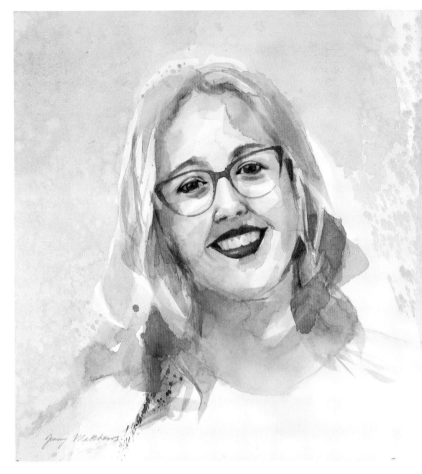

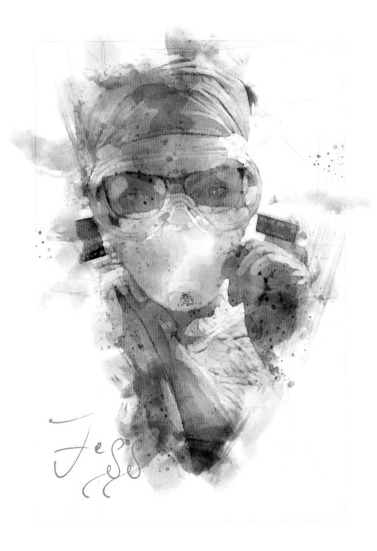

JESS CALLISTER
by GEOFF BEATTIE

DIGITAL WATERCOLOUR | 30 × 20 CM

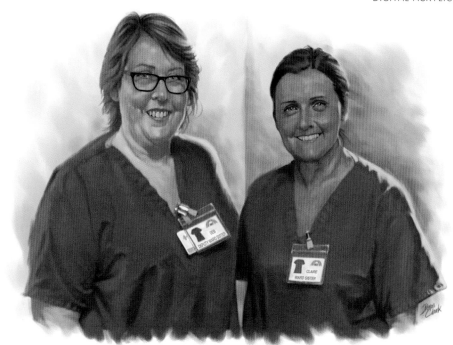

DEB & CLAIRE by DAVE CLARK
DIGITAL ACRYLIC | 29.7 × 42 CM

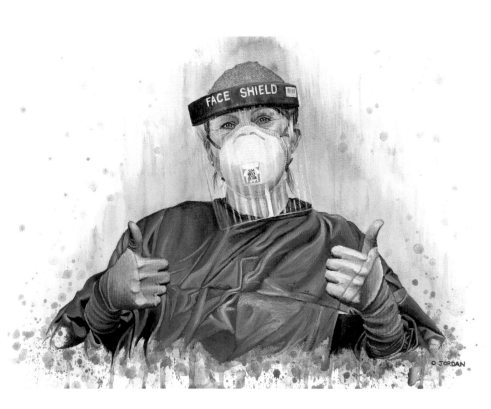

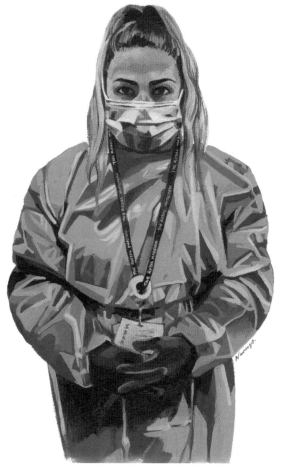

LYNSEY LAUCIUS by OLLY JORDAN

ACRYLIC | 29.7 × 42 CM

LAUREN GROSTATE
by NANCY O'CONNOR

ACRYLIC | 30 × 25 CM

MOHAMMAD KAMRAN SHAHID
by STEPHEN EARL ROGERS
PENCIL ON PAPER | 24 × 16 CM

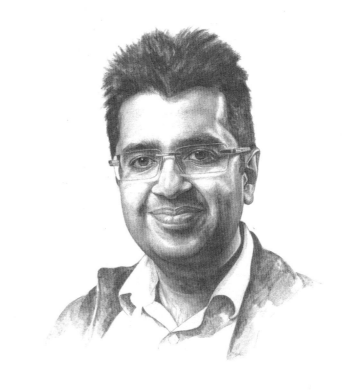

MICHAEL SUGDEN
by GEOFFREY HARRISON
WATERCOLOUR AND GOUACHE ON PAPER | 20 × 15 CM

'I was really pleased to be able to paint a paramedic. I had already painted a couple of senior NHS people and wanted to do someone more from the front line. I hadn't spoken with Michael directly, and the pictures that he sent me seem to be of someone who wasn't exactly comfortable in front of a camera, but one image of him smiling seemed so genuine that I picked that one to work from. At the time I wasn't able to get to my studio and my usual oil paints, so I fished out an old watercolour set. These portraits were the first time I'd really got to grips with this medium, and I was actually surprised by the results I was able to get. The painting of Michael is one I really like. When he received it, he gave me a call to thank me, which was very nice of him. We chatted for a bit and I got the sense of him being a humble and quiet man, kind and thoughtful. This portrait was a pleasure from start to finish.' GEOFFREY

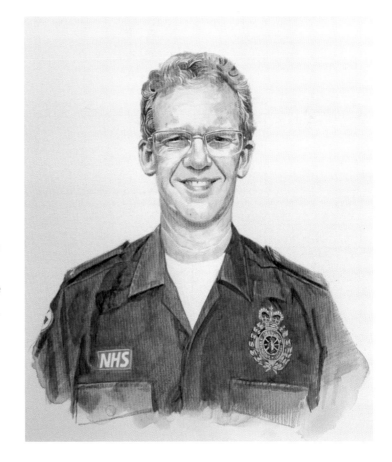

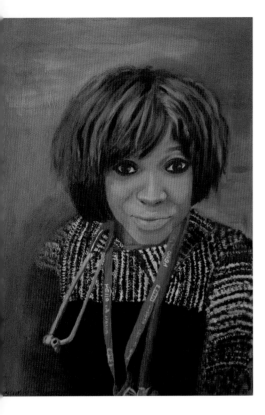

IFEJOBI OKEYODE
by KIRSTY SEMPLE

ACRYLIC ON CANVAS | 40 × 30 CM

DR NEELMA AMJAD
by GABRIELLA MARCHINI

OIL ON LINEN | 40 × 30 CM

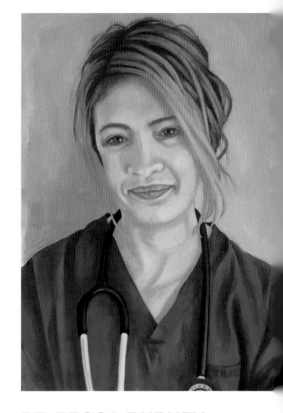

DR BECCA BURNEY
by TINA FIRKINS

OIL | 43 × 30 CM

LEON by JAMES QUINN

OIL ON BOARD | 30 × 23 CM

SAM DOWNES
by MICHAEL DAVIS

OIL ON CANVAS | 35.6 × 27.9 CM

KIRAN by KAYE HODGES

OIL | 48 × 40 CM

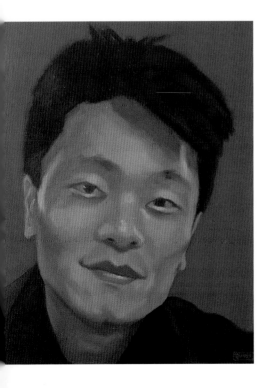

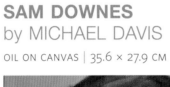

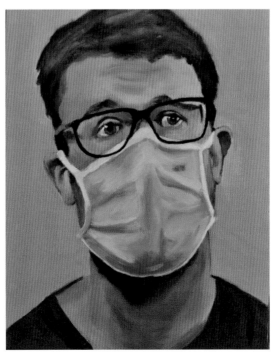

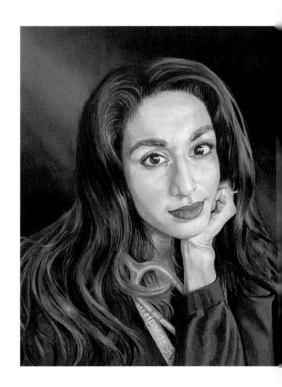

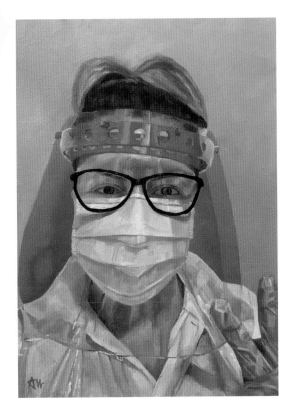

KATIE by ASHLEY ALLEN

OIL | 25 × 20 CM

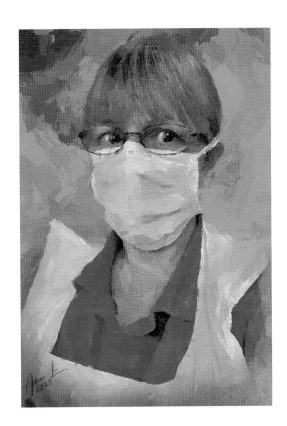

ANNETTE SCAIFE
by ADRIAN LEE

DIGITAL | 40 × 30 CM

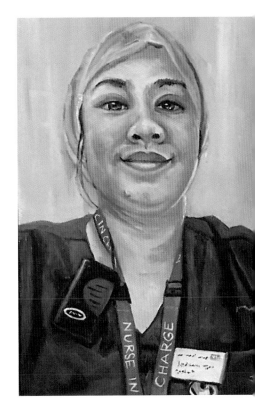

JEN SOR
by JACQUI CAHILL

OIL | 31 × 20.5 CM

BECKY by SARA REEVE

OIL ON CANVAS | 30 × 20 CM

JENNIFER COLE
by MIRIAM MAS

OIL ON CANVAS | 25.4 × 20.3 CM

LAURA
by MICHELE ASHBY

PASTEL | 29 × 21 CM

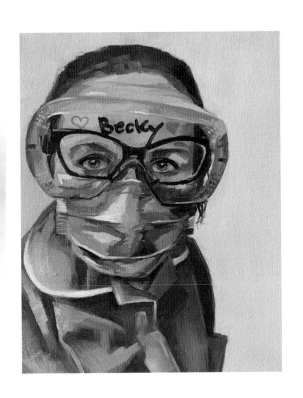

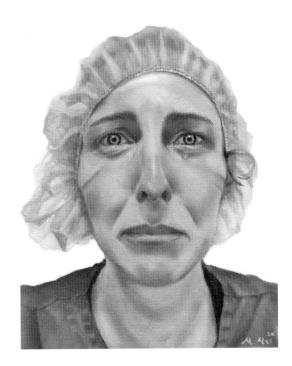

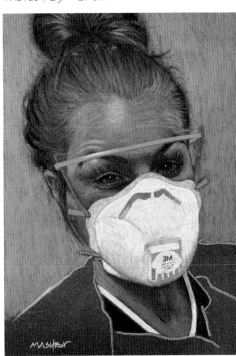

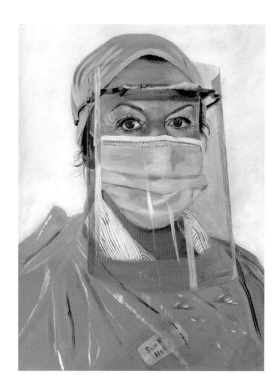

SUE MORGAN by CLAIRE CROSS

ACRYLIC | 41.5 × 29.7 CM

DR ANNA STILWELL
by MAUREEN NATHAN

ACRYLIC ON CARD | 20 × 20 CM

ELLIE by RHONA CARRELL

ACRYLIC | 29.7 × 21 CM

FRAN by VITAL PEETERS

FUSED GLASS | 44 × 33 CM

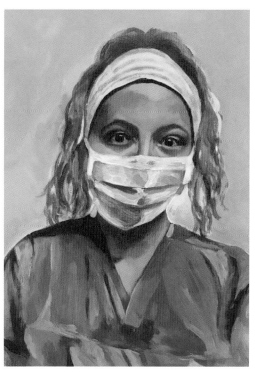

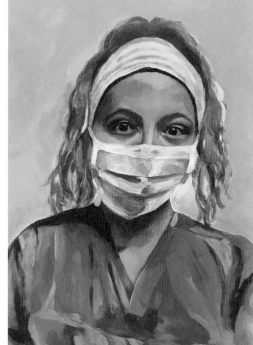

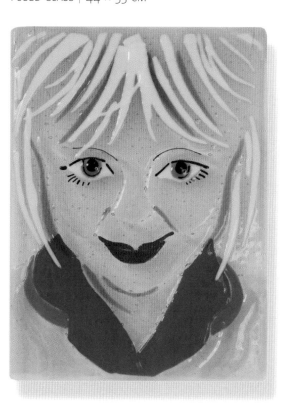

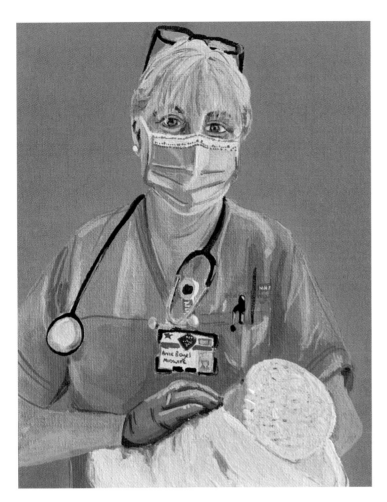

ANNE by SARAH CALLAWAY

ACRYLIC ON CANVAS BOARD | 25 × 20 CM

'Anne is a midwife superhero. Bringing new life into the world at a time of such uncertainty is a sign of hope for the future.' SARAH

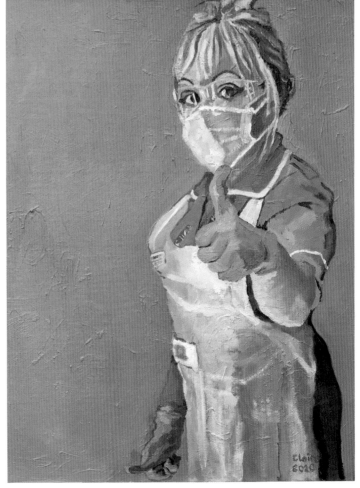

CLARE PARR by CLAIRE JACKSON

OIL ON BOARD | 60 × 40 CM

'I've always been struck by the wonderful sense of humour among hospital staff, even in times of great stress. As well as being brave, dedicated, supremely hardworking and highly skilled, they find the strength to be cheerful too. Clare, from Huddersfield, has this good cheer whilst maintaining great professionalism.' CLAIRE

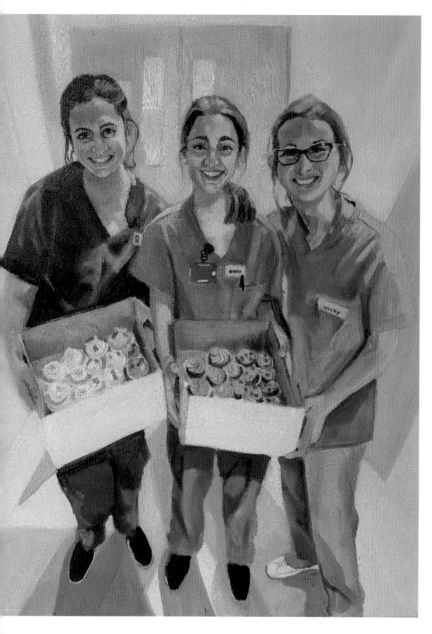

NICOLETTE MARTIN by FIONA HOOPER

OIL | 30 × 24 CM

ELLIE, LAURA & VICKY by JANE CATON

OIL | 61 × 61 CM

'Ellie, Laura and Vicky were all working together on a Covid A&E ward at Kings College Hospital, London. Their smiles upon receiving the cupcakes from Ellie's mum, to help them get through a difficult week, were captivating; they appeared so strong in the face of incredible adversity. I wanted to paint a happy painting, full of colour, in oils, to reflect this.' JANE

'Our beautiful portrait is displayed in our office where we can all share and see it. We are neuro-oncology clinical nurse specialists, and were redeployed to a Covid ward. It's been hard work, but the support has been amazing. On this day my mum very kindly had 36 cupcakes delivered to the ward to give us all a boost!' ELLIE

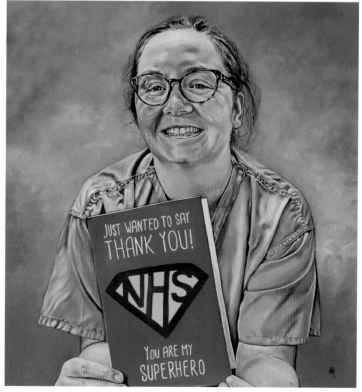

SINEAD WALTON by ANNA REED

OIL ON WOOD PANEL | 47 × 46 CM

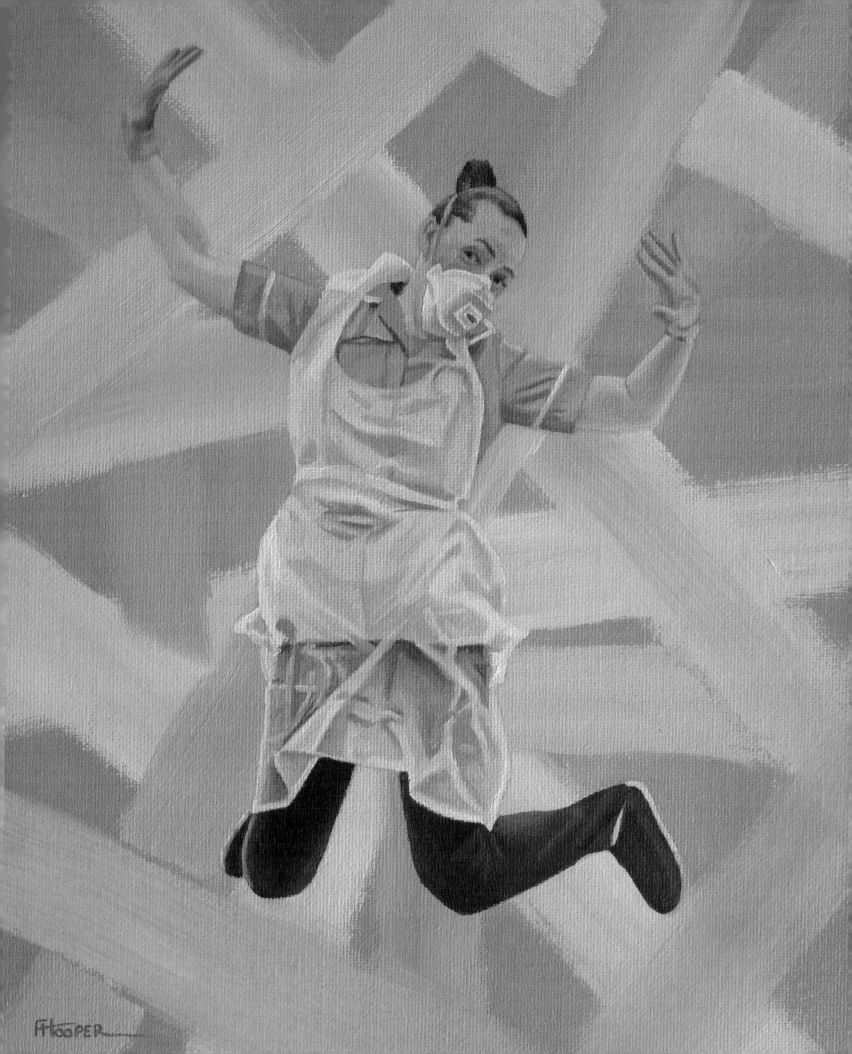

INDEX of ARTISTS